EARL CUNNINGHAM

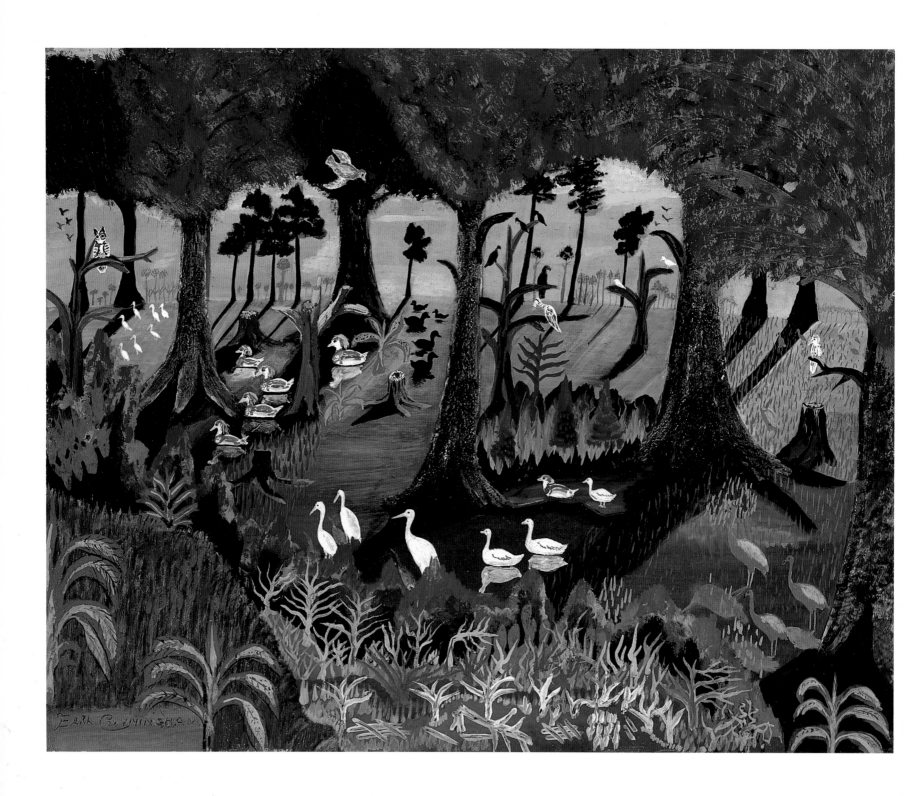

EARL CUNNINGHAM
PAINTING AN AMERICAN EDEN

By Robert Hobbs

Foreword by Lynda Roscoe Hartigan

Harry N. Abrams, Inc., Publishers

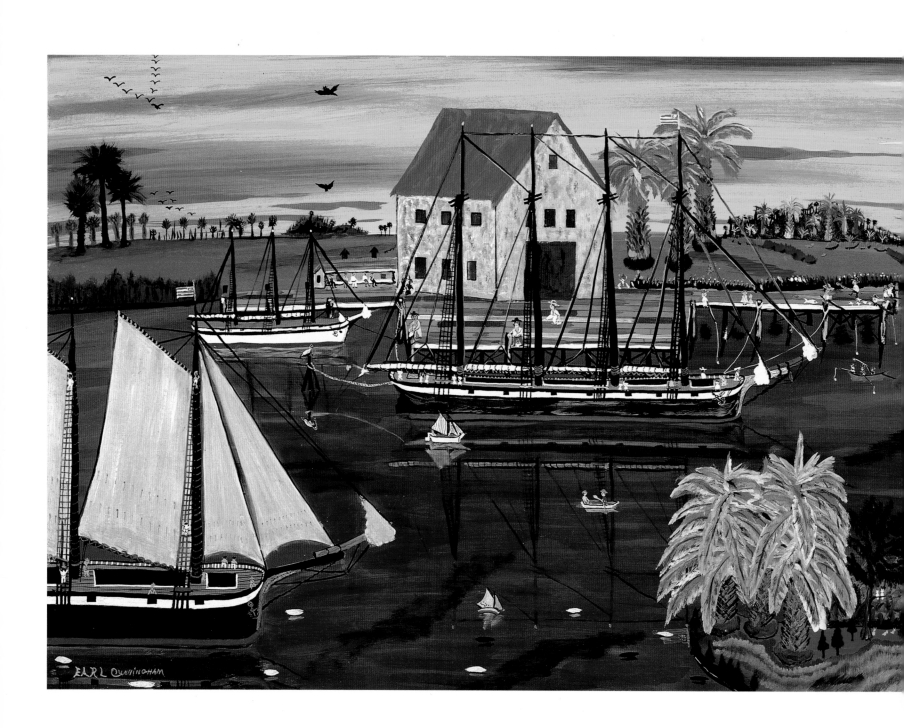

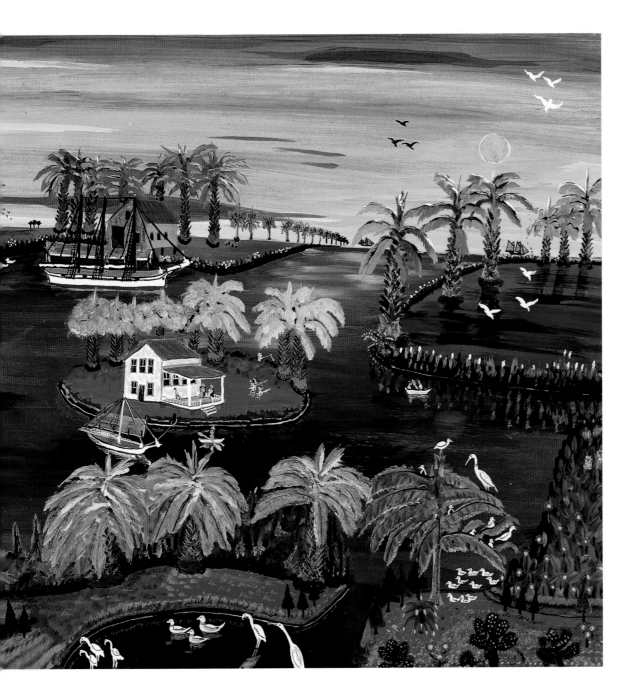

Contents

Left: Palm Beach. *19×48"*
Page 2: Marsh Birds. *16×20"*

Dedication

In the visual arts, collectors have made more significant contributions to the appreciation and understanding of vernacular art than to any other area. Among those who have enhanced this understanding are The Honorable Marilyn Logsdon Mennello and Michael A. Mennello. In the past decade they have collected and conserved the majority of the extant works of the vernacular painter Earl Cunningham, who worked from 1949 to 1977 in St. Augustine, Florida.

Their efforts, however, go far beyond collecting the art of a single painter. In the process of saving Cunningham's art for posterity, the Mennellos have located and preserved his diary, scrapbooks, personal photographs and snapshots, painting materials, brushes, and drawings, thus providing access to this thoroughly private individual and the opportunity to piece together his life and work. Because Cunningham wanted to create a museum of his art, the Mennellos' dedication to his art has maintained the integrity of his undertaking and has made possible the investigation of his life and dream that is the purpose of this book.

While Earl Cunningham was still living, Marilyn arranged for the Loch Haven Art Center (now the Orlando Museum of Art) to feature his work in a one-person exhibition, which was held in May 1970. This exhibition may have encouraged the artist to trade a painting with the internationally recognized photographer Jerry Uelsmann in return for a series of photographs of his antique shop, his gallery, and himself. These photographs are crucial documents for understanding Cunningham's business and his

informal museum on historic St. George Street.

In 1984 Michael Mennello began to make inquiries about Cunningham because he wished to acquire a painting for Marilyn. He discovered that the artist had died in 1977. Wondering what happened to his extensive collection of paintings, the Mennellos left their name with several art galleries in the St. Augustine area and heard a few weeks later from the nephew of Theresia Paffe (Cunningham's long-term patron), who offered to sell sixty-two paintings on the condition that they were purchased as a group. After acquiring this collection, the Mennellos decided to try to find the rest of the paintings completed at the time of the artist's death by working with the estate lawyers.

Not content simply to collect the art and related archival materials, the Mennellos felt obliged to share the paintings with the public. With the guidance of Robert Bishop, director of the Museum of American Folk Art in New York, a collection of sixty-six works was shown in 1986 under the joint auspices of his museum, The Center for American Art, and New York University, before touring a number of museums across the country.

Because of the foresight, pertinacity, and generosity of Michael and Marilyn Mennello, an important segment of twentieth-century American art has been preserved for future generations to enjoy. For these reasons, this book is gratefully dedicated to them.

ROBERT HOBBS
Rhoda Thalhimer Endowed Professor of Art History,
Virginia Commonwealth University

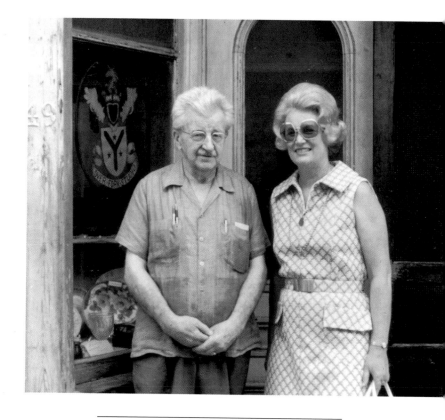

Earl Cunningham and Marilyn Logsdon Wilson (now Mennello) in front of Over Fork Gallery, 1970

Acknowledgments

Books are of necessity collaborative endeavors, and this one is no exception. A great number of individuals have generously contributed in a variety of ways to its publication.

Among those deserving special thanks for aiding in the understanding and appreciation of Earl Cunningham's work are the following: Dr. Maude Southwell Wahlman, professor and chairperson of the art department at the University of Central Florida, Orlando, has painstakingly gathered a great deal of primary and secondary material on the artist. The late Robert Bishop, former Director of the Museum of American Folk Art, was one of the first to recognize Cunningham's importance. Long a believer in Cunningham's significance, Lynda Hartigan, curator of painting and sculpture at the National Museum of American Art, has championed this publication and provided reasoned responses to the author's questions. Both Marilyn Logsdon Mennello and Michael A. Mennello have been wonderfully generous with their collection of Cunningham's work and papers and have provided most congenial surroundings for researching his work. The late Theresia Paffe was for many years Cunningham's patroness and benefactor; without her continued support, many of these works would never have been realized. Ned Rifkin, Director of the High Museum of Art, enthusiastically has endorsed this project. Together with his excellent staff, including Bill Bodine and Ellen Duggin, Rifkin has created the opportunity for this author to curate an exhibition in conjunction with this publication.

For providing pertinent and helpful information

for this project, the following scholars are gratefully acknowledged: Kristen Congdon, John Hubenthal, William C. Ketchum, Mary Lynch, Joan Muller, and Henry Niemann. Many members of Cunningham's extended family have been open to the author's many questions, including Neil Cunningham, Robert Cunningham, Harvey Rossiter, Bernice Spinney, and Beverly Winslow. And his old friends and acquaintances, particularly Charles Brigham, Kenneth Dow, Robert Harper, John Surovek, Jean Troemel, and Jerry Uelsmann, likewise have responded generously to inquiries about Cunningham.

A number of museum professionals have contributed in different ways to this project: Tom Butler, Director of the Huntington Museum of Art; Christina Orr-Cahall, Director of the Norton Gallery; Gary Libby, Director of the Museum of Arts and Sciences, Daytona Beach; Virginia Mecklenburg, Chief Curator of the National Museum of American Art; and Marena Grant Morrisey, Director of the Orlando Museum of Art.

This book would not have become a reality without the following individuals. A number of photographers have been most helpful: among them, Philip Eschbach and Jerry Uelsmann deserve special recognition for their many fine photographs; and Marjorie Greathouse, George Mann, Robert Mullis, and Heather Protz have provided needed images. Most of these photographs are indirectly indebted to the highly professional work of conservator Bonnie Jones. For their secretarial assistance, Ariana Bracalante, Phyllis Green, and Betsy Patterson deserve special thanks. And on the staff of Harry N. Abrams, Inc., particularly Margaret Rennolds Chace, Assistant Managing Editor, and Dana Sloan, Designer, have been superb.

For their general enthusiasm and aid to Cunningham's art the following people merit special recognition: Ed Bookbinder, Nancy Bowers, Joe Brunson, Betty Castor, Jane Dart, Senator Paula Hawkins, William Heyler, Bruce Koplin, Carole Nelson, Roberta Peters, Dale Reis, Ronald Stow, and Lynda Wilson. A number of collectors of Cunningham's art have supported the idea of this undertaking: Pam and William du Pont III, Eva and Sergio Franchi, Nancy and Larry Godwin, Rosalee and Eddie Kaminsky, Linda and Allan Keen, Samuel and Marion Lawrence, Rita and John Lowndes, Sonia and Lester Mandell, Sylvia and Steven Overby, Vivian and Tom Sterns, and Lynda Wilson.

R. H.

Foreword

*To conjure, even for a moment, the wistfulness
which is the past is like trying to gather in one's
arms the hyacinthine color of the distance. . . .
The past is only the present become invisible
and mute; and because it is invisible and mute,
its memoried glances and its murmurs are infi-
nitely precious. We are tomorrow's past. Even
now we slip away like those pictures painted on
the moving dials of antique clocks—a ship, a
cottage, sun and moon, a nosegay. The dial
turns, the ship rides up and sinks again, the yel-
low painted sun has set, and we, that were the
new thing, gather magic as we go.*

MARY WEBB, *PRECIOUS BANE*, 1924

For the better part of his eighty-four years, Earl
Cunningham heeded dual siren songs—the itinerant
way of life and creativity. From youth to early mid-
dle age, his was a literal American odyssey, in search
of opportunity and adventure up and down the east
coast and into the South and Midwest. Although a
sporadic source of financial support, painting was a
passion even then.

Settling after 1949 in Florida's historic St.
Augustine as the proprietor of a modest antiques
shop may have granted Cunningham refuge in a par-
ticular place and business, yet his love, indeed his
need, for the freedom and challenges of itinerancy
hardly abated. No, once devoted to painting after the
1940s, Cunningham embarked on a creative odyssey
that motivated him to sift, evaluate, and transform
memories, experiences, impressions, and observa-
tions—the tracks of one man's lifetime, one man's
perception of his country's natural and cultural
resources.

Ultimately, Cunningham traveled the route of
the artist in search of security, self-awareness, and
immortality, aspirations made abundantly clear in this
monograph. That he is currently not widely known as
a twentieth-century American painter should also be
evident. Moreover, he is an anomaly—an artist virtu-
ally unschooled in the traditional sense yet conversant
as much in the ways of the world as in its colors,
forms, and lines. While these characterizations might
seem odd avenues of introduction at the moment of
Cunningham's arrival on the national scene, they are
not intended to raise notions of reputation or aberra-
tion. Instead, the issues at hand are those of taste and

timing, ambition and identity, navigated by the artist and the art world alike.

Jettisoning the term folk art from this exploration of Earl Cunningham may be tantamount to throwing away a pair of old shoes, comfortable, familiar, well-worn, dependable. Yet that is exactly what the reader is about to experience because the alternatives proposed by Robert Hobbs reflect growing efforts to redirect the interpretation of artists such as Cunningham. The old shoe, however, is not devoid of value if we pause to consider several salient coincidences.

Cunningham was obviously not in the right place at the right time as he painted intermittently before 1949. That is to say, he went unnoticed as some of the period's advocates of American folk art ventured beyond the preindustrial era and antiques into the twentieth century and living practitioners of "the art of the common man." Modern art dealer and self-styled art historian Sidney Janis, for example, examined the work of more than five hundred self-taught artists before selecting the thirty featured in *They Taught Themselves: American Primitive Painters of the 20th Century*, his influential book of 1942.

A footloose life-style and limited output undoubtedly diminished Cunningham's opportunities for consideration by the discerning likes of Janis, but the absence of such notice is not significant. Far more to the point is the degree to which Cunningham's credentials fit the bill of the day even during what must be considered the tentative phase of his efforts.

Born in 1893, Cunningham landed squarely at the end of the two generations that had produced most of the artists discovered and promoted as mod-

ern-day naives or primitives during the 1930s and 1940s—from Anna Mary Robertson "Grandma" Moses (born in 1860) through Morris Hirshfield and Horace Pippin (born in 1872 and 1888, respectively) to Lawrence Lebduska (born in 1894). Had interpreters at the time encountered Cunningham's semi-documentary, semi-idealistic subject matter, they would have undoubtedly presumed, as they did for Horace Pippin and others, that an artist whose life straddled two very different centuries must have been motivated by nostalgia for experiences and values of the past. Membership in the ranks of American memory painters, as so many of these artists were then dubbed, would have been Cunningham's for the taking.

"Patrick J. Sullivan, housepainter; Joseph Pickett, storekeeper; Emile Branchard, truck driver; Cleo Crawford, laborer (Negro)"—so goes the listing of artists in the table of contents for Sidney Janis's book. Earl Cunningham would have been at home in such a list, whether as a tinker, peddler, mariner, farmer, or shopkeeper. Janis's manner of characterization reflects the art world's perception of early-twentieth-century self-taught artists as working-class people who engaged in the creative act as an avocation and without the benefit of artistic training. Thus, when artists such as Cunningham emphasized the decorative effects of pattern, outline, and color as well as close variations of subjects, the results were considered honest but naive attempts to grapple with the complexities of visual principles and content.

As Cunningham settled into painting with greater regularity after World War II, these were the

criteria that the art world had established not just for living self-taught artists but for their presumed predecessors—from highly skilled craftspeople to amateurs—who had been active during the eighteenth and nineteenth centuries. Inevitably and incorrectly, the art world had arrived at a notion of folk artists as a national pool of intuitively creative people, a notion that attempted to assert a lineage rooted in individuality rather than community and broader social meaning. As terms like naive and primitive were mixed and matched, the folk artist and the self-taught artist became one and the same in the world of art and antiques.

By the early 1950s, however, a divorce of sorts occurred, for interest in twentieth-century self-taught artists had plummeted even as the romanticized definition of folk art persisted. Old things simply had greater social, artistic, and commercial cachet. Cunningham quietly pursued his painting for the next several decades, unaware of this development as he included "primitive artist" on his business card. Before his death in 1977, however, the pendulum of notice resumed swinging in the direction of twentieth-century self-taught artists, largely because of changes initiated by the populism and cultural upheavals of the 1960s and 1970s, not to mention the rush on Americana inspired by the Bicentennial.

How did this affect Cunningham? In 1970, a Florida museum organized his first one-person exhibition, evidence that his work received some professional and popular attention within his adopted state during his lifetime. Short-term dividends, it would seem, were otherwise negligible. Cunningham, for

example, was not included in "Twentieth-Century Folk Art and Artists," the modestly scaled yet landmark exhibition organized by the Museum of American Folk Art in 1970. Nor did he appear in the even more influential publication of the same title, coauthored four years later by the exhibition's curator, Herbert Waide Hemphill, Jr., and Julia Weissman.

That Cunningham discouraged most attempts to see or buy his paintings surely worked against Lady Luck, herself a significant factor in matters of discovery. Yet he did not escape the net of this renewed and expanding awareness of artists considered the contemporary folk. Neither the timing of his first significant showing in an American museum nor that of his 1969 encounter with the woman who gradually acquired most of his works was mere coincidence. The elderly Cunningham's vibrant paintings of a familiar yet exotic American paradise readily suited the expectations of an audience newly responsive to the nostalgia, naiveté, and authenticity associated with folk art, especially when produced by its most comforting embodiment, the memory painter.

In its search for contemporary expression across the country, however, the folk-art world began to stretch its emphasis on individuality more and more, to the extent that it has spurred the ascendancy of self-styled creators whose solitary, often visionary or institutionalized, experience seems to set them apart from society's norms and the art world's concerns and traditions. First identified as the "outsider artist" in 1972, the eccentric man has replaced the common man as the twentieth century draws to a close.

A sampling of recent coverage in the popular

press tells it all. In 1989, the art column in *Newsweek*'s Christmas Day issue proclaimed, "Outsiders Are In. American Folk Artists Move Into the World of Money and Fame." In October 1992, the makings of a craze or fad were even more evident as the lead of an article in *Art and Auction* asserted, "Whatever label you apply—Naive, Self-Taught, Visionary, Intuitive, Grass-Roots, Contemporary Folk or Art Brut—Outsider art is in."

Earl Cunningham was a troubled, obsessive man who chose suicide as the final solution to his personal and circumstantial difficulties. His use of color was impudent if not downright audacious, while his sense of pictorial composition was freewheeling, combining as he did variously scaled elements from different times, places, and cultures. This constellation of factors and characteristics could easily suggest that he worked from an idiosyncratic inner vision, the now-commonplace beacon for identifying someone as an outsider artist. The term, however, has seldom been applied to Cunningham, whose paintings exude such an emphatic sense of America's natural wonders and history that surely his is the carefree, old-fashioned world of the memory painter as folk artist instead.

By now, it should be evident that the century-long attempt to understand the achievements of nonacademic artists has created quite a stew of terms and notions. Whether the art world has perceived artists like Cunningham as the common man or the eccentric man, it has first and foremost cast them in the role of artist, complete with all of its connotations of intent, ambition, and commitment. To do so implies that we assume a dialogue occurs between an artist and his work as well as between the work and its audience. Yet as critic Brian O'Doherty has pointed out,

The artist's intention does not always guide his work into its most worthwhile context. The work itself offers different complexions to contemporary— and—succeeding audiences. . . . The expectation of a specialized audience is, in modernist art, one of the artist's indispensable frames of reference. The broader reception of the work brings us to cultural needs and expectations, ideas of what constitutes an artist, and, indeed, art.[1]

O'Doherty has explored his concern with what he terms the voice and the myth of the artist solely in relation to key figures in modern art as diverse as Edward Hopper and Jackson Pollock. His observations are relevant nonetheless to the realm of the nonacademic or self-taught artist where the absence of the artist's voice has become as deafening as the presence of the artist's myth. In large measure, this can be attributed to the assumption that an Earl Cunningham has worked—not just without the benefit of self-awareness, artistic decisiveness, shared experience, or culturally relevant resources, but without a specialized audience of his own selection or negotiation as well.

No, Cunningham and his self-taught peers have been defined primarily by the art world's perception of itself as the audience that arbitrates the broader reception and cultural expectations, factors that someone like O'Doherty assigns to realms other than the art world. But why not be the arbiter, the litmus

test, one might ask. After all, the men and women we have designated as folk artists or self-taught artists or outsider artists have usually informed us that they did not know they were artists until we told them so or that what they have made is not their own doing, but the product of other instructing, inspiring forces, divine or otherwise.

Why not? Because the objects and the makers become lost in very meaningful ways. Old objects seem so separated from their origins or have accumulated so much misinformation and myth that retrieval of maker and meaning is assumed to be impossible. Contemporary material and anything offbeat, old or new, have become so negatively identified with eccentricity that connections to something beyond the individual seem pointless if not nonexistent. But connections are the point—first, to place the objects and their makers in their specific originating realities and, second, to find the interaction between those realities and our larger diverse culture.

The quest for those connections is at the heart of this study of Earl Cunningham, a study that appears during a period of increasing willingness, indeed eagerness, to do so, as the recent exemplary publications on wood-carver Elijah Pierce and painter Horace Pippin make evident.[2] Here, too, the questions that Robert Hobbs applies to both the artist's myth and the artist's voice point to how the artistic and cultural literacy of nonacademic artists can be established as the key to their identity. From the outset, for example, the pace of change is set by stating, rightfully, that Cunningham is not a memory painter because he neither dwelled on the past nor memori-alized it. Instead, as we are ushered through his paintings, it becomes clear that Cunningham mined the past as one of many resources to negotiate the present and to build for a future.

Here also is a man who did not need us to tell him that he was an artist. His business card may have read "primitive artist," but the affectation of a beret and smock, the designation of his business as a gallery and his role as a curator, the conceptualization of his body of work as an entity worthy of a museum all point to someone exploring his ambitions in the persona of the "artiste."

Those ambitions might seem to run contrary to his attempts to limit if not eliminate an audience, but Earl Cunningham did indeed concern himself with an audience on both a short- and long-term basis. His enterprising spirit, born of necessity at an early age, should not be underestimated, nor should his appreciation of sales techniques or the appeal of roadside attractions and limited access. Anyone genuinely disinterested in attention did not have to put a painting in the window of his own store with a not-for-sale sign or ceremoniously issue select visitors into the locked room of paintings coincidentally adjacent to his shop. Such practices are after all two of the oldest come-ons, call them strategies, in commercial practice and human behavior. Moreover, his desire to retain his body of work reveals the degree to which he assigned it artistic and human value and consequently believed that it warranted the audience of posterity.

Accessories and titles and strategies, of course, do not make the artist, but the intent and ability to produce persuasive pictorial form and content do.

This is the definition of a visual artist in its most basic, universal form. In our century, however, several contradictions have insidiously shaped how the efforts of self-taught artists are evaluated, to the extent that terms such as folk or naive immediately imply lesser artistic ability, no matter how delightful or provocative their work is said to be.

Modern art is based on the desire to alter conventions of representation and to experiment with what can be considered materials, techniques, goals, and even art at the hands of the artist and in the eyes of the world. Modern professional artists have often derived inspiration from self-taught artists because they are seen as free spirits, free of the conventions of formal education, the art world, and even society. Is it not then hypocritical to assert that a self-taught artist's unconventional handling of materials, modes of representation, color, and content are the result of "making do" in the absence of proper training, exposure to ideas, or the exercise of artistic choice? Worse yet are the cries of foul play or trespassing that still arise when any hint of canny negotiation or inflection of art and culture is detected in the self-taught artist's work or life view.

One self-taught artist cannot stand for all, but we encounter here abundant evidence that Earl Cunningham was an artist attuned to and conditioned by personal, historical, and collective experience that one could well risk describing as his unofficial training ground. His world was shaped by agrarian, maritime, and commercial ventures, regional diversity, love of natural wonders and man-made curiosities, self-sufficiency, and a reserve of suspicion that verged on paranoia. He was, it is shown, a fan of popular and Native-American culture, a history buff, and one of many Americans deeply affected by the possibilities generated by the advent of automobiles and highway systems.

Moreover, we are left with little doubt that Cunningham was a deliberating artist. His unflaggingly bold use of color is not the mark of someone who did not know any better, did not have access to a better range of materials, or preferred decoration to expression. Mother Nature showed him the extremes, the subtleties, and the possibilities, as did reproductions of European modern art. Cunningham also relished the potential of exaggeration as much as the specificity of detail because it suited his pictorial, interpretive, and psychological ends—shaping a view of the world that was not imaginary but utopian in its idealism. That he juggled repetition and variation need not be taken as the sign of a limited repertoire, if we consider the fact that artists who work in series often do so because of a drive toward perfection or apotheosis.

There is nothing wrong with gathering magic as we go, to paraphrase the early-twentieth-century British author Mary Webb. Magic in itself promotes inquisitiveness, wonder, and transformation as long as we acknowledge the difference between reality and illusion. Comprehending the voice and the myth of an artist requires a similar exercise in discernment. Join now the self-taught artist's odyssey of perception—mirrored so well in Earl Cunningham's example—toward a port of understanding.

LYNDA ROSCOE HARTIGAN

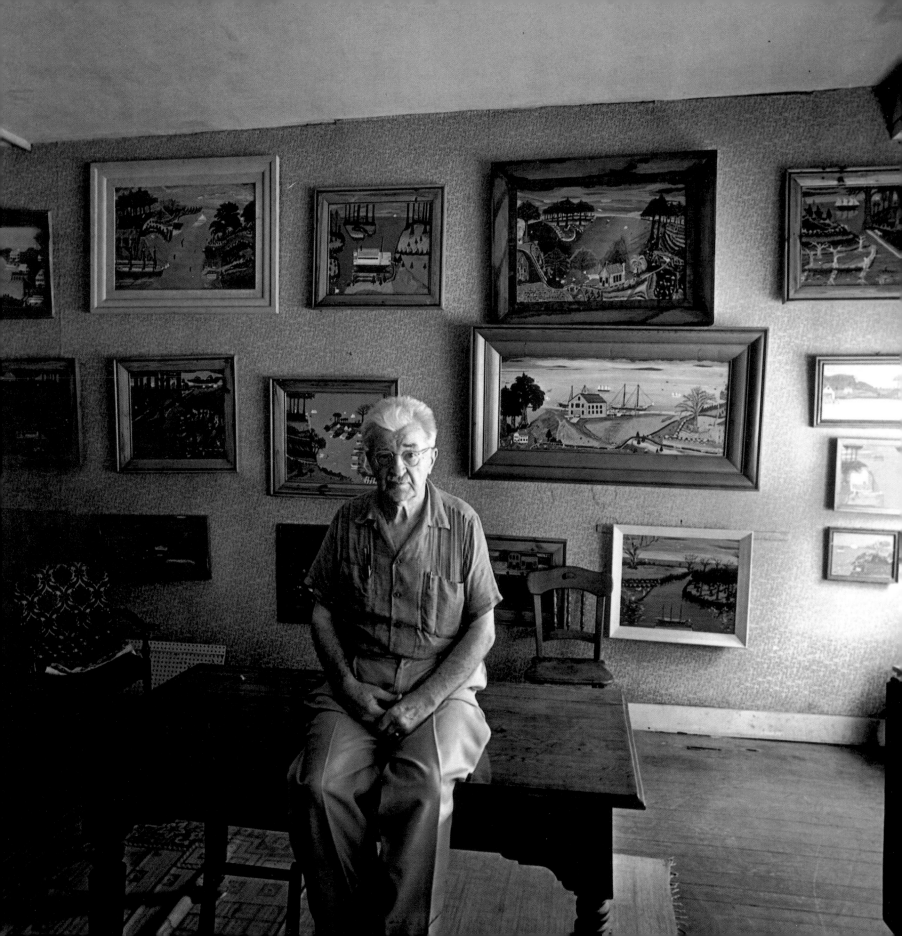

Earl Cunningham: Painting an American Eden

D isenchanted with life, King Arthur and Queen Guinevere in Lerner and Loewe's musical *Camelot* wonder how simple folk cope with reality. Their speculations about the so-called simple folk are indicative of many sophisticates who periodically indulge in fantasies about an uncomplicated world. Such an indulgence was voiced in a review of the groundbreaking 1924 Whitney Studio Club exhibition that featured the work of American self-taught artists. Apropos this exhibition, the critic Charles Messer Stow commented, "In the midst of a sophisticated existence it is refreshing to turn to something that totally lacks sophistication. And these early paintings give that refreshment."[1] But the folk and their attitudes are not nearly as naive as Lerner and Loewe's musical and Stow's review suggest and as new historians intent on an upstairs/downstairs reversal of traditional hierarchies are discovering. The popular culture specialist Fred E. H. Schroeder has pointed out: "The expressive *forms* of popular arts . . . must be simple, but the underlying ideas, concepts and philosophies may be most profound. . . . It is my contention that the popular audience, if it is given a choice, will always tend toward the more profound meanings, so long as the aesthetic demands of simplicity and clarity of expression are not violated."[2]

This book on the art of Earl Cunningham (1893–1977)—a marine painter working mostly in Maine and Florida from the teens to the 1970s—will examine his not-so-simple vernacular art from a

Earl Cunningham seated on table in back room of Over Fork Gallery, 1970. Photograph by Jerry Uelsmann

number of contexts, including the artist's personal world, the realm of intuitive art, and mainstream culture. Rather than segregating his Edenic views into a separate realm where they can mainly be appreciated as charming and idiosyncratic, this study will examine them in relation to some of the major historical and cultural debates of their time: the significance of belief in a country attuned to skepticism, American isolationist views versus the country's international commitments, and the role of the past in a culture dedicated to both the present and the future.

According to Robert Bishop, who was director of the Museum of American Folk Art, which cosponsored in 1986 the New York City showing of Cunningham's paintings, this artist is a "truly great painter" whose work is "not in many ways unlike that of [Henri] Rousseau from France."[3] He considered Cunningham remarkable for "his technique [which] is considerably more painterly than that possessed by most 20th century self-taught artists" and "a master colorist."[4] Regarding the Cunningham exhibition as "the rediscovery of a major twentieth century American folk artist," Bishop wrote, "Today his work remains at the forefront of the 'historical fantasy' evolution of twentieth century American folk art."[5] Bishop thought that Cunningham would achieve as important critical standing as Grandma Moses, an assessment that the artist himself would have disputed, since he regarded Anna Mary Robertson as important but not daunting competition. Cunningham collected clippings on Grandma Moses and no doubt studied her paintings to see

how he could improve on her style.[6]

Cunningham was a painter with messianic zeal about his work, which he wanted to be the basis of a museum. In the 1960s he told the photographer Jerry Uelsmann that he hoped to create a total of one thousand paintings for this museum.[7] Sometime in the 1920s this self-taught painter first began to build a museum on his twenty-five-acre farm in Maine, which he named "Fort Valley." Located near the road but situated in a draw with a pond, the farm, which he purchased from his family, was both protected and accessible to traffic. According to Robert Cunningham, his nephew, Earl "always had irons in the fire and was full of ideas and excitement."[8] He may have intended his first house on the property to be a museum since it contained many collections, which were destroyed in a fire that took the house in the 1920s.[9] He later continued to pursue the idea and in 1940 purchased a fifty-acre farm in Waterboro, South Carolina, where he subsequently raised chickens for the United States Army during World War II. After the war Cunningham relocated to St. Augustine, where from 1949 until his death, in 1977, he operated an antique shop and an art gallery, which served as a temporary museum. He called this combination business/museum "The Over Fork Gallery."[10] His friend Charles Brigham has related that the antique shop itself was organized as a museum, and sometimes Cunningham would take people on tours through the shop, telling them stories as if they were visiting a history museum. He once admitted to Brigham that he had been refused a job as a curator somewhere in Maine,

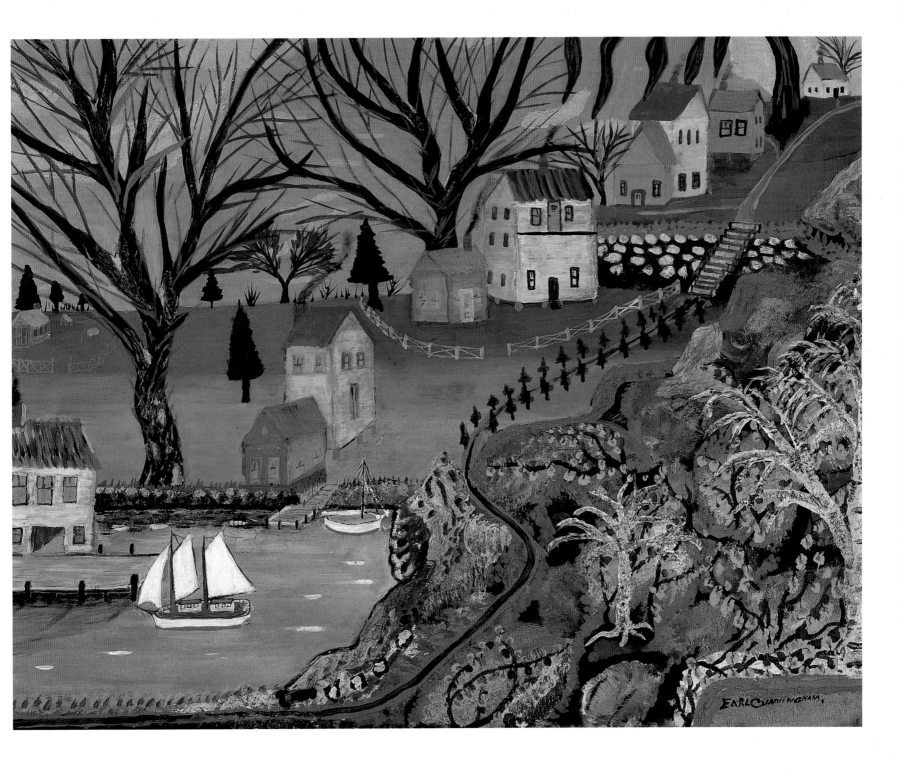

New England Autumn. *16×20". Collection of Samuel B. and Marion W. Lawrence*

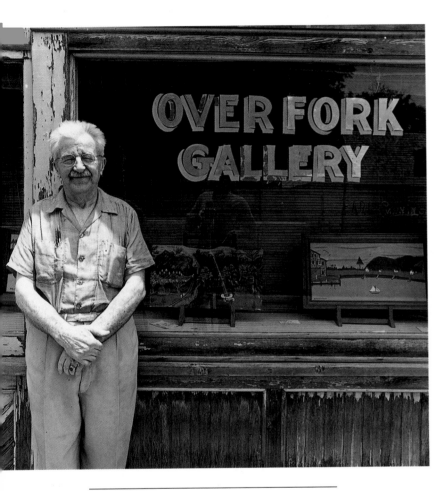

Earl Cunningham standing in front of Over Fork Gallery, 1970. Photograph by Jerry Uelsmann

but Brigham did not give this story much credence.[11] According to another friend, John Surovek, who was director of the Museum of Arts and Sciences, Daytona Beach, where Cunningham's second retrospective was held, Cunningham was the director, docent, art historian, and author of his collection of paintings.[12]

Although he sold a variety of antiques in his shop, Cunningham was reluctant to let go of his paintings. To Surovek he stated, "Every one of my paintings are brothers and sisters. I can't separate my family of paintings."[13] He even made a sign stating, "These paintings are not for sale," which he displayed prominently in the gallery. On occasion he traded paintings for necessary services and such goods as a used car and wood,[14] but he sold only a small percentage of his works because he wanted to preserve them for his museum. He evidently believed that the sum total of 450 extant works that he managed to keep in his possession until the end of his life represented an important statement about the world. In addition to his reluctance to part with his paintings, Cunningham was not receptive to commissions. According to Surovek, Cunningham would not incorporate the Daytona Museum of Arts and Sciences into a painting even though he would have been generously paid for his efforts.[15]

Cunningham's gallery on St. George Street was an almost sacred enterprise that he was unwilling to share with the great numbers of people frequenting his shop in the heart of historic St. Augustine's tourist district. Only a few visitors were allowed into the locked gallery adjoining the shop. It was

located in a space that had been a restaurant, and a few booths remained from that time. Whenever Cunningham decided to open the gallery, he would close the antique shop, even if he had to ask prospective customers to leave. Then he took the honored guests into the museum.

A curmudgeon with a sense of humor, Cunningham, who became known as "the Crusty Dragon of St. George Street,"[16] admitted that the locked door made his museum all the more intriguing. He relished telling the story of the former major and U.S. senator Walter B. Frazier, who "bought a spring and called it the Fountain of Youth and built a six-foot fence around it, and . . . used to say, 'You can take the Fountain, just leave me the fence.'"[17]

Cunningham might have joked about the museum, but he was also deadly serious about both it and his identity as an artist. He was fond of wearing a beret as a way of reinforcing his artistic identity. When he painted, he also wore an artist's smock with a crest on the back bearing the name "Over Fork." The crest, with the addition of the words "Over Fork Over," was the same family seal that he used to advertise his gallery. This crest served as a wry badge of approval, and, strangely enough, it legitimized both the museum and the shop, which Cunningham had indicated on a number of occasions was operated solely for financial reasons. To imply his primarily mercenary attitude toward this business without alienating customers, Cunningham used "Over Fork" as the name for his gallery.[18]

Even though Cunningham left no written record about his museum, his collection of paintings

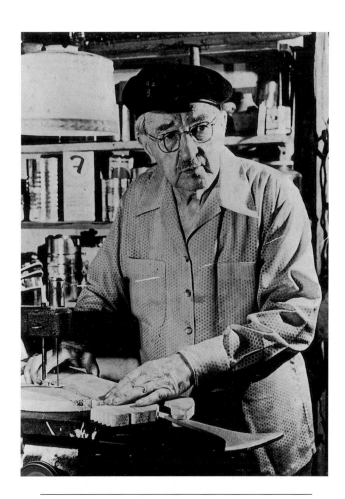

Earl Cunningham working on wooden angel sculpture c. 1972. Photograph by Robert Mullis

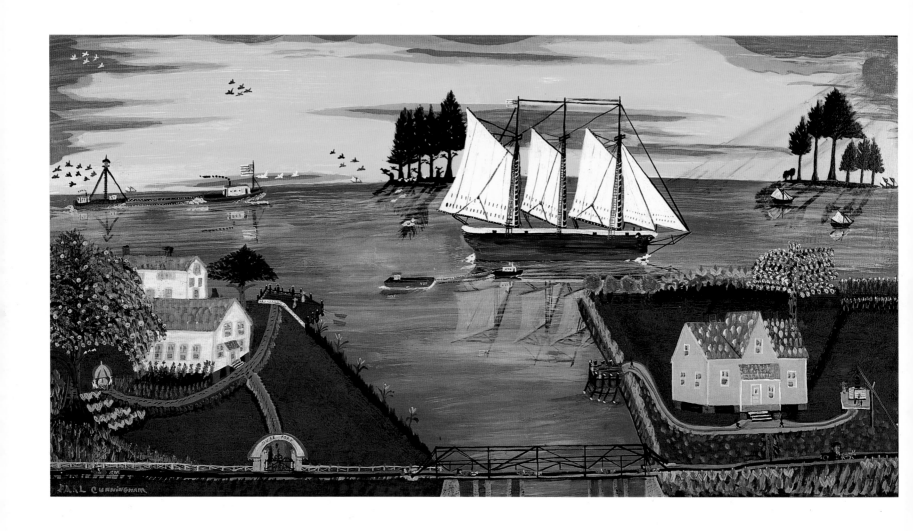

Summer Day at Over Fork. *22½ × 43"*

Summer Day at Over Fork *(detail)*

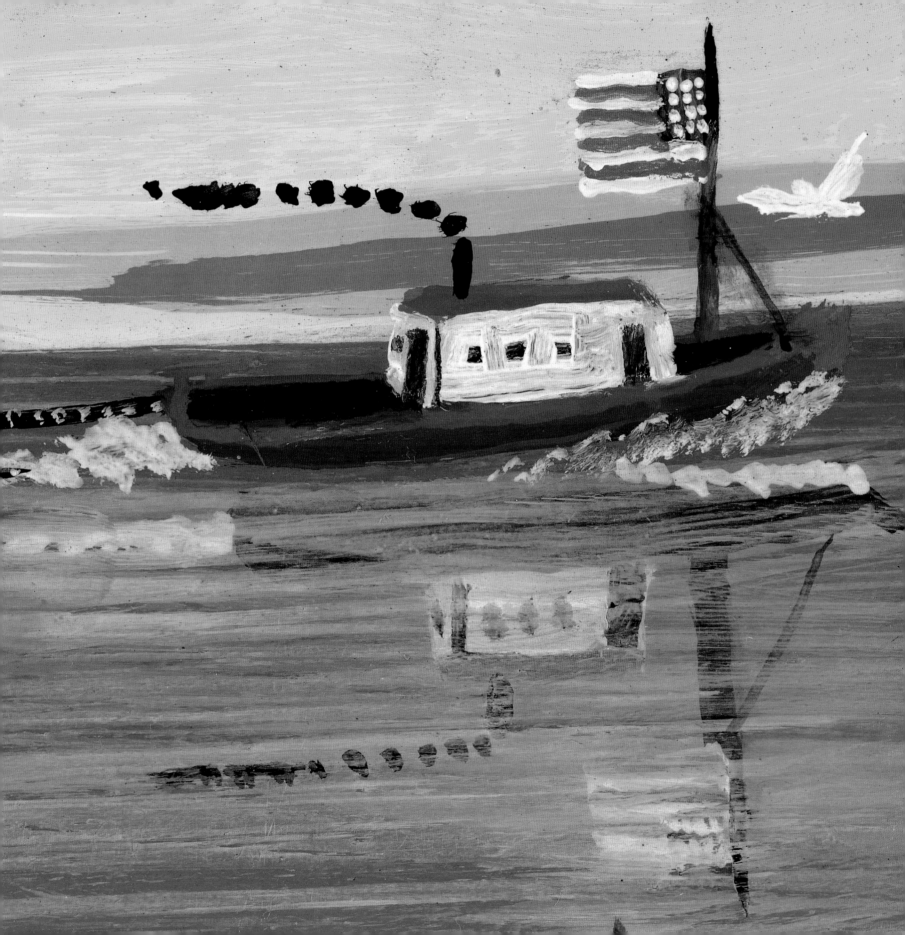

fortunately has been preserved almost in its entirety. An investigation of major themes in this collection reveals some important concerns of this self-taught painter whose art offers an important alternative to the values and concerns of mainstream culture. In works filled with a sense of fantasy about the past as well as a subtle and disarmingly charming critique of the present, Cunningham presents a new symbolic genesis of America. His paintings re-create the past to give a halcyon view of what America could have been and might still be. In many of his paintings Cunningham symbolically reenacts the beginnings of America by bringing early Norse explorers and Native Americans together with the late-nineteenth- and early-twentieth-century sailing vessels of his youth. To reinforce the great antiquity of the Norse ships, the artist would often paint patches on the sails. An individual tormented with inner conflicts and deep suspicions about others, Cunningham used his art as a way of reaffirming an Edenic view of the world. His own inner turmoil makes the harmonies of these works all the more significant because they represent momentary victories over the doubts plaguing him.

Cunningham wished to honor his artistically constructed memories in his museum. These memories are significant fabrications that reorder reality to meet the artist's present needs. The sense of nostalgia pervading these works is key to the way that Cunningham re-presents the world rather than merely reflects it. Although the term "memory painter" often is used for such individuals as Cunningham, in his case it is particularly confusing because it suggests that his creations are mere reflections of his youth rather than a highly symbolic and necessary reconstitution of it. To call him a memory painter would thus trivialize and invalidate his creations by implying that his broad cultural reassessments are merely charming and inaccurate recollections.

In order to understand the problematic implications of the term memory painter, it is helpful, for the purposes of comparison, to consider the case of Anna Mary Robertson Moses, a contemporary of Cunningham who came to be regarded as a special disseminator of nostalgia. In keeping with this role, Mrs. Moses, who signed her works simply with her last name, was called Grandma Moses by both the press and her gallery, even though her own grandchildren called her at first "Bonny" and later—probably as a concession to the media—"Gram."[19] In order to jog her memory about her youth, Mrs. Moses relied on Currier & Ives lithographs, which were then widely reproduced, as well as a host of mass-produced images, including greeting cards and illustrations in magazines and newspapers. Her nostalgia is thus a socially and culturally encoded construct that depends as much on the popularity of the American past, beginning in the 1930s, when American Regionalist art became important, as it does on her own memories of her childhood in rural upstate New York. The term memory painting is thus inadequate to describe Moses' paintings and also Cunningham's work because it considers memory to be a true reflection of past reality rather than a distinct re-creation of the past that frequently

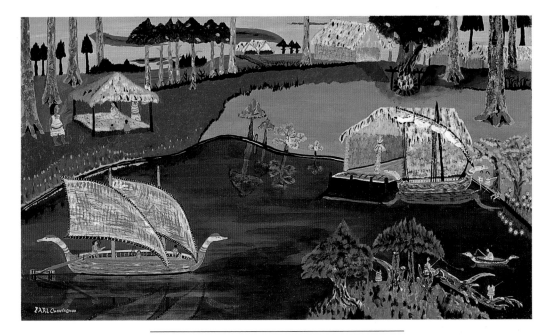

Seminole Village, Brown Water Camp. *17×29"*

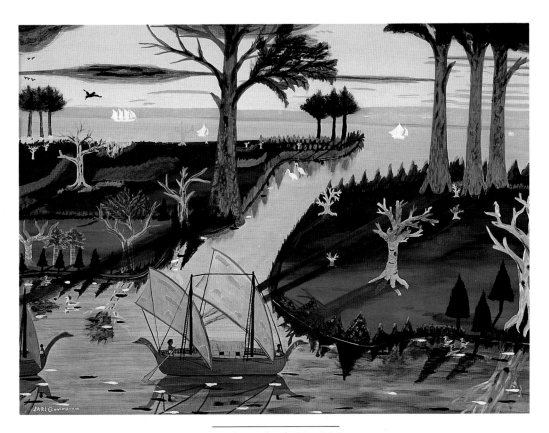

Pawleys Island. *22×29"*

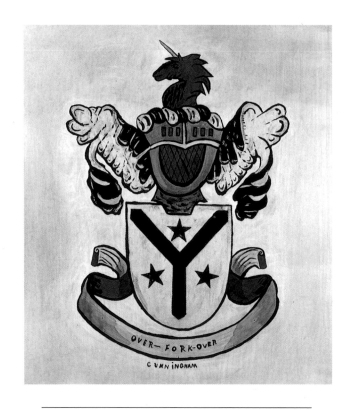

Over Fork Over, *Cunningham's coat of arms. Oil on board, 24×20"*

terizes established groups such as the Shakers and the Moravians, it is less appropriate for such self-taught painters as Cunningham because it implies that he subscribed to a vocabulary of forms commonly accepted by a distinct subculture. Robert Bishop stated that "to confuse Earl Cunningham with folk art seems rather naive these days. His contributions were that of a unique visionary artist."[20] To regard Cunningham as a folk artist denigrates by implication his individuality and originality. The term naive is also problematic because it connotes a simplicity of thought that is inconsistent with the nature of Cunningham's art, particularly the complexity of his symbols, the range of his artistic sources, and his sophisticated use of color. While Cunningham was innocent of such established academic techniques as one-point perspective and the classical way of rendering human anatomy, he was sophisticated in his use of a number of ideas germane to modern art. The term that suits Cunningham is "vernacular art." John Hubenthal has summarized its special usage:

> *Vernacular art is not folk because it is at best marginal to tradition. It is not popular because it is outside the system of mass production which is inherent in the industrial nature of popular culture. It is not outsider because it is not severely marginalized with regard to its culture. It is not fine art because it lacks the self-conscious historicity of the art of the elite. It is the spontaneous art of people who are within the contemporary system without patronage.*[21]

compensates for the inadequacies of the present.

Although Cunningham usually is labeled a folk artist, this study will avoid the terms folk artist and naive painter. The first term is inaccurate in its assumption that there is a common folk tradition from which Cunningham and other like-minded artists originate. While folk art adequately charac-

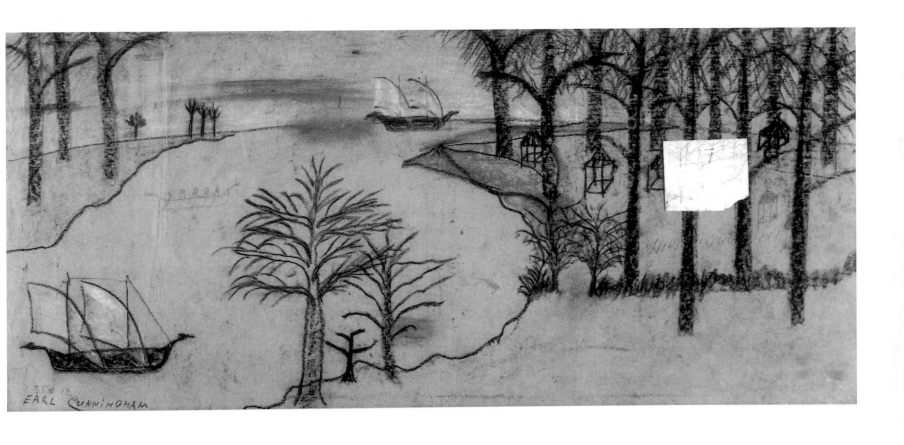

Working Drawing. *Mixed mediums on paper, 18 × 40½″*

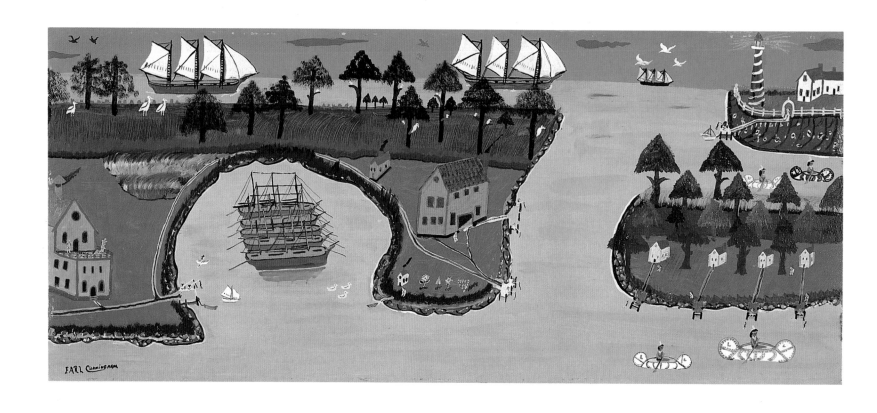

Safe Harbor. *16×37"*

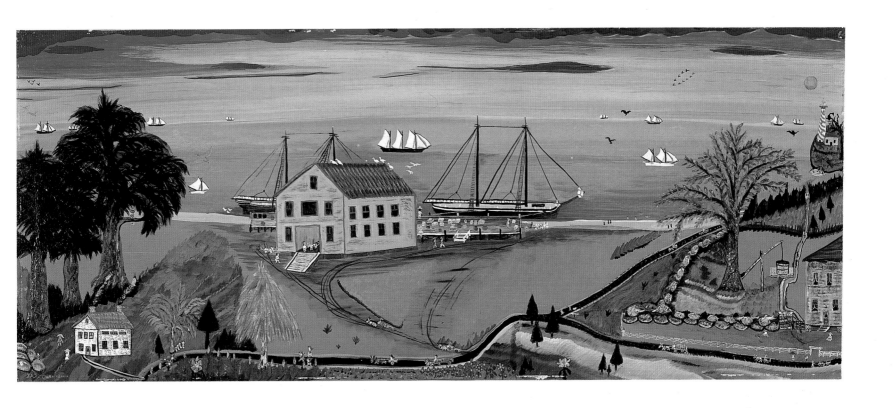

Warehouse at *Hokona* Settlement. *20×47¾″*

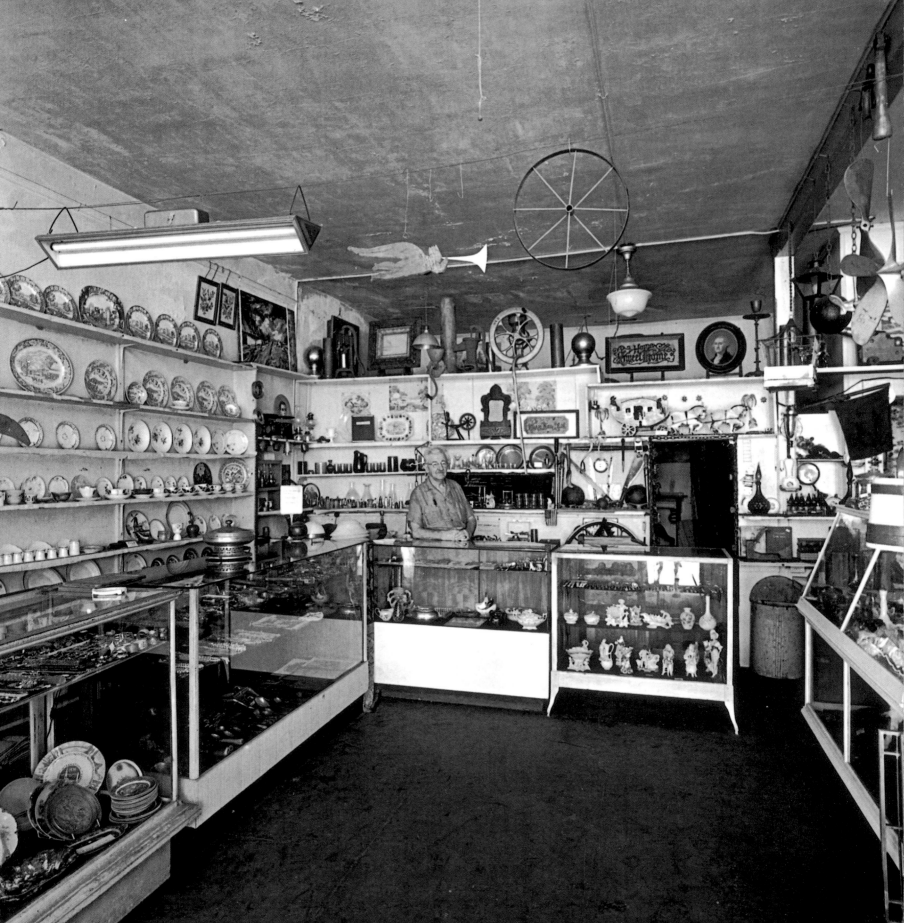

In recent years a number of folk-life specialists have become highly critical of the ways that folk art has been colonized by mainstream culture in general and by modernist aesthetics in particular. Among these critics, one of the most articulate is Simon J. Bronner, who has pointed out that aesthetic considerations have trivialized folk art by keeping it exotic and strange. In addition, Bronner believes that such judgments have masked a series of latent desires to keep the folk suppressed. "The folk art object," Bronner has written, "is converted into the fine arts system of painting and sculpture, patronage and appraisal, dominance and control."[22] He also has pointed out the inadequacies of the term folk art: "For those stressing the art, folk represented an appealing romantic, nativist qualifier used in the marketplace. For those stressing the folk, it represented a sense of community and informal learning examined in academe."[23] Despite the cogency of Bronner's arguments, he himself is guilty of romanticizing the folk by describing them in terms of "an integral type of learning and social exchange, viewing folk as a constant, dynamic process, and characterizing folk as part of vitally functioning communities which often downplay individual capitalist competition."[24] Although it is commendable to see the folk in relation to themselves, their own cri-

Interior of Over Fork Gallery with Earl Cunningham, 1970. Photograph by Jerry Uelsmann

teria of excellence, and their distinct set of symbols, as Bronner suggests, much of the art currently designated as folk, such as Earl Cunningham's paintings, cannot be segregated from mainstream culture: Cunningham's work was made for museum viewing, and his style indicates a familiarity with modern art.

Thus when considering his work one should resist such pronouncements as the following one by Charles Brigham: "In Earl Cunningham's work, there is no real knowledge, no aesthetic theory that lies behind his work. It is all a spontaneous effusion of a high mark."[25] Despite Brigham's sincerity and enthusiasm, his belief in an unmediated vision is unrealistic and inconsistent with the nature of art as a means of establishing a common identity. While it is unrealistic for a critic or an art historian to subscribe to the idea of a pure vision, such a conviction is often an essential working premise for many artists who need to regard their vision as unique in order to maintain it.

Cunningham's naiveté was very knowing. As Surovek has stated, "Cunningham was the most unaffected affected guy in the world." He has pointed out that this artist was aware of people's critical remarks about the flamingos that were out of proportion with his houses but was unwilling to accede to their criteria. Although hurt by these remarks, Cunningham took comfort in Picasso's freedom of expression, which he often compared with his own.[26] In his work and in his life, Cunningham manifested a mixture of simplicity and sophistication that is characteristically twentieth-century even though it is disconcerting to anyone trying to apply

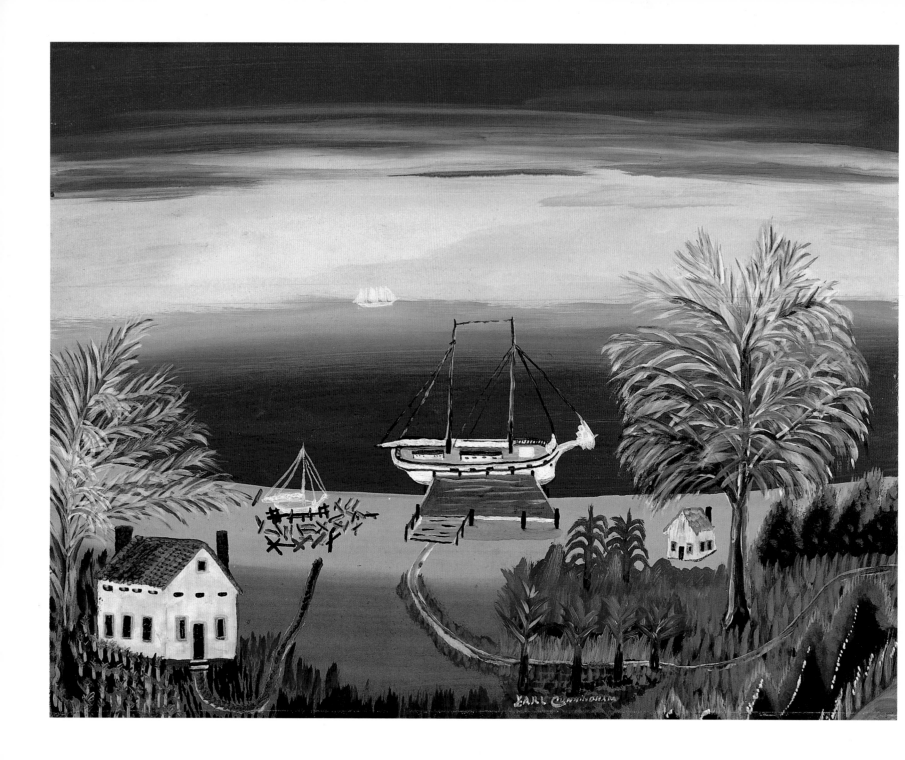

White Ship, Blue Sea. $15\frac{1}{2} \times 20\frac{1}{2}''$

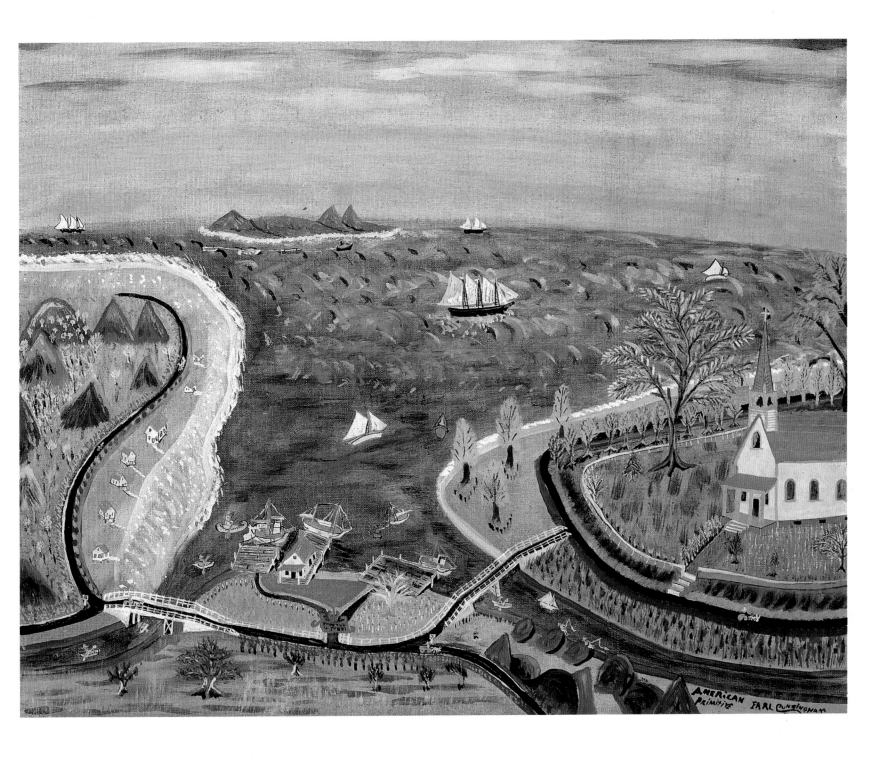

New England Church. *Oil on canvasboard, 21 × 25″*

Gallery

55 ST. GEORGE ST.

Primitive

Studio

49 ST. GEORGE ST.

Artist

Cunningham

Earl Cunningham

49-55 ST. GEORGE STREET ST. AUGUSTINE, FLORIDA

OVER-FORK STUDIO

Earl K. Cunningham

CURATOR MINERALOGY

PRIMITIVE OIL PAINTINGS
MINERALS CUT AND POLISHED
FINISHED SEMI-PRECIOUS STONES
SMALL ANTIQUES

Earl Cunningham's business cards

traditional labels such as naive and folk artist. This mixture of simplicity and sophistication makes Cunningham appear to be postmodern, but he is involved with belief rather than doubt. When Cunningham signed a painting "American Primitive"[27] and later when he had business cards printed with the designation "Primitive Artist," he inadvertently set up a tension between intuitive art and later postmodern neoprimitives such as David Bates and Hollis Siegler. His knowledge of his status indicates a sophistication that is at odds with the usual expectations concerning vernacular artists, and it points to the fluidity of language in the twentieth century, when naiveté and sophistication can no longer be considered as polarities. By using the term "Primitive Artist" to refer to himself, Cunningham doubles the codes for vernacular art with the goal of using one to reinforce the other. This designation, however, which is characteristically used by a member of the mainstream culture to refer to someone who is marginalized, serves the reverse function of questioning the authenticity of his work. The doubling of sophisticated and vernacular codes continues in his reappropriation of the so-called folk-art forms used by many modern artists, including the Fauves, and in his reliance on the tradition that includes Edward Hicks, Grandma Moses, and Joseph Pickett. Depending on one's point of view, Cunningham's approach can be considered an appropriation of modernism, a reappropriation of the vernacular that modern art itself had appropriated, a revival of the American folk-art tradition as seen in the works of Hicks and others, and a survival of nineteenth-

century traditions that Cunningham himself continues. Of course his approach is representative of all these attitudes, considered singly or in combination. Although Cunningham was self-taught, he was definitely not naive; and although he was knowledgeable about his status as a vernacular artist, he remained an intuitive painter who attempted to synthesize his experiences in a visual form. The problem for traditional scholars who are accustomed to regarding vernacular as a marginalized activity is that Cunningham was both trusting enough to follow his convictions and yet self-aware; he was both marginalized and mainstream at the same time.

Such knowing naiveté is evident in Cunningham's use of both housepainter's and artist's supplies. Since he enjoyed scavenging, he availed himself of the used lots of house paint that he acquired for sometimes two dollars a box. Surovek remembers seeing in the artist's studio twenty to thirty cans of paint that Cunningham had found at garage sales. He believes that the pinks, greens, and yellows in many Cunningham works may have been commercial paint. According to Surovek, if Cunningham had a paint color available, then he would use a lot of it in his paintings.[28] Cunningham apparently used artist's tube colors in conjunction with the house paint. In the studio at his death was a large variety of costly brushes and a range of palette knives. His oil paints included tubes of colors sold by Grumbacher, Schmincke & Co. Dusseldorf, Sheffield Colors, and Winsor & Newton.

The majority of Cunningham's works are painted on Masonite. The smoothness of this material was important to him, perhaps because of the final polished surfaces it permitted him to achieve. These enamel-like surfaces distilled and purified his scenes, making them appear permanent and inevitable. The smoothness also allowed him to indulge in a wealth of details with the assurance that they would be pristine and intense. His polished surfaces encase his forms in a chrysalis of jewel-like light that protects and separates them. This glossy surface functions almost like quotation marks that set this artist's images at a remove from prosaic reality: action is suspended, creating the effect of a constant state of being—an inevitability that is a subtle and yet strong force in the art.

Cunningham enriched this smooth surface with a variety of techniques, which included scratching through paint to determine forms, using feathered brushstrokes, combing in such shapes as foliage, and laying on heavy impasto for rocks and the bark of certain trees. Frequently he allowed the underpainting to show through the top layer of semitranslucent color and thus change the perceived tone of a given hue and give his work a distinct harmony. This preference for underpainting and for scratching and combing colors allies Cunningham with the techniques of Henri Matisse and helps to support the claim that Cunningham was aware of the subtleties and range of mainstream avant-garde art.

Deeply serious about his art, Cunningham took time to carefully work out compositions, as his extant drawings show. On a number of these drawings the artist posed questions for himself and for others. On a study of Mackinac Island (circa 1950),

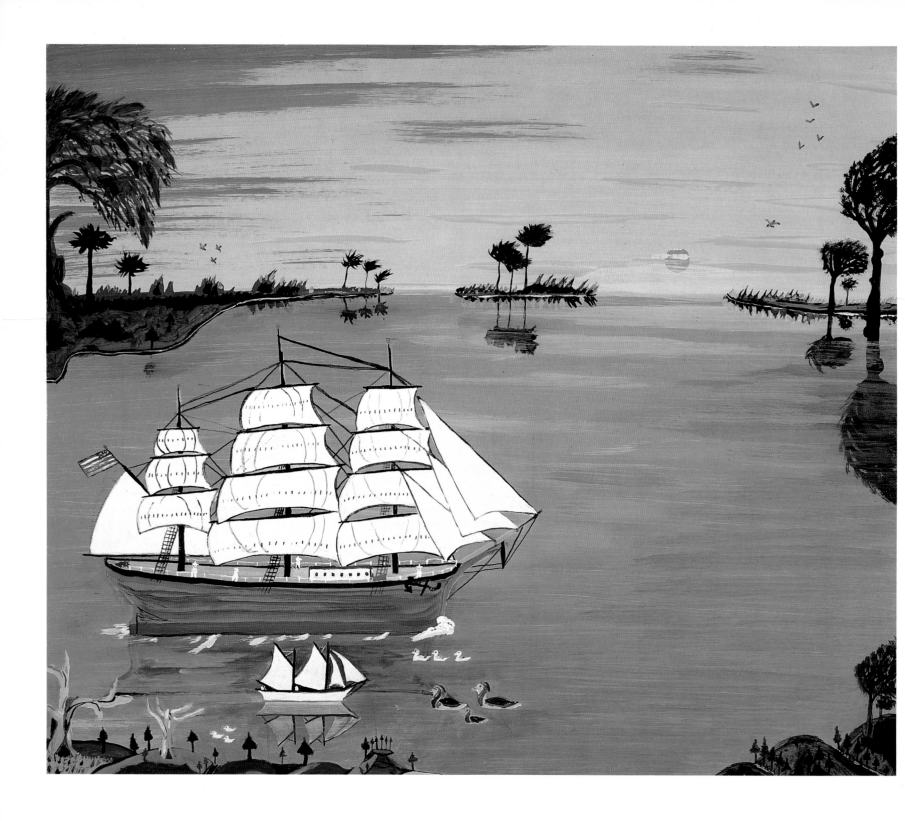

A'Sail at Dawn. *20×24"*

he asked a member of the Michigan Historical Society, which commissioned it, "Does this want to be here—just say yes or no in letter. Have not put it in." At other times he noted changes that he intended to make in the oil version of the composition. And he often jotted down reminders of exactly which colors he planned to use when translating a drawing into a painting.

Although some artists consider frames to be mere decorative accessories and allow their dealers or clients to choose them, Cunningham's concern with the frames for works such as *Flamingo Bay*, *Springtime Squall*, and *Blue Water Cove* indicates his belief in them as crucial aesthetic components. He made all the frames for his paintings. The most important ones were modeled on American Empire ogee frames, which had mahogany veneers. Cunningham's variations, without veneer, are similar to the stripped-down pine and poplar wood frames of the "Early American" revival style of the 1940s and 1950s, except that Cunningham's frames are highly varnished or decorated with colorful, free-form shapes resembling military camouflage. The shiny, heavy frames are imposing; they circumscribe and separate Cunningham's world, keeping it special and semiprivate.

Although Jerry Uelsmann "can't imagine Cunningham reading art books,"[29] the artist did come in contact with modern art and accepted a number of its tenets. Surovek has referred to Cunningham as "a Socrates of the first order, who learned everything you can learn from language,"[30] and so he may have picked up important information about modern art

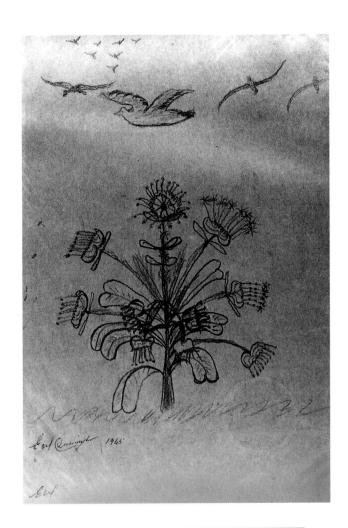

Flowers and Birds. *1965. Graphite and charcoal on paper, 15 × 10¾"*

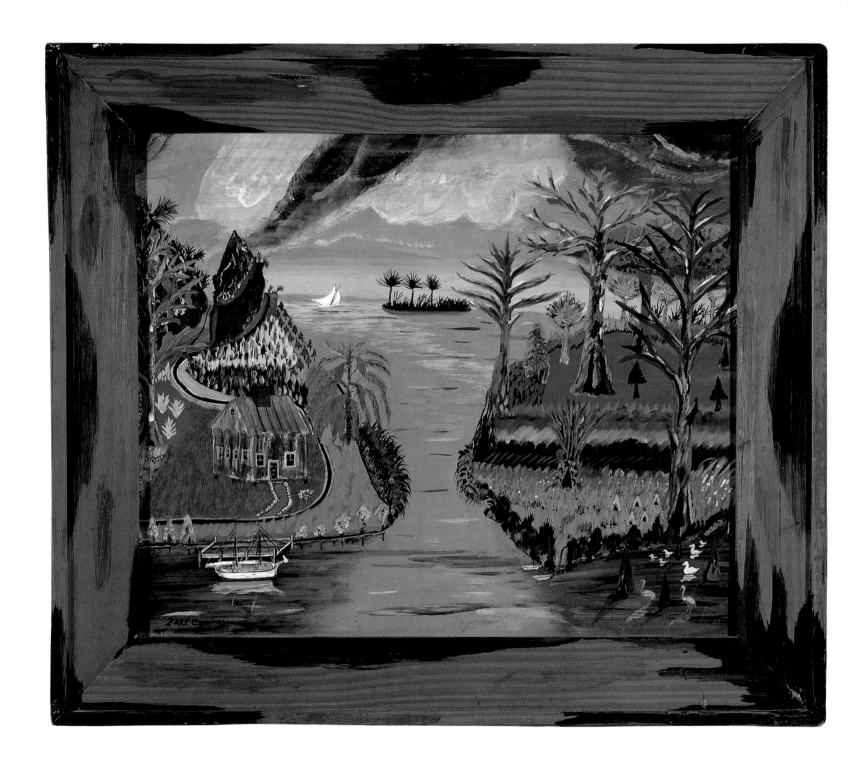

Springtime Squall. *16×19½"*

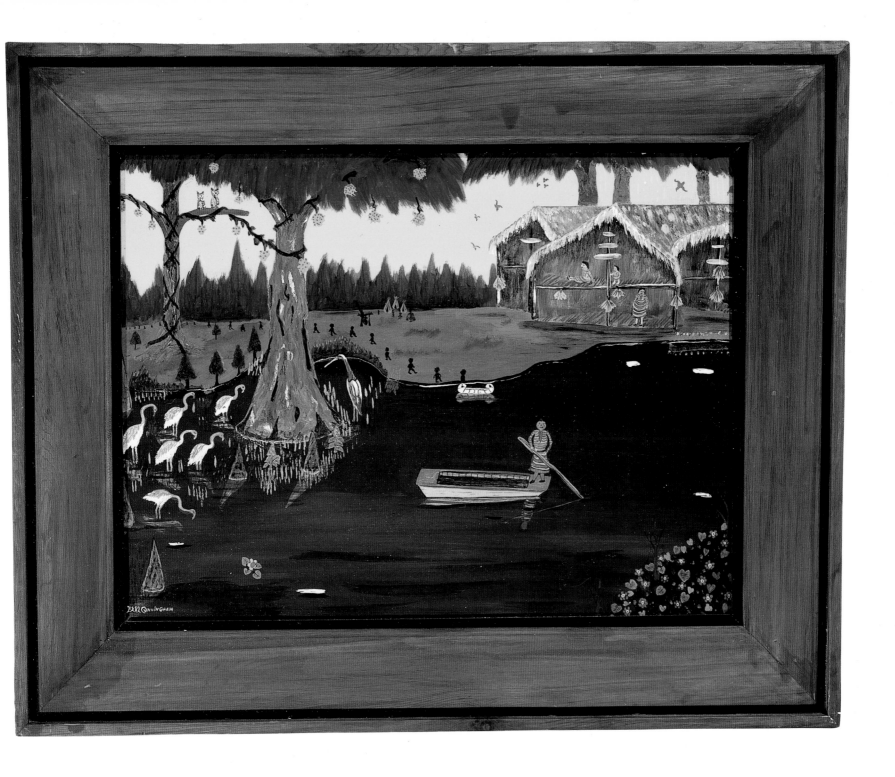

Flamingo Bay. *18×23¾″*

from visitors to his antique shop and other painters in the St. Augustine area. Even if Cunningham did not read art books, as Uelsmann suggests, he could have become acquainted with modern art from the surprising number of articles on the subject that were published in *Life* magazine beginning in the late 1930s. Uelsmann remembers that in Cunningham's antique shop there were stacks of *Life*, *Collier's*, and *National Geographic*, "so many in fact that it was dangerous."[31]

In addition to *Life*, Cunningham had the opportunity to know some modern works of art through large reproductions. In one of the photographs of his antique shop taken by Uelsmann in 1970 appears a framed reproduction of a late Maurice de Vlaminck that was being offered for sale. Considering the existence of this image in his antique shop, it is possible that Cunningham sold over the years second-hand reproductions of popular works by Vincent van Gogh, Matisse, and the Impressionists. Access to these reproductions would have exposed him to some of the basic concepts of modern painting and might explain his penchant for strong colors.

Cunningham also could have come in contact with a number of basic attitudes about modern art by watching such Walt Disney animated films as *Snow White and the Seven Dwarfs* (1937) and *Fantasia* (1940). At some time between the late 1930s and early 1950s Cunningham made paintings of Disney's seven dwarfs. This art suggests that he saw *Snow White* and was enthusiastic about its strong color and sense of fantasy.[32] Because the artist did not take commissions, the choice to re-create the

dwarfs was no doubt his own. Cunningham's knowledge of this film is an important clue to his overall work because it indicates a familiarity with expressionistic ideas, which are evident in the forest scene early in the film, when the huntsman takes Snow White outside the palace. In this segment the forest begins to take on some characteristics of Charles Burchfield's early paintings, particularly the repeated outlines around trees and plants that suggest spiritual emanations and sometimes reveal incipient anthropomorphic features. Even though the latter does not occur in Cunningham's work, the repetition of outlines is readily apparent in some of his earlier paintings and relevant to his overall style. Although this device in Burchfield's work indicates connections with both synesthesia and the art of the Russian Expressionist Wassily Kandinsky, who wished to establish equivalences between color, shape, and sound, in Cunningham's work it points to the art's attempt to get beyond surface appearances and reveal a more profound cross section of life itself. *Snow White* and *Fantasia* could also have served Cunningham as short courses in modern art's seemingly arbitrary intense colors, which originated in the work of Van Gogh, Paul Gauguin, and the Fauves.

It might seem farfetched to align this self-taught artist with the highly sophisticated ideas of the French Symbolist movement, which provided Gauguin and Matisse, among others, with the rationale for using saturated hues. But if one recognizes how profoundly these Symbolist concepts permeated popular culture, including animated cartoons, mass-

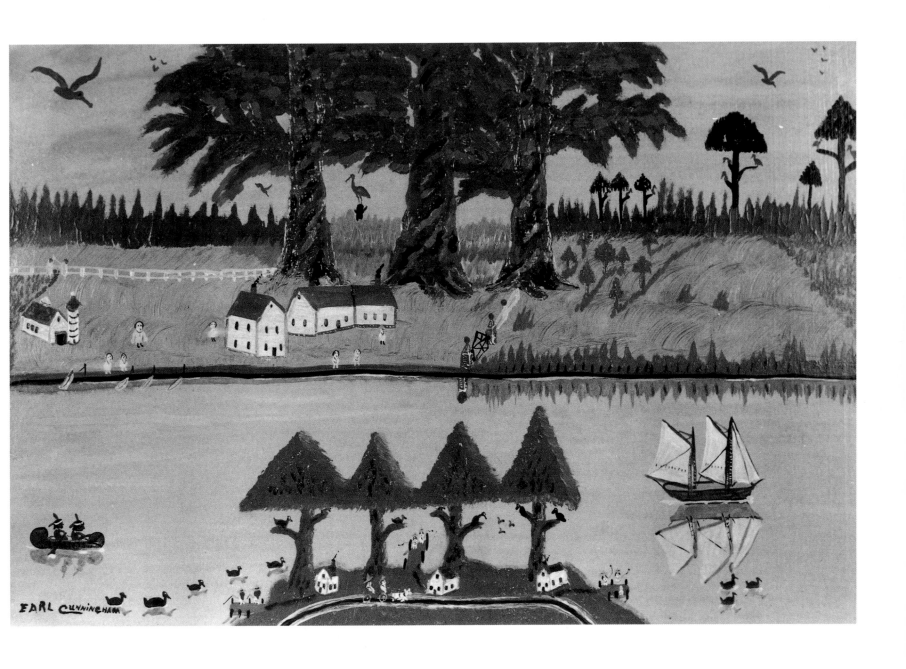

Big Tree Park. *16×24". Akron Art Museum, Ohio,*
Gift of The Honorable Marilyn L. Mennello and Mr. Michael A. Mennello

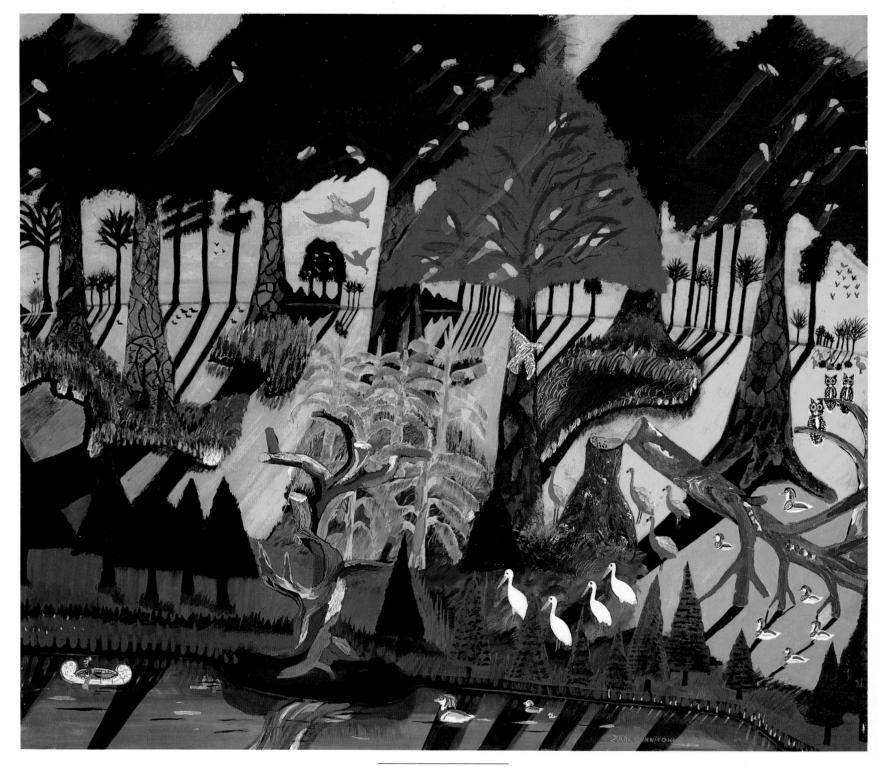

Tranquil Forest. *22 × 26"*

Tranquil Forest *(detail)*

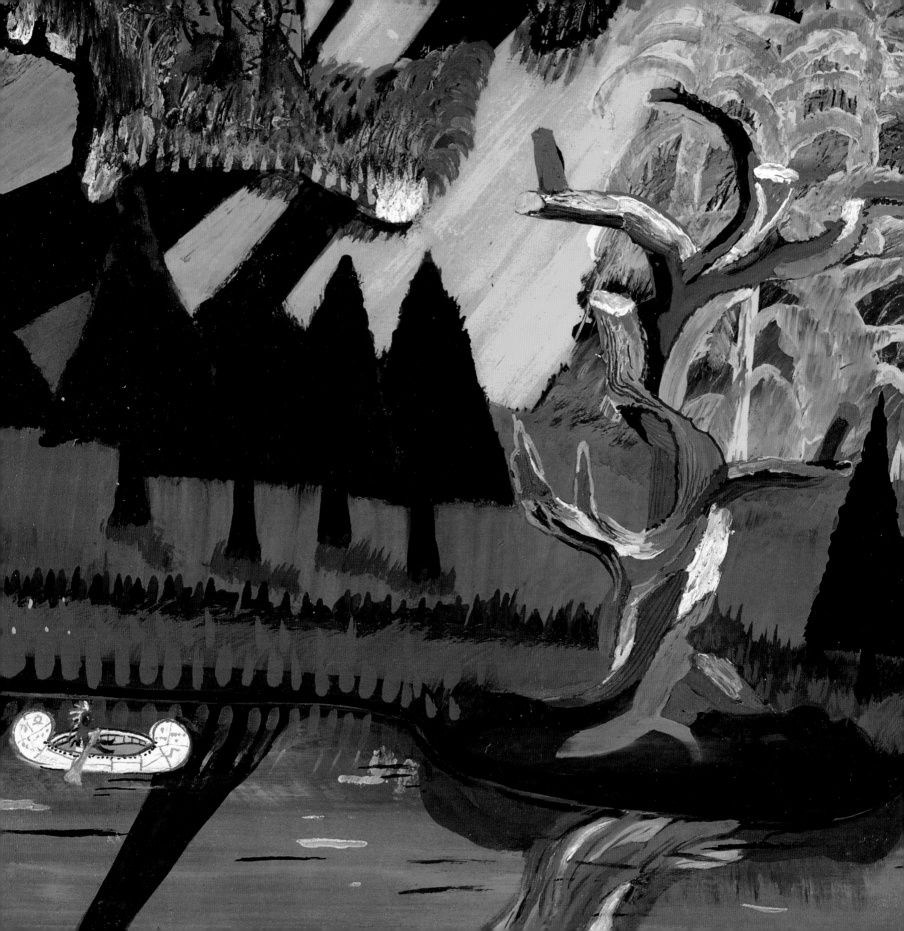

media advertising, and fashion, their indirect impact on Cunningham seems far more plausible. The reason for pointing out their relevance to his art is not simply to elevate his paintings by association, even though that might be a residual effect, but to point out how Cunningham has claimed for vernacular art certain avant-garde concepts that have become disseminated throughout the culture.

In his work Cunningham invokes some of the original Symbolist concepts, such as the absolute reality of the abstract components of painting. This belief in the reality of art's formal language has a source in Stéphane Mallarmé's thought. A major Symbolist poet, Mallarmé was fond of asserting that poems are made of words not ideas. By this statement he meant that poetry must be separated from prose, and the "inner alchemy of the word" must be preserved. Following Mallarmé, modern painters realized that works of art are made with colors and shapes that must be freed of many encumbrances created by fictive illusions in order to communicate directly. Although Cunningham never relinquishes the realm of appearances, he does revel in the abstract power of color as his saffron oceans, raspberry bays, and chocolate waterways all indicate.

While Cunningham was susceptible to the abstract power of strong color, he had only a rudimentary education and consequently did not use philosophical concepts to explain the ideas that his works manifest. In conversations with Uelsmann he would defend the colors of his skies and bodies of water as actual.[33] Although Cunningham may have fervently believed in the veracity of his color, he

may also have confused two different orders of reality informing his work: one being external references to nature and the other the truth of his intuitive vision, which he was compelled to manifest in his art. This seeming contradiction between actuality and a transcendent reality recapitulates many aspects of the classical philosophical debate between Aristotle's ideas on the substantiality of concrete particulars and Plato's theory of forms.

This debate about the nature of reality, which the Platonists view as a nonsensible entity approached through pure reasoning and the Aristotelians consider grounded in both the sensible and the mutable, is of central importance to the study of vernacular art. Its first important application to the study of intuitive art occurs in the book *Santos and Saints: The Religious Folk Art of Hispanic New Mexico* by the Jesuit priest Thomas J. Steele.[34] Steele notes that Platonic ideas are philosophic equivalents for spiritual being, which places importance on sacred persons and "pattern-setting actions."[35] He writes: "The important thing is not a flow of knowledge—of explanation—from the more intelligible [the spiritual] to the less intelligible [the earthly], but a validating participation of the greater holiness of the greater (saint or saving event) by the lesser (santo or cultic ritual)."[36] In other words, the sacred ritual or the work of art (in this case, the santos) is a vector pointing to a transcendent realm; it is important because of its connection to an elevated spiritual plane and because it can ensure a continued relationship between ordinary mortals and the saint or spiritual state to which it alludes. Steele refers to

this spiritual state as "folk Platonism,"[37] and he notes that the preeminence of the transcendent truth over the cultic ritual or object representing it can result in an unfortunate situation in which "the artifact or the religious ritual [can] deteriorate into an unimaginative and mechanical imitation."[38] He elaborates on this idea, saying: "The santo is like a commissioned portrait, where the subject's likeness is the dominant consideration and the artist's style and artistic ideals are less autonomous than when he is working from his own inclination."[39] In the realm of secular, intuitive art, this Platonism takes the form of an autonomous concept that the artist must render to the best of his or her ability.

Even though Steele does not deal with secular objects in his book, his "folk Platonist" theory can be applied to them with little difficulty. Although in the religious work of art the importance is shifted from the actual object to the Platonic realm of non-sensible form, in the secular, vernacular work of art significance is placed on the power of the original concept, which can be comprehended only through the work of art. Unlike santos, which can be effective sacred objects even when uninspired, the secular, vernacular objects must convey the artist's belief in his or her vision in order to be effective. The vision, in other words, must be powerful enough to inspire the vernacular artist to surmount the difficulties of a rudimentary technique. Because there is no religious orthodoxy to validate the secular intuitive artist's vision, artistic quality is a key factor in assessing the significance of this vision.

In his essay "'Suffer the Little Children to Come unto Me': Twentieth Century Folk Art," Donald Kuspit elaborates on Steele's concept of folk Platonism[40] by emphasizing the role of feeling and by addressing the problem of the typical and the commonplace that so often occurs in vernacular art. In regard to feeling, Kuspit points out that "the [vernacular] artist became so intoxicated with the idea (not simply reality) of them, that only a toy home or a toy animal could do them justice, for only that toy made their Platonic intelligibility and necessity visible."[41] Thus feeling allows the vernacular artist to dispense with aspects of visual reality in order to emphasize the concept.

Although he does not mention Robert Motherwell, Kuspit's attitude correlates well with the thinking of this Abstract Expressionist, who described abstraction as a form of emphasis:

> *One might truthfully say that abstract art is stripped bare of other things in order to intensify it, its rhythms, spatial intervals, and color structure. Abstraction is a process of emphasis, and emphasis vivifies life. . . . The need is for felt experience— intense, immediate, direct, subtle, unified, warm, vivid, rhythmic.*[42]

Motherwell's statement helps explain the fact that the abstraction of vernacular art is a necessary coordinate of the artist's intense feelings.

In his conclusion Kuspit goes beyond the vernacular artist's intoxication with an idea to emphasize the role of conviction: "Powerful belief has Platonized both sign and idea. [The toy] is a Platonic

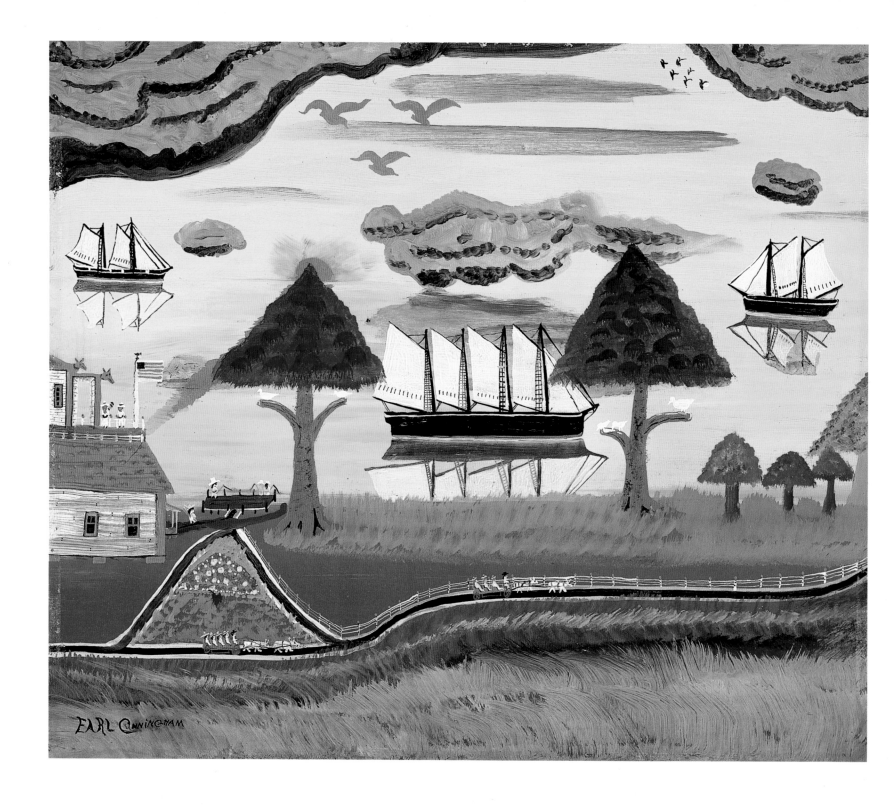

Twin Pines. *16×20"*

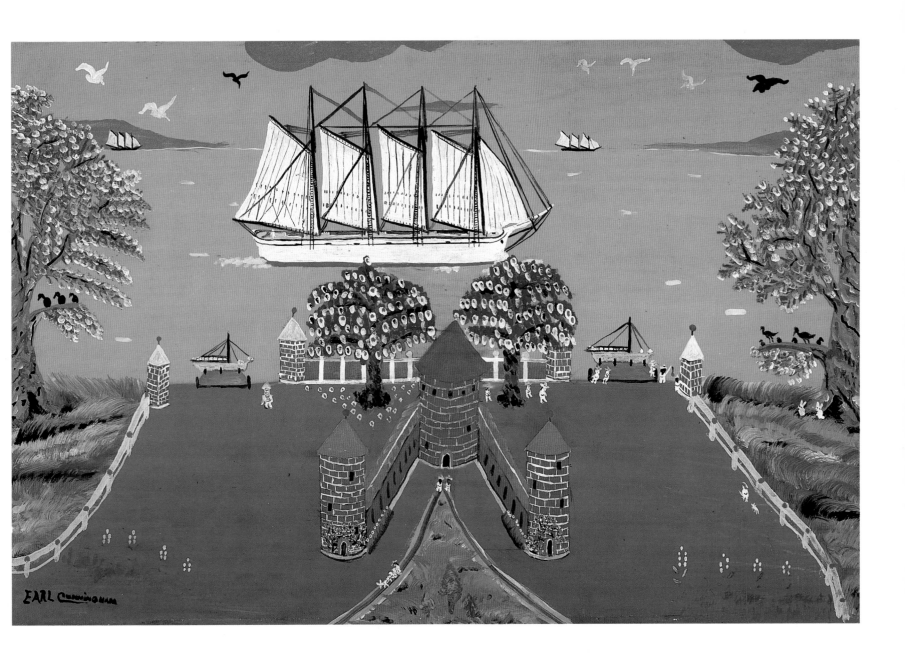

Summertime at Fort San Marcos. *16×24"*

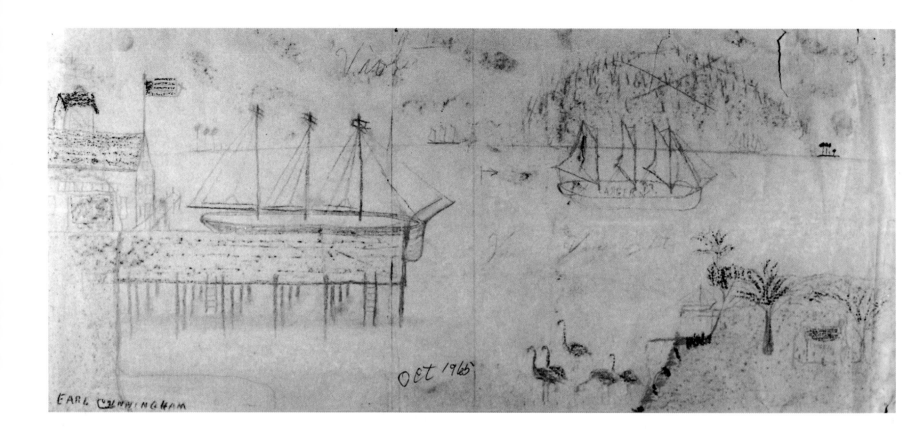

Study for Widow's Walk. *October 1965. Graphite and crayon on paper, 15½ × 32″*

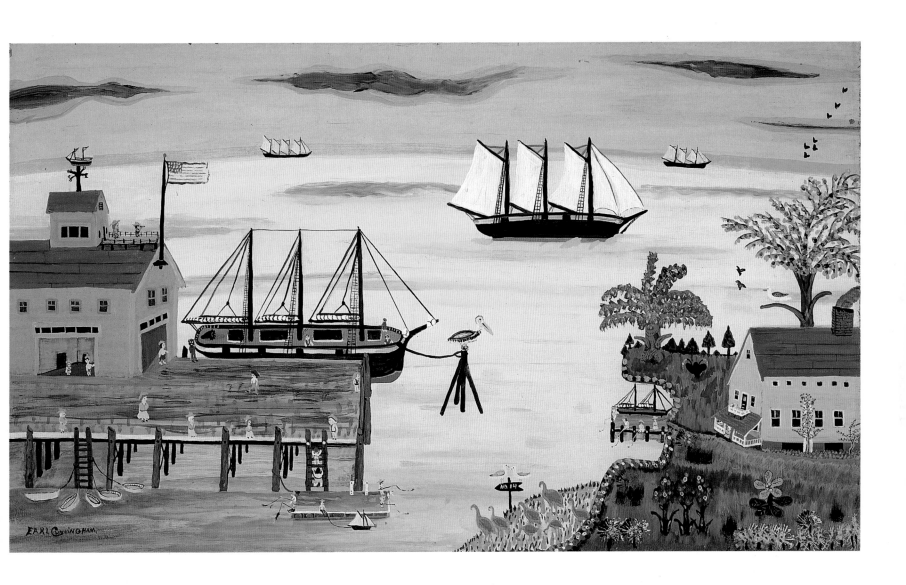

View from the Widow's Walk. $20\frac{3}{4} \times 26\frac{3}{4}$"

idea in scarecrow form, remaining Platonic so long as it is passionately believed to be uniquely itself, and as such autonomous."[43] Belief is thus crucial, according to Kuspit, because it enables the vernacular artist to view the commonplace as representative of the transcendent. The vernacular artist therefore reinvigorates clichés through a sincere conviction in their importance and in the process renders the specific in a more generalized form that points to the ultimate reality of the intuited concept.

In his essay Kuspit wrestles with the role of the commonplace in vernacular art because it might appear to contradict the folk Platonist theory he is elaborating. He therefore presents the role of clichéd ideas in vernacular art in a rather circuitous manner:

> The folk artist's ability to reveal the relevance of what seems irrelevant—because it is commonplace—depends on his ability to read facts as fated or to take what is culturally presented as fated to be factual, thus making what is commonplace the sign of an uncommon, because unique, fate. For him the commonplace is the inescapable, which is what makes it so profound and important. For the folk artist, art is a way of making one's peace with what is given, and of recognizing that givenness as something neither wantonly there nor wantonly dispensable. It is uniquely and inevitably what it is, precisely particular yet necessarily the case. Each of its details testifies simultaneously to its particularity and necessity.[44]

The danger of the commonplace in vernacular painting is that the Platonic realm, which can only be indirectly alluded to in works of art, could slip into Aristotle's concrete particulars, which would result in a diminishment of the vernacular artist's contribution to knowledge. In that case the work of art would be a far less adequate representation of external reality than academic art, and its only contribution to human culture would be its awkward charm and rustic syntax—qualities that would support the patronizing delight that sophisticates have taken in this so-called humble art.

The folk or vernacular Platonist theory, which has been admirably developed by Steele and given an important psychological dimension by Kuspit, now needs to be carried a step further so that it can be used to analyze specific stylistic characteristics of this art as part of a world view rather than merely a result of little or no formal training. In this painting, belief overcomes the great obstacles stemming from lack of training and even uses the obstacles, imperfectly understood, to reinforce vernacular Platonism. Some of the stylistic qualities occurring in this art include a lack of facility with perspective, which works in tandem with arbitrary scale, intense color, reliance on schemata, and predilection for symmetry and patterns to create a situation in which each object imperfectly signals the artists' originary concept or feeling. The use of multiple foci in vernacular art helps to disembrace objects from their representative function and to secure their Platonic role as signs. Because the objects in vernacular paintings often are seen from different

vantage points, they deconstruct the Aristotelianism of Renaissance perspective, which apportions a relative and consistent scale to all objects in a painting by subsuming them all under a unified point of view. Instead of the Renaissance view, vernacular paintings emphasize painted objects as inadequate representations of reality, thus suggesting truth rather than manifesting it. What holds these random vantage points together in an individual work of art and makes it an arresting image is the artist's conviction that it must be painted. In this type of art the ultimate reality of the mind/spirit must be acknowledged even though it can only be implied through a host of different vantage points, including the bird's-eye point of view that indicates an omniscient artist/creator or a divine viewpoint. Predominant in many of Cunningham's paintings this vantage point helps to transform his world into a storybook realm.

In addition to using the bird's-eye point of view, Cunningham frequently curved the horizon, as a former seaman might, to reinforce the fact that the world is round. Because this curved horizon is seen in conjunction with Cunningham's highly personal transformation of scale, it appears more a sign than an illusion and thus supports the Platonic realm so important to his art. When Surovek asked Cunningham why the horizons were curved in his paintings, the artist took the question as a criticism of his view of the universe and responded matter-of-factly that Surovek must be one of those people who believe that the earth is flat.[45]

Among the codes of conviction of vernacular art, balanced and symmetrical compositions are particularly important. The symmetry that occurs so often in vernacular painting bespeaks a world order and an underlying harmony. In Cunningham's art, symmetry functions as an assumed center of balance that is respected but not rigidly followed. In place of bilateral symmetry, he looks for variety through repetition and harmony within the limitations of balancing the right side with the left, the top with the bottom, or the upper left with the lower right.

In art, symmetry connotes a special orientation to the world. In contrast with unbalanced compositions, symmetrical ones imply a desire to invoke tradition. Since symmetrical compositions change a dynamic and chaotic world into a predictable and balanced one, they assume the force of an absolute and reflect an understanding of history as a recurring law rather than an irreversible line of unique events. This predictability reinforces the idea of a fundamental, unchanging state, and it points to a timeless and permanent world consistent with a transcendent, Platonic realm. When symmetry serves as a basic compositional structure in Earl Cunningham's paintings, it bespeaks a desire to reinforce a transcendent order as the ultimate reality. Symmetry is thus a device for manifesting the concept of universals over particulars and a way of pointing to a golden age that transcends the accidents of time. For Cunningham, symmetry was a system for transforming his unique experience into a universal equation.

Closely related to symmetry is pattern, which plays an equally important role in making the world conformable to one's expectations. Whenever

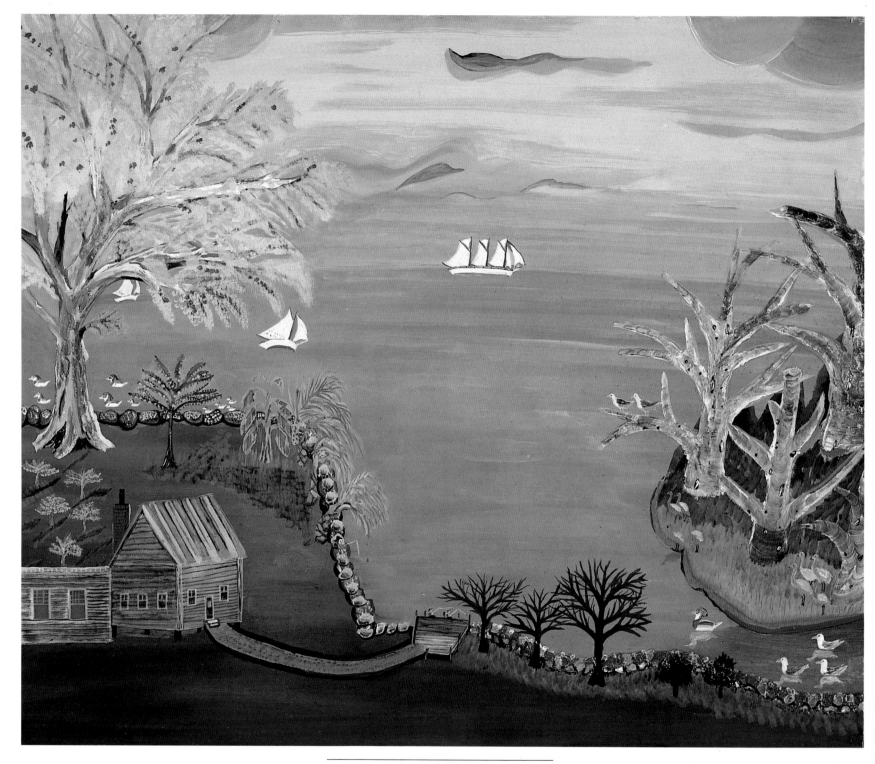

Springtime at Bay Point, Georgia. *22 × 26"*

Springtime at Bay Point, Georgia *(detail)*

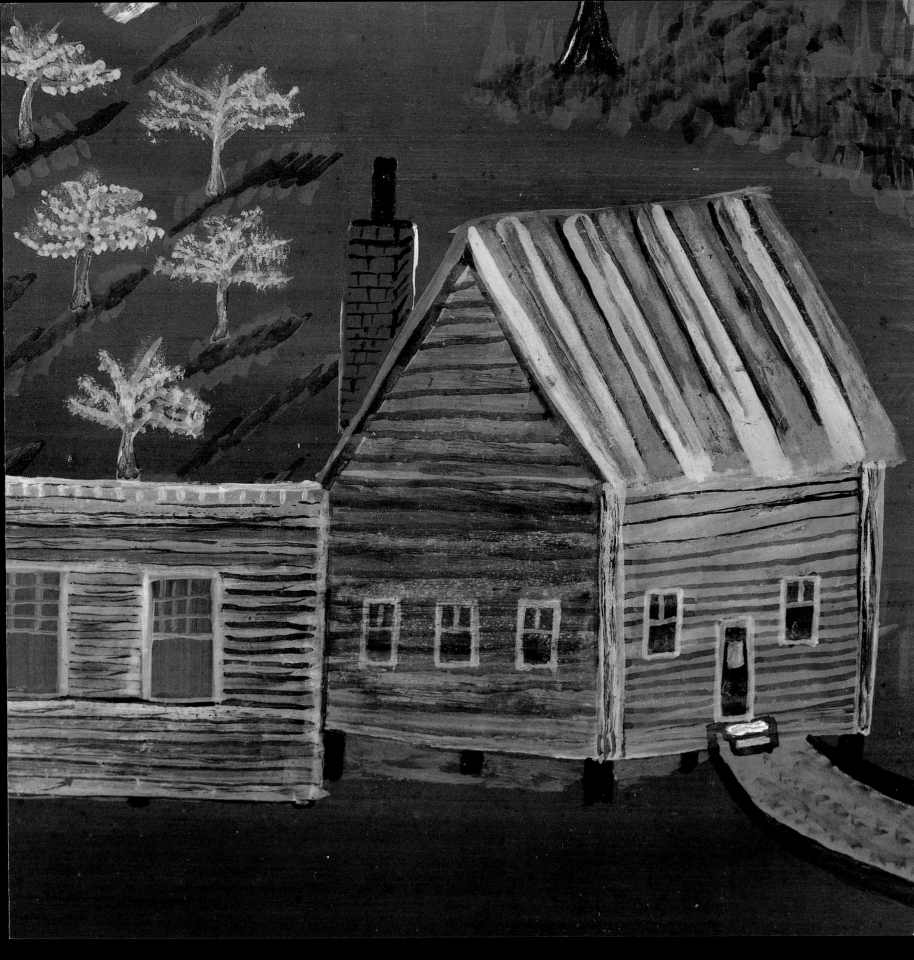

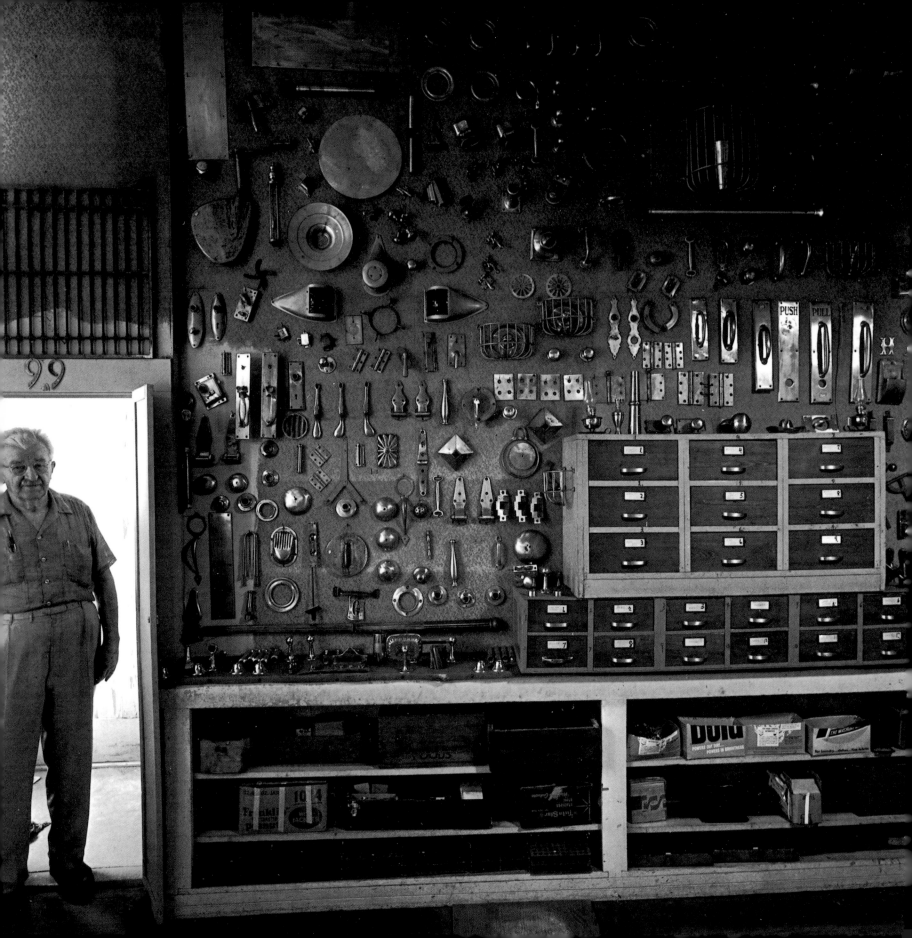

objects, be they plants, houses, or clouds, are transformed into patterns, they become predictable and thus affirm an overall schema for the world. Patterns served an important function for Cunningham because they made his dreamscape predictable and were therefore psychologically reassuring. In his art, Cunningham created multiple borders of plants around islands and land masses, he balanced sloops, cutters, and schooners so that they formed meaningful designs, and he articulated even skies and birds so that they participated in an overall governing plan. Patterns order his dreams with identifiable and repeated elements that help to establish rhythmic harmonies throughout a given work. These harmonies, consisting of variations of elements within strictly defined limits, make the patterns seem inevitable, as if they, too, are reflecting the ultimate reality of a transcendent Platonic reality or Edenic view of the world. The sense of rhythm pervading these works may have a source in Cunningham's enjoyment of music: he played the harmonica well and enjoyed such old songs as "Old Black Joe," "Red River Valley," and "Home on the Range."[46]

In order to comprehend the meaning of his patterns, it is helpful to look at Neolithic art that Cunningham collected in the form of Mound-Builder pottery. The repetition and regularity of patterns

Earl Cunningham in Mariner's Room of Over Fork Gallery, 1970. Photograph by Jerry Uelsmann

apparently first began to assume great importance for societies dependent on the yearly agricultural cycles of planting, tending, and harvesting crops. The predictability of patterns decorating the pottery and textiles of these cultures, which are divided into distinct zones, may reflect a desire for regular high crop yields, a pride in the geometric harmony of straight lines of plants, and a concern about accurate land divisions.

While Cunningham was in all probability unaware of the social basis of the Neolithic Native-American art, his own painting is involved with a similar desire for predictable patterns and for rigid limitations. Cunningham's obsession with order was also reflected in his antique shop, where everything from brass fittings for sailing vessels to bottles, cards, and buttons was neatly and obsessively organized. Uelsmann remembers that in Cunningham's shop there were at least twenty mason fruit jars filled with small items such as marbles and screws, as well as many notebooks containing such late-nineteenth-century printed material as German Valentines and greeting cards decorated with flowers. Because of his desire for order, Cunningham even organized these cards into different series. He arranged images of roses, for example, according to size. While this sense of order partially stems from Cunningham's seafaring days, when every object aboard ship had to be accounted for and given a place, his continuance of it in his art and in his antique shop indicates a desire to maintain control over his environment.

Ironically, limitations provided Cunningham

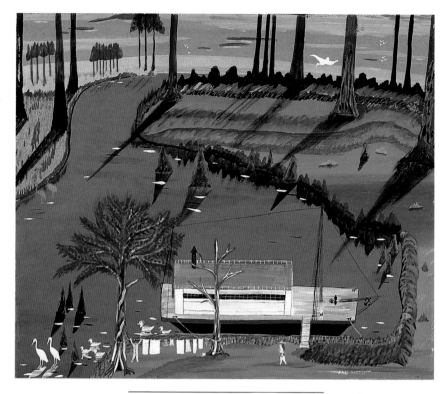

Houseboat at Oyster Key. *20½ × 24"*

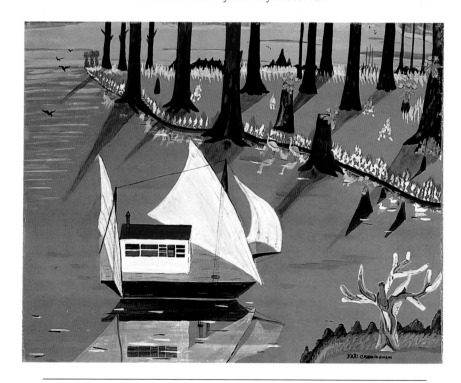

Houseboat on Flamingo Bay. *15¾ × 20¼". High Museum of Art, Atlanta,*
Gift of The Honorable Marilyn L. Mennello and Mr. Michael A. Mennello, 1992.49

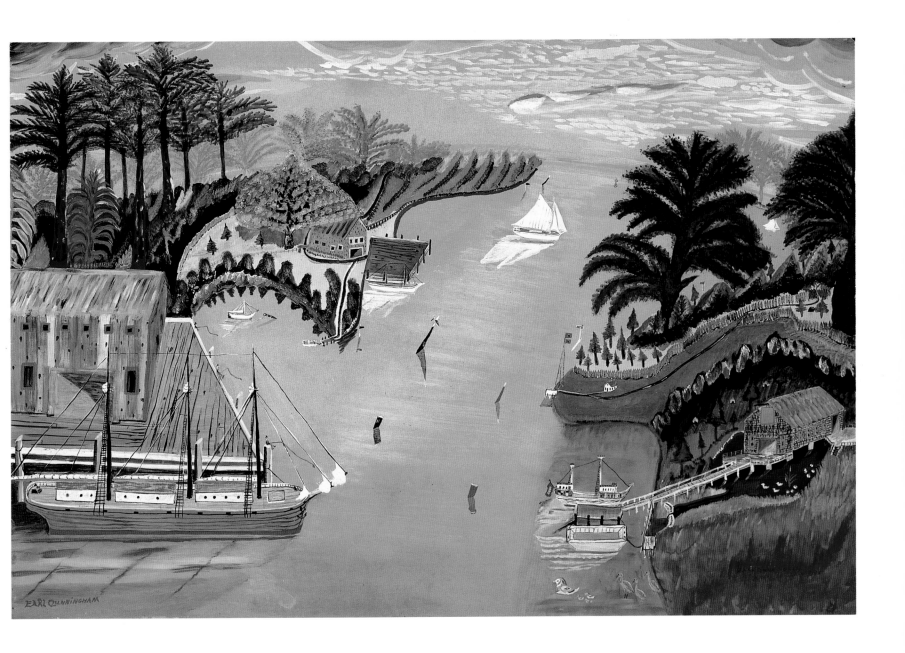

Squirrel Hollow. *19×30"*

with great freedoms. His borders and symmetrical schemes, which partition the world according to a predictable plan and thus safeguard his dream, allow him to indulge in a free play of scale and color. This element of play is crucial for his art because it permitted him to use scale to invest works with emotion. If in a particular painting he was more interested in birds than in schooners and houses, then he would make the birds larger in scale. And if plants were more important to him than people, then the plants would dwarf the humans. This liberation of scale opens the world to exciting possibilities and radically new values. In an individual work, Cunningham's vision can shift between myopic intensity and far-distant views, causing the space in his paintings to fluctuate in tandem with his feelings. And from the perspective of Platonism, Cunningham's changing scale denies the world of external appearances and replaces it with a transcendent realm that can be approached through the artist's intuition.

The vernacular artist's reliance on symmetry and pattern can be related to schemata as a formal means that communicates an ultimate, preordained reality. The term schemata also can refer to conventional representations of sunsets, storms, clouds, and areas of land in the foregrounds, which are intended to be both encoded signs of these objects and representations of the objects themselves. Cunningham's conventionalized sunsets, for example, bear strong similarities to those occurring in nineteenth-century paintings as well as to the shorthand notations for sunsets found in animated cartoons and comic strips. The artist enriches this schema for sunsets by making references to actual sunsets that he has personally witnessed. A more complex schema in his art, appearing in *Twin Pines* and *Red Norse Ship at Sunset*, is his use at times of stylized shapes to convey the idea of clouds and also the look of drapery. These highly conventionalized forms conflate the clouds and drapery found in nineteenth-century portraits that frequently depict individuals placed beside a draped window revealing a sky with clouds. This visual rhyming of elements in Cunningham's painting strongly suggests a domestication of the landscape, which serves as a refuge for the artist and appeals to the contradictory desires of wishing to go to sea while wanting to remain as protected as if one were in an enclosed room.

Cunningham also manifested his convictions through strength of color. The saturated hues in his art imply a deep involvement with his subject to the point that he does not take time to modulate colors but instead prefers to use them in large doses to convey strong feelings. The freshness and intensity of color in Cunningham's art support his Edenic subject matter by communicating the idea of a world created anew: unspoiled, fresh, and full of intense light. His color also has the distinct psychological advantage of suggesting contradictory ways of approaching these dreamscapes. It probably served the function that the psychologist C. G. Jung noted when he "advised [a patient working on a mandala] not to be afraid of bright colours, for [he] knew from experience that vivid colours seem to attract the unconscious."[47] The question of whether

color makes the dream more real or whether it heightens its unreality and thus guarantees its status as a dream probably cannot be resolved. And this lack of resolution may have been one of the main attractions color had for Cunningham.

When one begins to investigate the great number of sources available to Cunningham, it is evident that his highly cathectic color was overdetermined. In addition to the sources listed above, he could have been as easily influenced by gaudy chromolithographs as by the vivid hand-tinting of the Currier & Ives prints he studied in the 1940s or the retouched color postcards he collected. The writer William C. Ketchum, Jr., has observed that Cunningham's colors are similar to those employed for commercially produced souvenir plates that have been sold to tourists in Florida since the 1930s and that this artist's pinks and off-greens resemble the colors used on quilts in the 1930s.[48] Whatever its sources, color was apparently a primary consideration for Cunningham since he chose to label his paintings according to their major hues as the following titles indicate: *Orange Brown Sky, and Water*; *Blue Sky and Water Some Greenish Yellow Sun Set*; and *Yellow Sky, Greenish Water, Dark Tan House*.

In most of his works, Cunningham subscribed to a dominant hue, which forms an embracing ambience that imbues all pictorial elements with its clearly distinguished tone. While the intensity of color in Cunningham's painting is indebted to popular-culture descendants of Fauvist art, his handling of it can also be traced to the tradition of Tonalism, an elitist artistic trend beginning in the 1880s and continuing into the teens of the twentieth century. Although Cunningham did not perpetuate the blurred forms and the poetic, intimate scenes of the Tonalists, he did sustain their embracing environments, albeit in a heightened palette that differs significantly from their subtly modulated hues. And he continued also the Tonalist desire to create a protected and idealized retreat to the past, even though his iconography differs markedly from the aristocratic, neurasthenic women that are often characteristic of this late-nineteenth-century style.

Although a search for aesthetic harmony through symmetry, repeating patterns, and schematic notations, as well as a desire to realize one's inner vision through intense color do not necessarily indicate an emotionally insecure personality, in the case of Earl Cunningham there is reason to believe that his art served as a way for him to symbolically reintegrate himself with the world. Art may have compensated for the inadequacies of everyday reality, for the slights he received, and also for the difficulties of reconciling the glories of his adventurous youth with the harsh realities of old age. In place of the open-endedness of his own past, Cunningham creates a halcyon world of protected harbors with elegant sailing vessels, schoolhouses, children fishing, birds nesting, and flowers blooming. The artist, however, allows himself a certain latitude in his evocations of the past. In his works signifiers are allowed to slip from one geographical context to another, and consequently one may find New England houses on South Carolina and Florida beaches or New England scenes with pink flamingos.

59

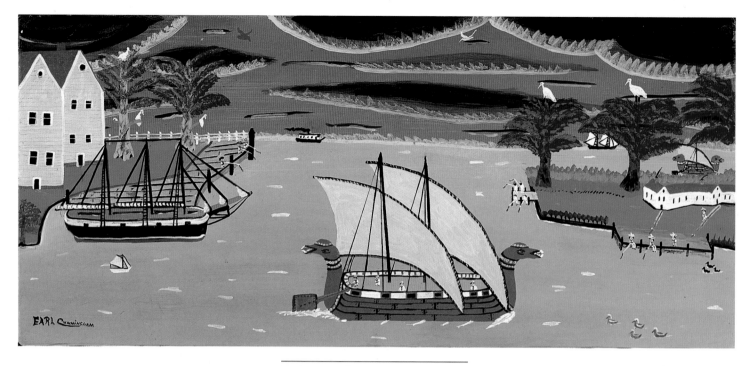

Red Norse Ship at Sunset. *16×36"*

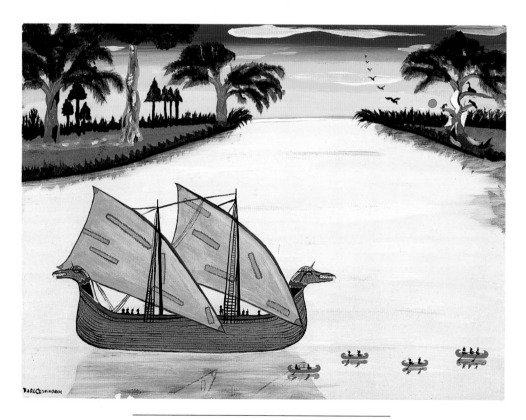

Norsemen Discovering the New World. *18×24"*

In order to understand how Cunningham's works may have compensated for the unhappiness of the second half of his life, it is necessary to examine the few extant records of his experiences for clues to his personality. According to the journalist Cynthia Parks, who interviewed the artist in 1972, he left his childhood home in Edgecombe, which is near Boothbay Harbor, Maine, at age thirteen, in order to become an itinerant peddler and tinker. Since his mother had made him promise that he would finish the eighth grade, he may have been eager for the itinerant life but remained in school to satisfy her. Upon Earl's completion of the eighth grade, his father, a farmer who was descended from a long line of farmers, declared him a man, and thus he ventured into the world.[49]

The young Cunningham left home with "a suitcase of pocketknives, darning eggs, pans and needles strapped to his back. . . . At nightfall he preserved his shoes from nibbling porcupines by hanging the shoes in a tree. He found a scrap of a wooden box on the shore, painted a scene on it and sold it for $5. Then he could buy a tarpaulin to sleep under."[50] In addition to selling new wares and on occasion his art, Cunningham also traded in secondhand objects.[51] According to his chronicler Brigham, "These [early] pictures of boats and New England farms were done on pieces of wood salvaged from the surf, planed smooth and transformed with paints from 'the five and ten.'"[52] Only later did the young peddler begin to employ more conventional painting materials to create works that sold for fifty cents.[53]

While today it would be deemed an act of cruelty to force a young teenager into the world, customs were radically different in the early twentieth century, when child-labor laws had not yet been enacted. In the various interviews about his childhood, Cunningham appears not to have harbored any bitterness about being required to leave home at such an early age, but since these interviews were conducted as many as seventy years after the events took place, it is difficult to arrive at any definitive conclusions. In his essay "'A Correct Likeness': Culture and Commerce in Nineteenth-Century Rural America," David Jaffee outlines the nineteenth-century custom of sending young boys off as peddlers and tinkers: "An itinerant life, peddling rural arts and crafts, was a stage in the life cycle as well as a method of social mobility for many young villagers. Farm boys with limited formal education found the roads of the North to be their open-air schoolhouse."[54] Jaffee also notes that a number of nineteenth-century itinerant painters began as peddlers and tinkers before graduating to portrait painting.[55] This information about nineteenth-century practices suggests that the radical break in Cunningham's childhood may have been an expectation and not a cruel ostracism. While it does not justify the early severance of dependency as well as the abbreviated childhood, it does establish this key episode in Cunningham's life as an established route for young rural boys of modest means that continued into the twentieth century. While Cunningham may have privately mourned his lost childhood, he would not have felt his role as itinerant peddler/tinker to be a unique and unjust one.

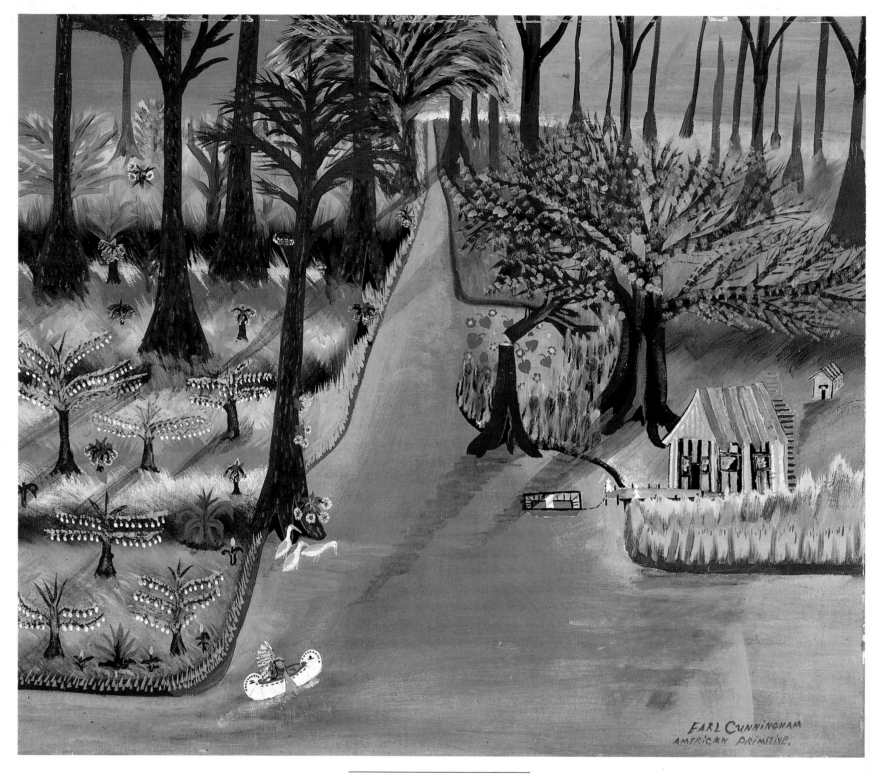

Ashepoo River in Spring. *20×24"*

Ashepoo River in Spring *(detail)*

The Cunningham family, Boothbay Harbor, Maine, c. 1917. Fourth, fifth, and sixth from left: Charles and Elwilda (Earl's parents) and Earl

Rather than being defeated by itinerancy, Cunningham appears to have relished it. Both the range and extent of his adventures imply that he was an intelligent, personally engaging, and entirely trustworthy young man who was resourceful and also capable of enjoying new undertakings. While still a tinker, Cunningham related that he met the son of the inventor and founder of the Diamond Match Company, who let him live in one of the company's warehouses and who "taught him how to run an electrical generating plant which supplied power for his 200-acre farm."[56] And in 1912, when he was nineteen years old, Cunningham received a certificate from the Hamlin Foster School of Automobile Engineering in Portland, Maine.

A few years later he met a Captain Foster, who introduced him to the exciting world of yachting. The following story, related by Brigham, summarizes their association:

During these years Cunningham met a Captain Foster, who was skipper of the millionaire Morgan family yacht, "The Grace." Captain Foster taught the young artist-tinker from Maine much of the ship lore he still needed to know and eventually Cunningham learned to sail the 35-foot yacht himself. At one time, seeing that a storm was brewing, he rowed out to check the moorings of the yacht, repaired the shackle which had been undone by the heavy weather and saved the Grace from disaster. The Captain made a fortnight's trip to Boston and returned with an 11-foot mahogany-topped white cedar canoe, a gift from

the Morgan family to the boy from Maine. Cunningham's friendship with the Captain continued and Foster helped him buy a 22-foot sailboat; the final payment on Foster's loan being made shortly before the Captain's death.

It was probably during this time that Cunningham received a government license as a pilot of harbors and rivers, for he sailed his twenty-two-foot sailboat to Jamaica Bay, Sandy Hook, and the Long Island Sound, coming within fifteen miles of New York City and even going beyond the narrows of the Hudson River. Although the story regarding Captain Foster and the J. P. Morgan family might appear on first acquaintance to be pure fantasy, contemporary annotated photographs confirm Cunningham's association with Foster. A photographic postcard of Boothbay Harbor contains the annotation: "from Portland ME. to BB [Boothbay] Harbor on the *Grace*. . . . Captain Foster's daughter and I went to the fire [of the big hotel in Boothbay known as the Menawarmet] around 9 o'clock at night June 1913."[57]

Cunningham's tremendous interest in the sea may have been stimulated by the stories his mother told about the fishermen in her family. Although some Cunningham family members believe their ancestors to be nineteenth-century sea captains commanding three-masted schooners, the acknowledged family historian, Robert Cunningham, has asserted that ancestors on their mother's side were "everyday fishermen."[58]

Soon after his association with Captain Foster and the Morgan family, Cunningham began to work

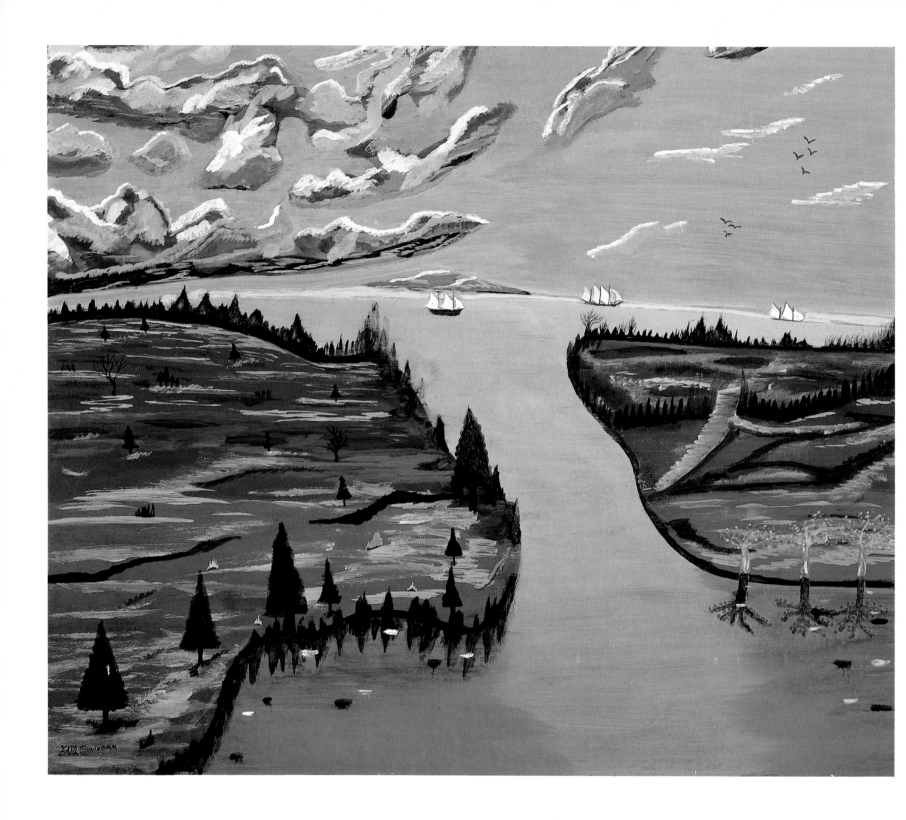

Gathering Clouds Off Little River Inlet. *20 × 24″*

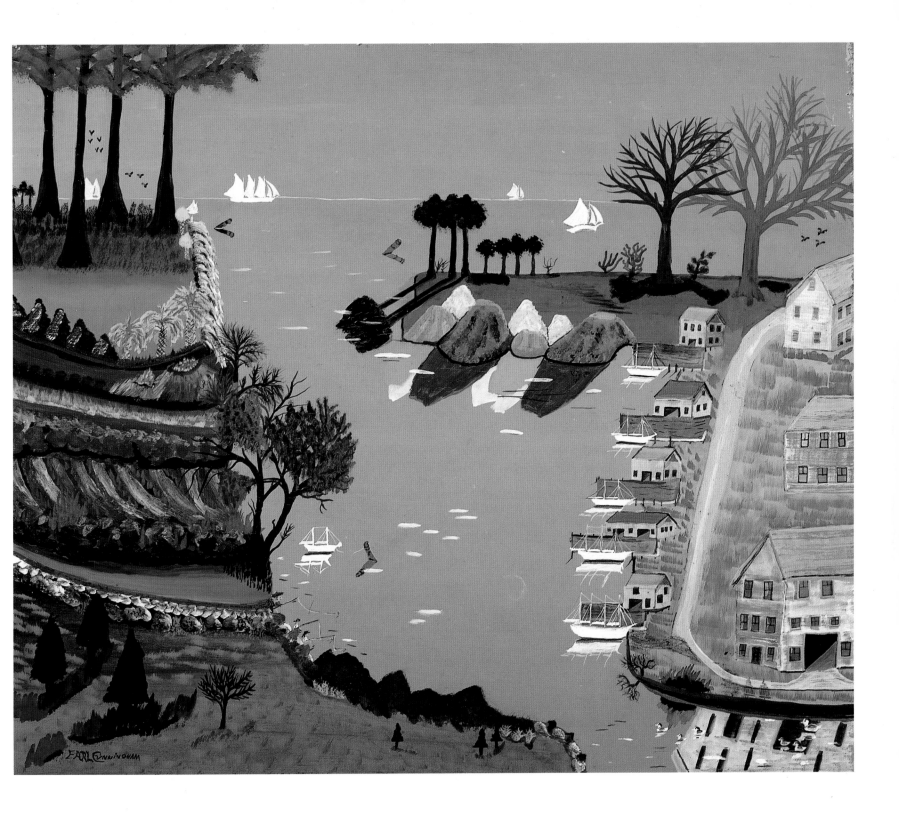

Harbor with Red Pilings. *20 × 23¾″*

as a seaman on the giant coastal sailing vessels, which he remembered as being "150 to 250 feet long with four and five masts, schooner-rigged."[59] These vessels on which Cunningham sailed carried coal, naval stores, and other cargo along the Eastern seaboard, where they made stops at ports from Maine to Florida. In addition to these cargoes, schooners customarily were loaded with fish, molasses, and pulpwood for paper mills. Although large cargo-bearing coasting schooners were most important during the late nineteenth century, there was a great resurgence of shipbuilding during World War I because of the vessels' economic viability. Even though Maine had been one of the centers for building schooners both in the nineteenth century and during the World War I boom, the state experienced a recession in the period following the war. But beginning in the late 1920s and particularly in the 1930s, the old Maine shipyards were the sites of an important revival: an increased interest in yachting, which created a demand for small and medium-sized pleasure craft, together with both the fishing industry's and also the government's need for new vessels helped to sustain the growth of this industry. Cunningham fortunately was able to enjoy the height of this revival during World War I, when he worked briefly as a seaman. During his periodical stays in Maine, which continued until the late 1930s, he witnessed firsthand the continued interest in using these magnificent vessels for commercial purposes and for pleasure. Cunningham's familiarity with sailing is of crucial importance to his painting, which at first memorializes his personal experiences,

then celebrates the survival of this impressive industry, and finally pays tribute to the passing of commercial shipping at the same time that it takes pleasure in the increasingly popular sport of sailing. His references to these sailing vessels as quintessentially American may stem from their grand history and may also result from the use of them during World War II, when foreign submarines were unable to detect them because of the ships' wooden hulls.

Cunningham's work as a sailor provided him with at least one occasion to come in close contact with nature. He related to Brigham a story about his time as a merchant seaman when he befriended the local animals:

> *Cunningham recalls that he was once taken by "coaster" to Labrador where he was put ashore for two weeks all by himself so that he could light a high bonfire as guidance for the ship on its return. His nearest neighbor for two weeks was 200 miles away, so he made friends with the raccoons and birds and other forest creatures, many of which reappear in his paintings.*[60]

As Brigham correctly notes, this special relationship with animals was to have great importance for Cunningham's art, which imbues birds, plants, and coastal areas with a sense of wonder.

Cunningham's early self-assurance held him in good stead through the 1920s and perhaps even into the 1930s, when he was able to continue his adventurous life of dividing the year into segments spent in the South and in Maine, with excursions to sur-

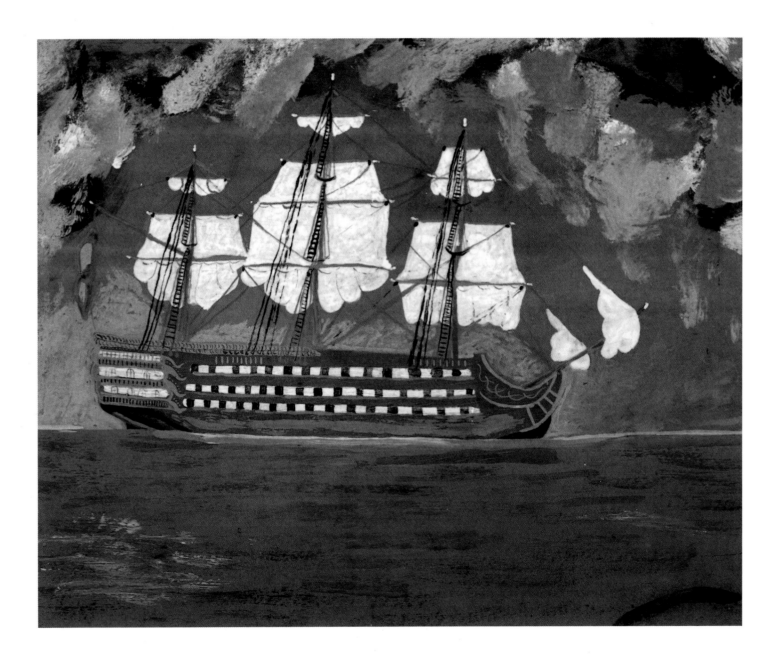

Three-Masted Square Rigger. *c. 1914. Oil on board, 8 × 10″*

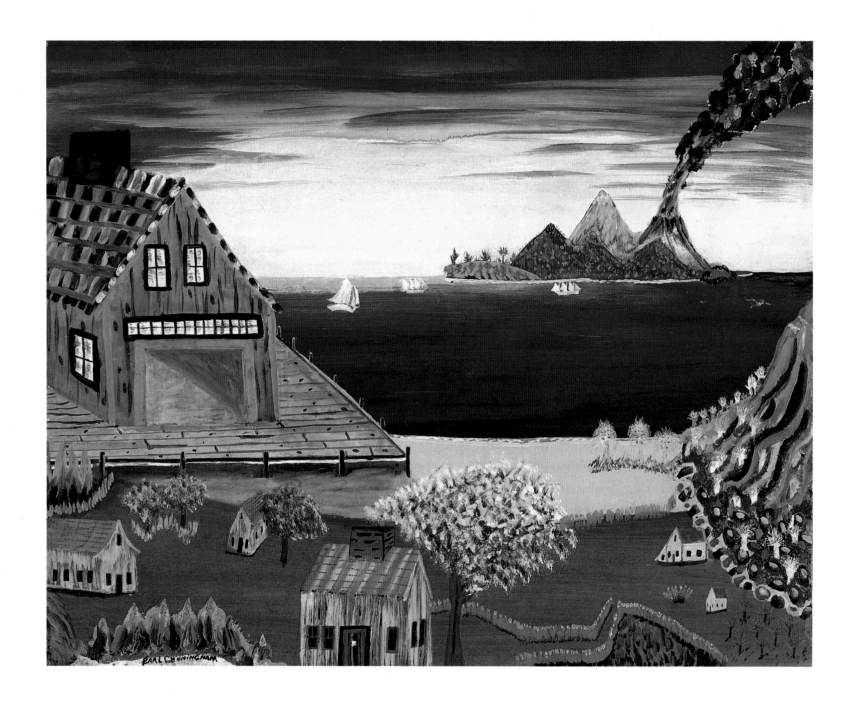

View of Volcano Island. *16×20"*

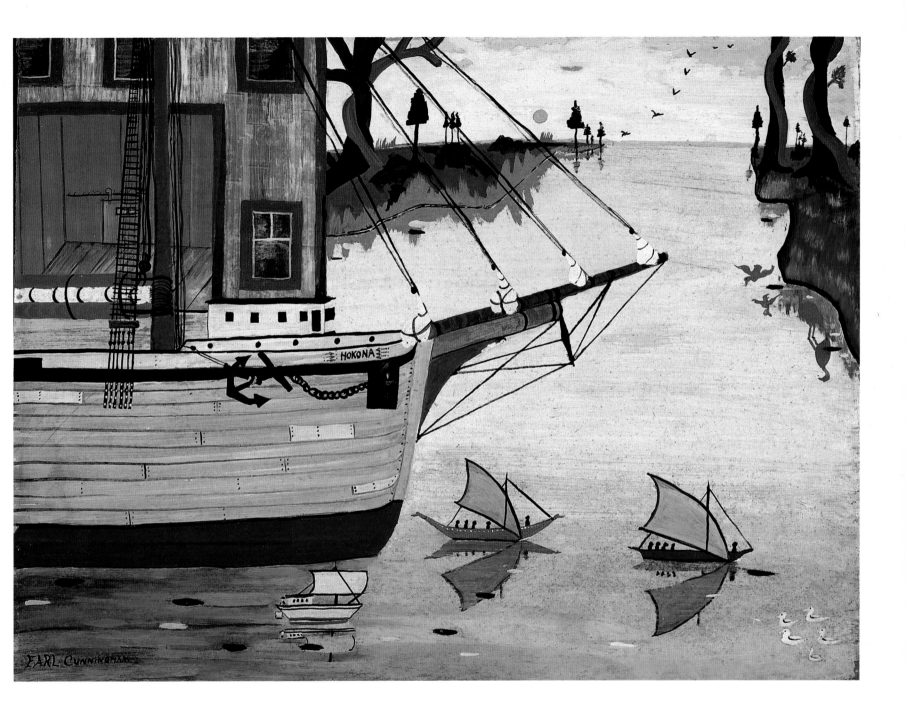

The *Hokona* Out of South Carolina. *17¾×24"*

Captain Earl Cunningham on Hokona, *1916*

rounding areas and to the Midwest. Although Cunningham had first become acquainted with Florida when he worked on schooners docked at various ports in the state, he later drove a six-wheeled truck on special assignments for the navy, which sent him to Jacksonville, Florida, to test an instrument used to detect alloys in junk metals. During this period in his life he married a piano teacher named Iva Moses, whom he called Maggie, and he bought a thirty-five-foot cabin cruiser, which he named *Hokona*. After the war he made a living by digging for Indian relics and collecting opalized coral, which he and Maggie took back to Maine to sell.

For these extended jaunts, Earl and Maggie Cunningham traveled in a truck converted into camper. On a photograph dated July 1921, Cunningham noted, "Mohawk Trail, Mass / Driago The Good Barge / Our Camp Car." In this annotation, which is significant for the way that Cunningham analogizes his truck as a marine vessel, he misspelled the name of the car, which is shown as *Dirigo: The Good Barge* on the vehicle itself. *Dirigo*, which is Latin for "I direct," is the Maine state motto—an appropriate name for a wondering, self-directed Mainelander.

During the 1920s millions of Americans began to take to the highways in a variety of vehicles. Some of them used nautical analogies to describe their automobiles as did Cunningham, and still others preferred to compare both themselves and their vehicles with gypsies and their wagons. The most favored terms for the phenomenon of autocamping were "motor gypsying," "motor hoboing," "nomadic

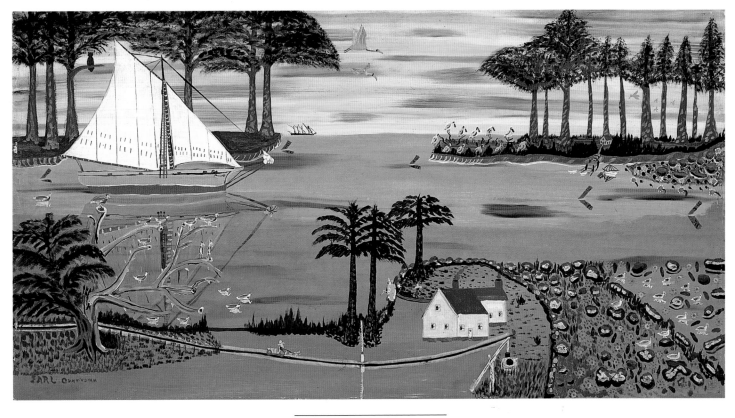

Spoonbill Point. *22³/₄ × 42³/₄"*

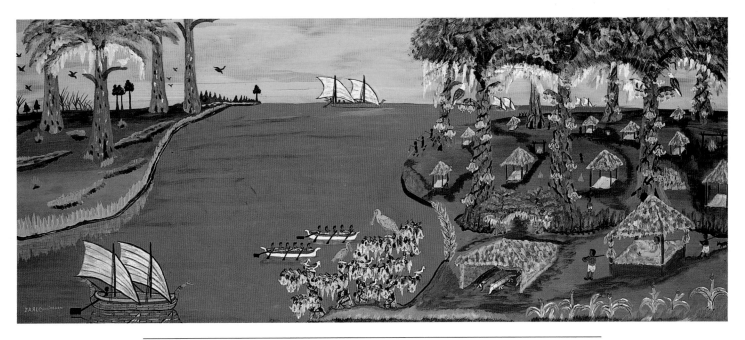

Seminole Village with Lavender Sky. *17 × 41". Lightner Museum, St. Augustine, Florida*

74

Cunningham's camping vehicle, Dirigo: The Good Barge, *Freeport, Maine, July 16, 1921*

Dirigo *with awning, Anastasia Island, Florida, September 1923*

motoring," "gypsying deluxe," "autotramping," and "motor vagabonding."[61]

In the decade preceding the Great Depression, autocamping became a national pastime. In 1921 the activity received official sanction when President Warren G. Harding joined Henry Ford, Thomas Edison, and Harvey Firestone on one of their autocamping excursions. In his book *Americans on the Road: From Autocamp to Motel, 1910–1945*, Warren James Balasco notes the following statistics about autocamping:

> *9 million Americans would go motor camping in the summer of 1921. The New York Times guessed that out of the 10.8 million cars on the road in 1922, 5 million would be used for camping. At an average of three passengers per car, this meant 15 million autocampers. . . . Generally the figures ran between 10 and 20 million autocampers for the mid-1920s.*[62]

To accommodate the great number of motor campers, individuals, cities, and states developed between three thousand and six thousand autocamps in the 1920s. Some of these camps were practically towns that extended over a number of acres—the largest was Denver's Overland Park, which had 160 acres and such amenities as electricity, water, clubhouses, a grocery store, comfort stations, showers, a lunch counter, and a laundry room.[63] Most of the people stopping at these camps were solid members of the middle class. They were conservative in their outlook and regarded their

experience as a return to prehistory where one could take in the "ozone" and bask in the splendor of nature.[64] At these modern caravansaries where the motor gypsies encamped, there was great interest in how enterprising roadsiders had transformed cars into "lodging houses" and trucks into "Pullmans on wheels" similar to Cunningham's "Good Barge, Dirigo." Specialty magazines such as *Motor Camper and Tourist* and *Popular Mechanics* provided autotramps with ideas, but many excellent concepts were developed by individuals.

Earl and Maggie Cunningham, together with the *Dirigo*, participated fully in the flourishing subculture of automotoring. His time spent as a professional motor gypsy reinforced Cunningham's early wanderlust by transforming it into a viable way of life. Years afterward Cunningham dreamed of returning to such a life in Florida, where he might live on a houseboat that could be temporarily docked among the lush flora and fauna of the state. His later paintings of the houseboat, together with a number of his other works of inland and coastal hideaways, can be considered an aesthetic response to this profound need. So great was this need that his close companion Theresia (Tese) Paffe noted in 1979, two years after his death, that "his lifelong ambition was to own a houseboat. . . . He died with the price of one in the bank, and every picture in Overfork has water in it."[65]

Although Cunningham obviously savored the free life of the highway and the sea, he tried to cope with the restraints of a more sedentary life first on his farm in Maine, then at the chicken ranch in

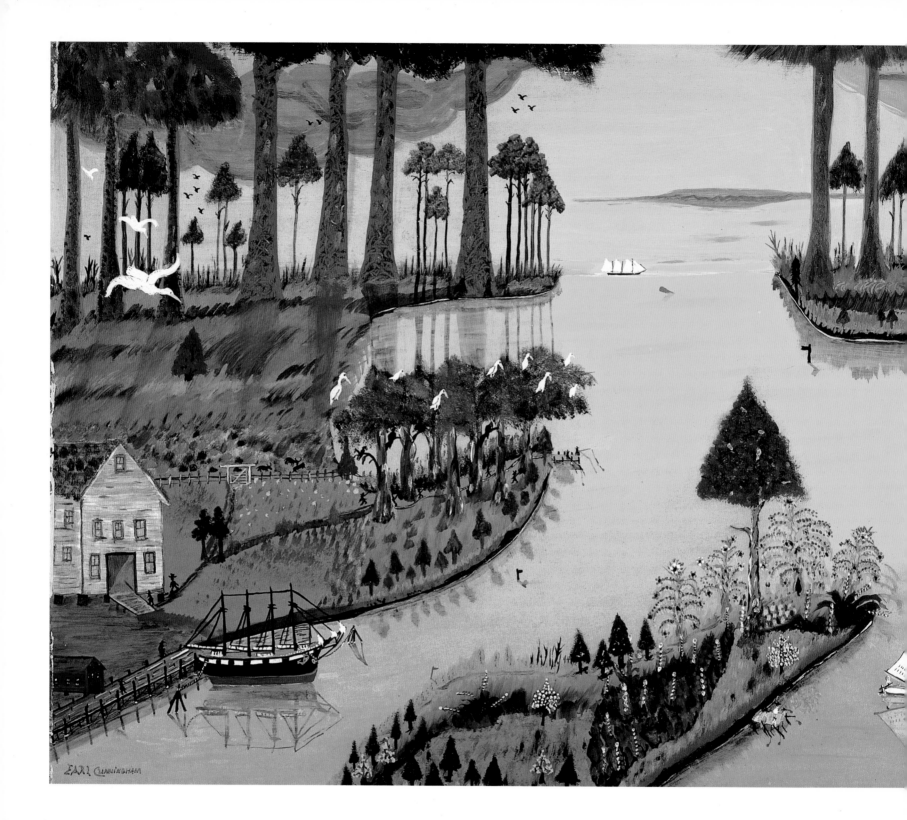

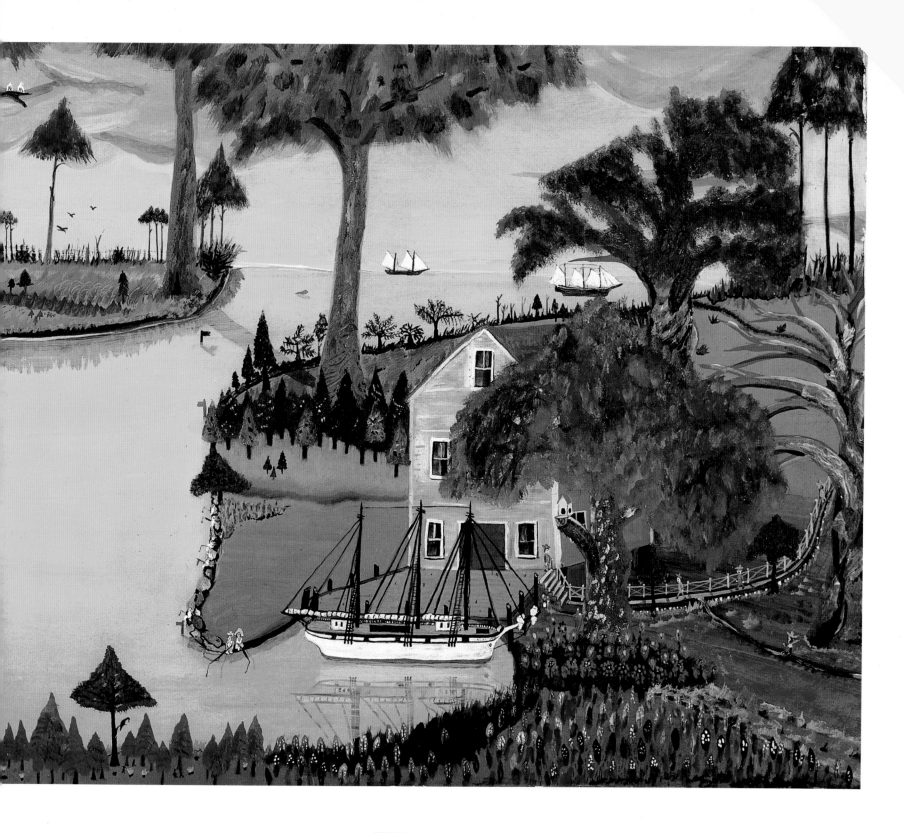

Nassau Sound. *19×48″*

Earl Cunningham, June 1948

South Carolina after his divorce from Maggie (around 1936), and finally in St. Augustine at the Over Fork Gallery. Friends such as Brigham and Surovek remember Cunningham as a particularly happy individual who was fond of jokes. But the confinement of keeping the shop coupled with the limitations of old age no doubt contributed to his increasing paranoia, which he carefully logged in a small notebook and later amplified in a large scrapbook, in which pasted-in news clippings seemed to corroborate the fears that were written in his sprawling hand or noted in typed messages glued to the pages.[66] This distrust may have surfaced at different times early in Cunningham's life, but he coped with it through travel and change. An example of his difficulties with his family in the 1920s is evident in the following reflection: "Later I moved to Boothbay Maine, this was the bigest mess I ever got into. Paul – Cory and my Mother on me all the time, tell I had to sell and get out. As long as Father lived he kept things running but when died thay jump on me hard. My father said thay dont know whair you get the money to do the things you do."[67] Although it is not necessary to dwell at length on his anxieties, they do merit attention since they establish a reason why Cunningham turned increasingly to his fantasy world. This paranoia also helps to explain his need to use the paintings to buttress his dreams and thereby keep them alive. His notebook has entries from 1949 to the mid-1960s, and his scrapbook contains a few early sheets from the notebook but begins essentially in the mid-sixties and continues until his death.

His notebook first focuses on visitors to his antique shop who steal articles, call him names, threaten him with physical harm, and disrupt prospective customers. Not all of his difficulties, however, were imaginary; his paranoia appears mainly in the way that he focused on these fears and thereby enlarged actual events into great delusions. Cunningham had moved to the small town of St. Augustine and had become friends with one of its respected, unmarried citizens, Tese Paffe, who owned the building at 51–55 St. George Street that he rented. Earl occupied the downstairs spaces, while she made her home upstairs. The building had been in the Paffe family since the turn of the century, and Tese, together with her mother, had used it until about 1947 as a shop in which greeting cards, stationery, children's books, toys, games, and artists' materials were sold. Cunningham's close association with Tese no doubt set him up for public disapproval, ribald jokes, and children's pranks.

Cunningham also did not always make himself accessible to customers. According to William Ketchum: "He frequently would close the shop in a very whimsical manner, sit inside, refuse admission to anyone that he didn't choose to do business with, or arbitrarily shut up in the middle of the day and chase out all the customers. He was not what you might say a paragon in the eyes of the Better Business Bureau."[68]

After two boys damaged some items in his antique shop, Cunningham called in the police, who picked them up. This incident, according to the artist, created problems for a number of years and resulted in kids pounding on the doors of his shop and shouting obscenities, spitting on the windows, blocking entry for customers, chasing him with motorcycles and racing their engines in front of the store, threatening him with physical harm, throwing objects at the store, and kicking at the door. One boy in particular bothered the artist for years. In his notebook Cunningham admitted that some of these difficulties were experienced by the other shop owners, but he seems to have taken little comfort in his shared misery. In addition to the above problems, Cunningham wrote that on a number of occasions women at the local A & P would push their carts against him, leaving him black-and-blue.

In the course of conducting business for seventeen years, an entrepreneur probably would experience some problems with the public, but there are few shopkeepers who would dwell on their misfortunes to the extent of keeping a record of them in a notebook. Also, since the 1950s was a period when teenagers began to form local gangs and staged group rebellions, a cranky and eccentric antique dealer might be expected to face some difficulties. At this point in his life Cunningham had lost the confidence of his youth and had become a frightened individual who harbored resentment against all personal injustices.

Beginning in the early 1960s Cunningham perceived a threatening enemy in the form of the chairperson of the St. Augustine Restoration, Inc., which in 1968 became the St. Augustine Historical Restoration and Preservation Commission. As the property he was renting from Tese Paffe became

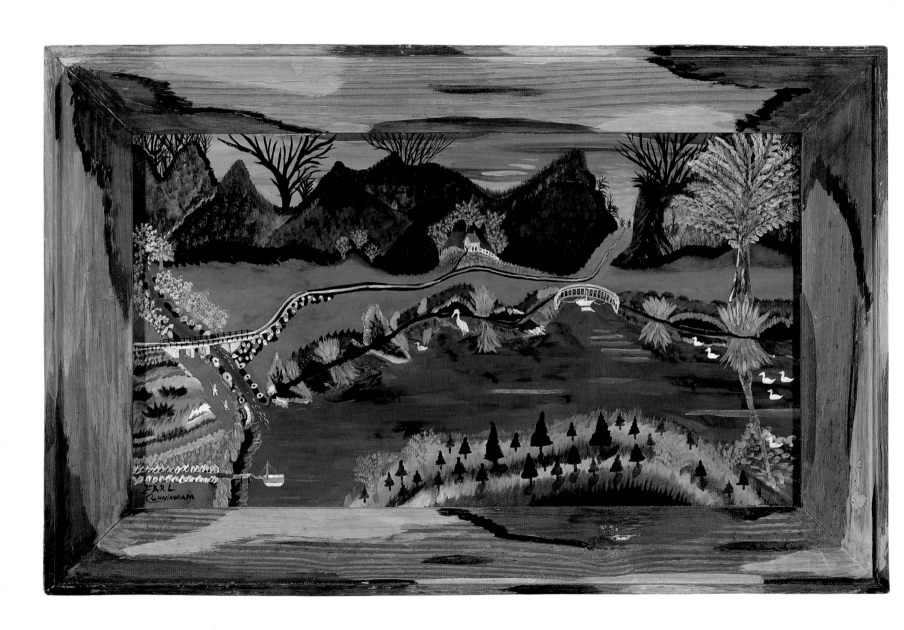

Blue Water Cove. *12×22"*

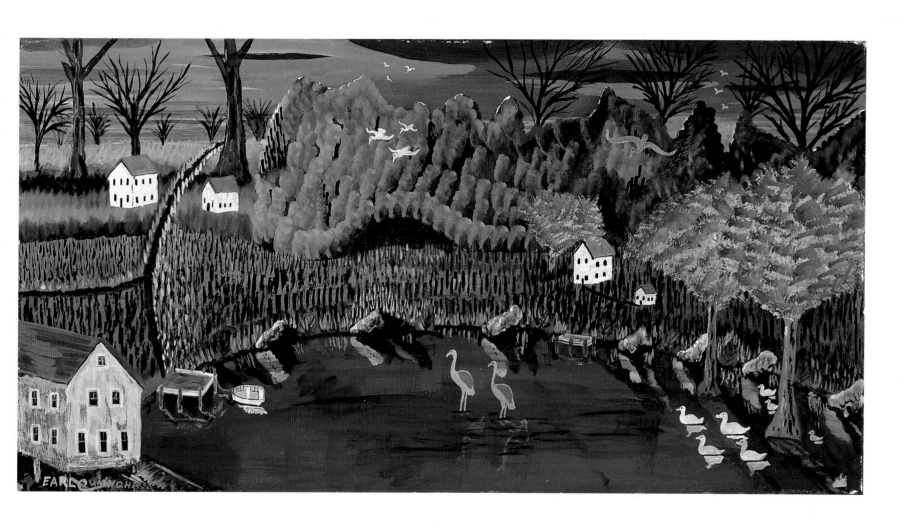

Night Scene. *12×22"*

more valuable and as the local committee for the restoration of the old district of St. Augustine gained prominence, Cunningham became increasingly alarmed about the possibility of bodily harm to himself and arson to Miss Paffe's buildings. The threat of fire was particularly terrifying to Cunningham because it would destroy his business and wipe out his life's work. Because of this fear, he collected news clippings of fires in the St. Augustine area and kept them in the scrapbook. He thought that the owners of the restored Old Spanish Inn wanted the Paffe property to build a parking lot, and he believed that certain individuals, including the head of the restoration society, would stop at nothing to achieve their goal. An undated note by Cunningham contains the following alarm:

> *This trash is a bad fire hazard. Now during this time. The St Augustine Resotration Preovation Comm. has sant me warning three times that they are going to set this building afire. One of thayr men came to me telling me to get my things out of this building this week for thay are going to burn it Sunday, arsen. This is a state comm. wood you beleave that a state wood do a thing like this.*[69]

In January of 1967, according to Cunningham, "The driver of the Site seeing trains [was] in front of my store, telling the people out a loud speaker, what a nice big bond fire this building is going to make, meaning the Paffe building."[70]

When his fear was not of fire, it was of simple destruction: "Mr. Sullivan," Cunningham wrote, "in my store telling me the Wolff gang told him that this building was all rotten and leaning over. Thay was taking it down by the first of oct."[71] And on July 11, 1968, the artist recorded that "Mr Sullivan in my store telling me things keep going like theay are someone going to get killed (that ment me)." Although Cunningham was obviously deeply concerned about his own personal safety and the precariousness of his business and museum, which depended on the continued generosity of Tese Paffe, he was also concerned about her welfare. In his own inimitable contentious manner, Cunningham expressed his concern: "If I leave my land lady will loose every thing she has to live on. Im trying to see her thou so she can live later. She does not try very hard. Thinks the world owes her a living and dont care how."[72]

Theresia Paffe was an important factor in Cunningham's life. She enabled him to make his art because she helped with many aspects of daily life. She provided him with space at an affordable price, cooked many of his meals, and even sewed his shirts. That she was in love with him is evident from her marriage proposal of 1957, which she introduced with the following supplication: "Dear Earl Please read this carefully and take you time to think it over and don't say no before you have. All my love Tese."[73] The letter reveals their mutual concerns and difficulties. It begins:

> *I know you have been worrying about business and finances. If we work together to pay bills, groceries, utilities and taxes,* No rent.

If you sell your stock that money is for the house boat you want.

If I sell the property, down payment goes on a home. Monthly payments fifty fifty. We go fifty fifty on any balance on the home, every thing in both names.

Now this is not to have my way, but to show this town and these people that we can do what we started out to do. I will have to put my pride deep down in my pocket to go to talk to the priest here. We do not have to be married in St. Augustine, but it would cost less here than having all the expenses of going away. . . .

Marrying in the church will not stop me from going for 6 months or a year on your house boat if you want to go. This is not trying to buy or bribe you. I just want to give you and I security in the years ahead.[74]

It appears that Earl made several attempts to become a Catholic so that he and Tese could marry. He met with priests three times to discuss the subject but became argumentative with them and consequently lost interest in joining the church. Although his family was Baptist, Earl rarely attended any church, but he did read the Bible each morning and thus developed strong religious convictions. Surovek has emphasized Cunningham's purity, which was manifested in his simple appreciation for God giving him talent and also for giving him

the ocean.[75] His refusal to become a Catholic so that he and Tese could marry put a definite strain on their relationship, which continued to the end of his life. Even without this difference, their relationship was not an easy one. According to Miss Paffe's close friend Jackie Clifton, Cunningham "was so peculiar. He was so jealous of Tese. He pouted and upset her, but he gave Tese a reason to live."[76]

Earl was at times distrustful of Tese. On the back of a photograph of her, he noted, "My land lady for 20 years She high hatted me always." Written in the late 1960s, this cryptic note is indicative of Cunningham's difficulty in trusting anyone. He expressed his frustration and lack of certainty about the relationship in 1968, when he wrote, "I know not how much longer I can stant it. Im slowly giving up. Afrade I will have the shingles a gaine. if I do i will go and leave most Every thing."[77] At times he felt ineffectual as when he noted in his scrapbook that in November of 1971 he had told Theresia that he would be moving in two years. Instead of taking his statement seriously, she laughed at him.

Cunningham believed that she had changed toward him; he wrote, "Now she has got her family all back again that means the end of me. I will not live though what I had to live though at the first of my coming her."[78] His fears may have some basis. On September 19, 1972, he noted that Theresia had asked him to be out of the St. George Street building by the first of 1973 but would not tell him why. He mentions turning down her lawyer, Charles Bennet, who had offered him five thousand dollars to leave. The rest of this entry details the work that

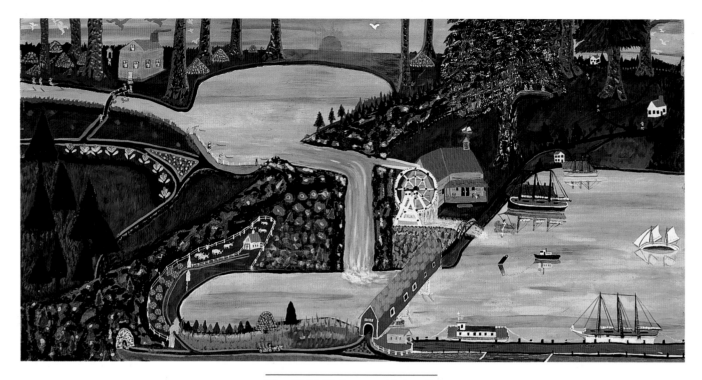

The Old Mill Stream. *22½ × 43″*

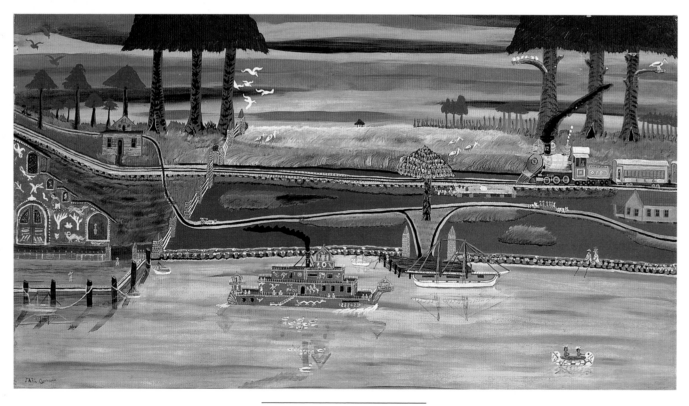

The Amusement Park. *24 × 43″*

Cunningham had done on Tese's two buildings since occupying them. He bemoans that in addition to paying rent he never charged for his labor. Unable to blame Tese, Cunningham surmises, "Her lawyer has got the best from her. Thay both belong to the same church."[79] After this rupture in their friendship, Earl and Tese were able to resolve their differences. The following year she acquired a house on Ponce De Leon Boulevard, which was also Florida's state road AIA and U.S. 1. The building contained a large room that could be used for Cunningham's combination studio/shop. His new shop had less space than the buildings on St. George Street, and thus he had to put some art in storage. A two-page ad appearing in *The Vacationer* on September 26, 1973, may have advertised the opening of the new gallery. Headed "This is the most unusual ad you will ever see; these paintings are not for sale," the advertisement contained photographs of the artist, a reference to his collection of two hundred "original 'primitives,'" and the note that "Mr. E. C. [*sic*] Cunningham is still working on his art collection."[80]

He maintained a close relationship with Tese Paffe to the end, but he continued to be riddled with great anxieties that may have been intensified by the book he was writing about his life.[81] In 1977 Earl Cunningham shot himself. Friends have speculated that either jealousy about Miss Paffe or possibly cancer were factors in his tragic ending.[82] Cunningham was eighty-four at his death.[83]

All of the difficulties, both real and imagined, that Cunningham experienced in the last twenty-eight years of his life—the years of his greatest cre-

Earl Cunningham and Theresia Paffe, c. 1960

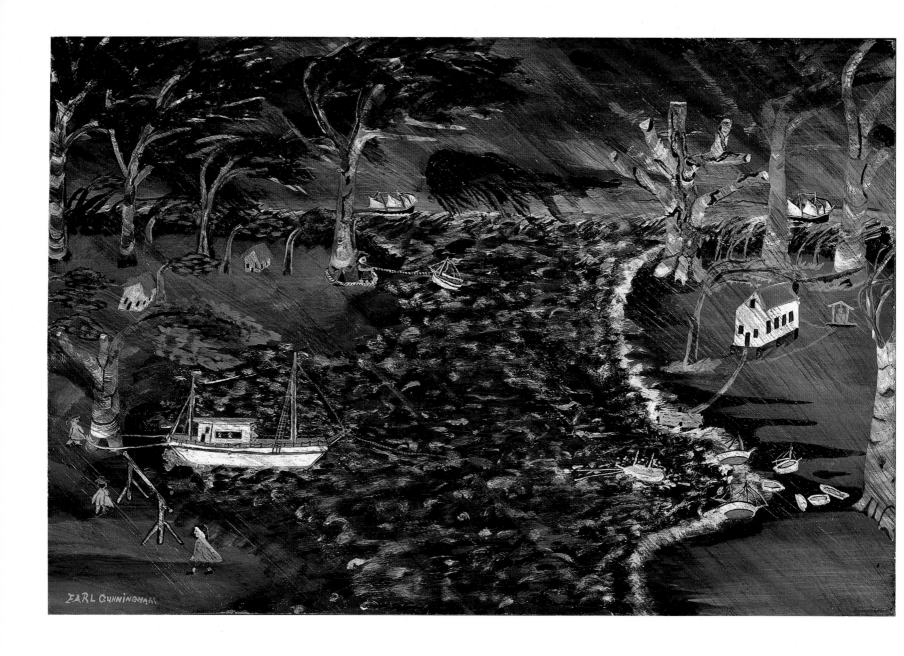

Hurricane Warning. *16×24″*

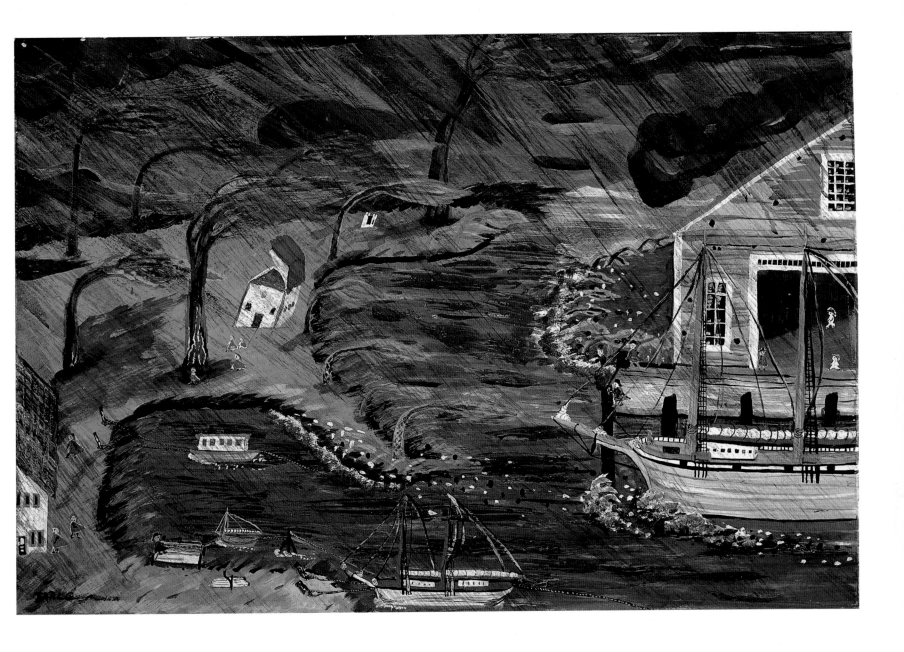

The Big Storm. *16×24"*

ative output—strongly support the claim that his art plays a compensatory psychological role. If his works do assume this role, they might be considered as mandalas—ritual devotional images or individual revelations that are given either a two- or a three-dimensional form and that represent, according to C. G. Jung, attempts to understand one's greater self and its place in the world.[84]

Although the Sanskrit word "mandala" means "circle," and many traditional mandalas take a circular form or deal with multiples of four, the psychological ramifications of a mandala, according to Jung, are concerned with "the *archetype of wholeness*."[85] Jung himself tended to take an orthodox attitude toward mandalas and regard them as necessarily circular. But his discussion of them as images of "the self—that is, [one's] whole being—actively at work,"[86] and his recognition that they

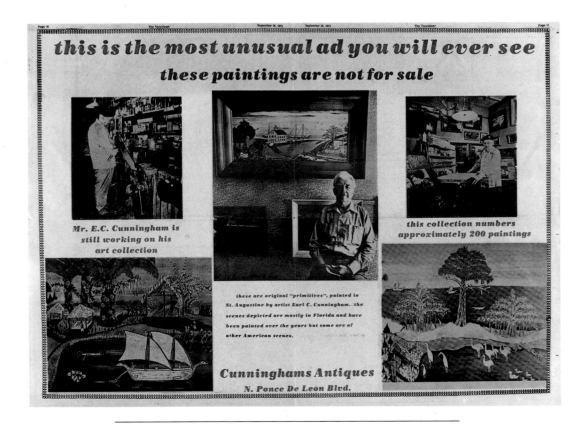

Cunningham's two-page ad in The Vacationer, *September 26, 1973*

"usually appear in situations of psychic confusion and perplexity" and function as a "psychological 'view-finder'"[87] suggest a usage for mandala symbolism in identifying and analyzing the psychological component of art.

Specifically, mandalas establish a means for comprehending how artists might subliminally use their art to mediate between the conscious and the unconscious mind and establish the identity of the self as opposed to the mere ego. Mandala symbolism might provide a way of thinking about how Cunningham's personal need for a harmonious integration with his immediate environment could be symbolized by his mythic images of the United States' peaceful genesis. His art presents this new beginning in terms of amicable interactions between Norse ships, Native-American canoes, cargo-bearing schooners, and pleasure craft that often take place in a landscape that refers to both the coasts of Maine and Florida. Because mandalas provide a means of symbolically compensating for a lack of balance and are "attempt(s) at self-healing on the part of Nature,"[88] they point to the power of a transcending order, which artists invoke in order to come to terms with the self. Thus mandala symbolism enables one to consider the Platonic aspects of Cunningham's art psychologically as well as philosophically and spiritually.

Cunningham's desire to keep the majority of his works at close hand suggests that they were an important part of his identity and may have provided some release from the daily tensions he experienced. His art may represent a symbolic resolution of these tensions—a function analogous to both traditional and individual mandalas. Cunningham's paintings appear to be products of necessary rituals that reenact different aspects of a personal myth of freedom represented by the openness of the sea and through the peaceful coexistence of different groups of people from different times, and through the many children who populate his canvases. In order to function, this myth of freedom had to be continually retraced and repopulated; it is a realm that Cunningham evidently needed to occupy through his imagination because it was so inaccessible to him in his daily life.

Cunningham's desire to reconnect with the images of freedom that his art offered him may account for his lack of concern about its stylistic development. Instead of working toward some unknown goal as have many artists, Cunningham evidently was using his art to gain an emotional sense of freedom and security. For this reason he sometimes appropriated stylistic characteristics of his early work in later pieces, thus confusing any clear chronological development. Although his work generally moves from small figures and wide vistas in the early paintings to larger, more close-up subjects in the later pieces, there are many exceptions to this transformation of his style. Similarly, he used more subdued colors and smaller formats in the 1920s and 1930s and began to paint with more saturated hues and larger formats in his later pieces. But again, there are a number of significant exceptions to this overall evolution of his style, making dating tentative and at times conjectural. Instead of

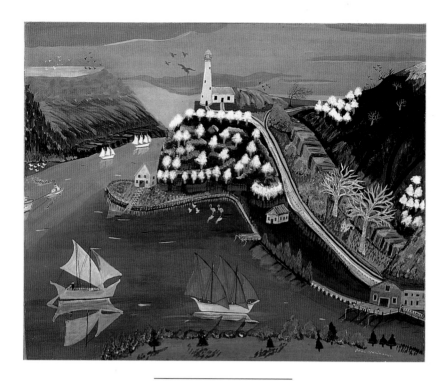

Inlet Lighthouse. *18×24"*

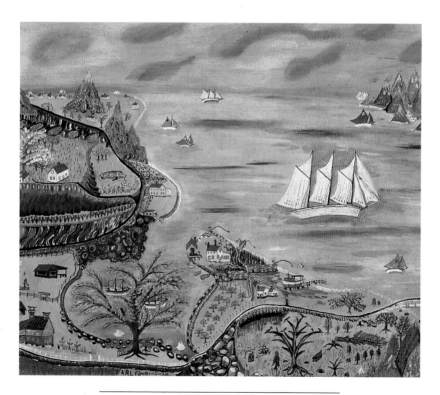

Untitled. *19½×23½". Collection of Jane Dart*

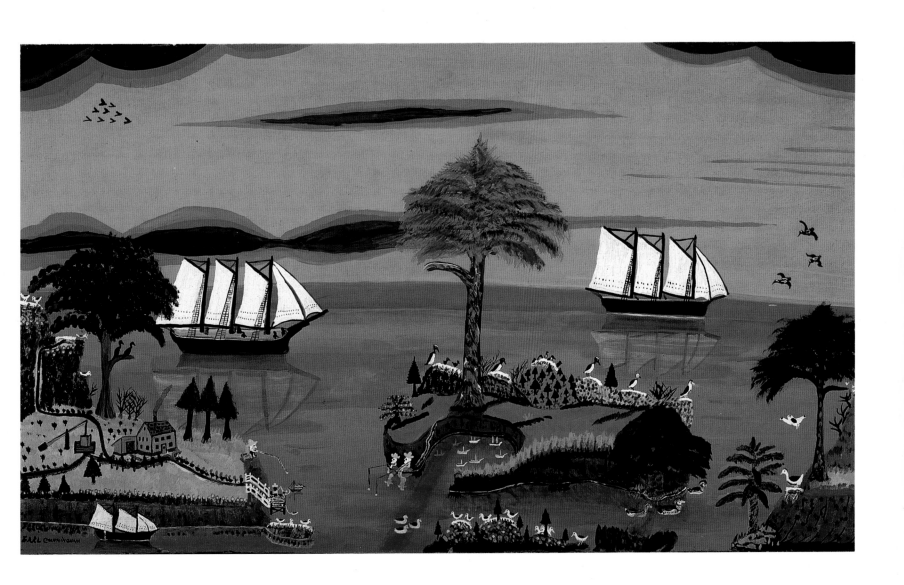

Red Sky Over Folly Beach. *31¼ × 41½″*

92

considering Cunningham as a self-conscious painter intent on using his art as a way of developing a career, it is more realistic to think of his art as an attempt to reaffirm his relationship with his adventurous past and—even more important—with his dreams, which were stimulated by this past.

Earl Cunningham's reintegration of the self through art may have both personal and national ramifications. In his art the self may be perceived as a balance of opposites, a meeting of different times and places, and a brightly colored haven for a host of living creatures, specifically birds, traditional spiritual harbingers. In addition, the self presented in Cunningham's paintings is never imprisoned by land: it always has access to open waterways. A patriotic individual who would often season his conversation with thanks to God for "our country" and "our way of life,"[89] Cunningham's art emphasizes the country's openness to the outside world at the same time that it ensures its security through the repeated image of the safe harbor.

Considering the difficulties that Cunningham experienced in St. Augustine, his art may have served as a refuge, and his museum in its entirety may have constituted a psychologically reassuring life raft. If one considers the layout of the four rooms making up Over Fork Gallery, the movement from the antique shop to the museum represents a progression that is heralded by the single Archangel Gabriel who hangs in the antique shop itself and who points to other Gabriels in the workshop in the adjoining room. This space and the third and fourth rooms were described by Cynthia Parks in 1972:

The shop is rusty-brown with age, the light from the yellowish bulb trapped within the cloudy window. The rich smell is an accumulation of years of varnish and woodshavings, for here Cunningham cuts and planes frames for his paintings and roughs out pine Gabriels—angel weathervanes. The finished ones swing crudely overhead, blowing trumpets, but like Gant in Wolfe's "Look Homeward, Angel," Cunningham has unfinished angels piled near his saw. . . . The third room off the hall, also closed to all but an elect, has a wall almost solidly hung with metal: brass hatches, door knobs, a cymbal, bells, fan blades, a copper ventilator. Another cabinet is full of little boxes with pulleys, brass rings for sails, nuts and bolts. Mostly the gear seems to be for boats. It feels as though a complete vessel is here, only it is not yet assembled. . . . He is also a painter. The curious can look into that dim fourth room, closed, of course, but we enter from the hall. The room is a gallery of his landscapes and seascapes.[90]

Parks's description is important for a number of reasons. First, it points out the progression from the public to the private spaces. The workshop, which was adjacent to the gallery, allowed the artist to work while keeping an eye out for prospective customers. The tasks that he undertook there were

Over Fork Gallery on St. George Street, St. Augustine, Florida, 1970. Photograph by Jerry Uelsmann

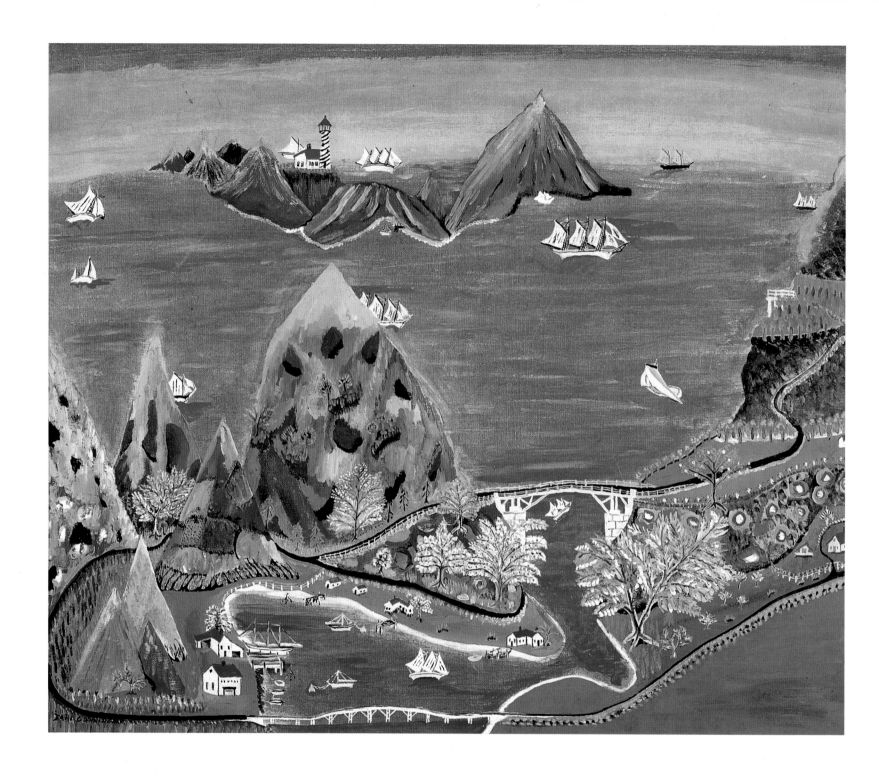

The Red Sea. *20 × 23½". Collection of Chuck and Jan Rosenak*

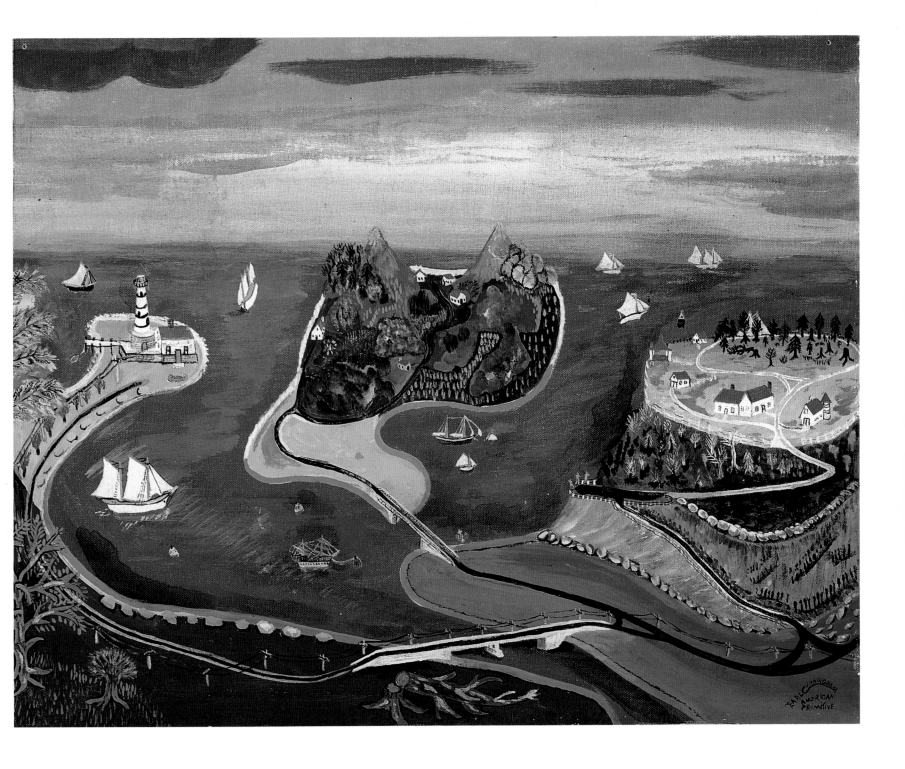

New England Landscape. *Oil on canvasboard, 15½ × 19½". Orlando Museum of Art, Florida*

routine woodworking projects, such as cutting out angels or making frames that would not require the concentration of painting. The third room, which contained nautical equipment, was semiprivate. This is where Cunningham catered to professionals needing antique and/or used equipment for their vessels. This space also functioned as an introductory gallery for the collection of paintings, which was hung from floor to ceiling. The nautical equipment would have reinforced the authenticity of Cunningham's vision by establishing his seamanship. Meticulously ordered, this room would also have created an appropriate nautical ambience for the marine landscapes that he painted. Except for the work area, his museum reenacted the narrative structure of most art museums and many natural history museums across the country, which have shops near their entries, followed by informational displays that orient viewers to the galleries of art and/or artifacts beyond. The $50,000 price for all of Cunningham's art that is mentioned in another place in the Parks essay is significant, for the painter did not wish to sell works individually but instead wanted the collection to be acquired as a whole. Toward the end of his life the price was raised to $100,000.

Cunningham's stationery (circa 1960s) identifies him as a curator. It reads, "Earl R. Cunningham, Curator Mineralogy, Primitive oil paintings, Minerals cut and polished, Finished semi-precious stones, small antiques." Referring to himself as a "Curator Mineralogy" is indicative of his expertise with minerals and also his desire to associate the Over Fork Gallery with a natural history museum. In 1972,

when his stationery was reprinted, he continued the designation "Curator of Mineralogy." On this letterhead devoted to the Over Fork Gallery, however, he does not mention painting but instead lists the following categories: cutting and polishing rocks for collectors, thunder eggs, guns and minerals, arrow points and ship models. While it might seem strange for Cunningham to omit the reference to his art on this stationery, it actually provides some insight to the privileged and separate realm that his paintings occupied.

This letterhead also demonstrates that Cunningham participated in a twentieth-century custom common among shop owners appealing to the tourist trade. To lure tourists into their shops, merchants would advertise free access to a museum or special collection that might occupy as small a space as a single shelf of the store or could constitute an entire room. These roadside museums may represent a widespread development of a merchandizing innovation that can be dated in the United States to the late nineteenth century, when such department stores as Macy's and Wanamaker began including galleries of fine art to both enlighten and entice their customers. This role of department stores as disseminators of culture continued into the twentieth century, when stores featured exhibits of American design; conducted classes in art, cooking, and child development; and helped dispose of such major art collections as the one owned by William Randolph Hearst. The innovative director of the Newark Museum, John Cotton Dana, believed that in the 1920s and 1930s the public gained a greater

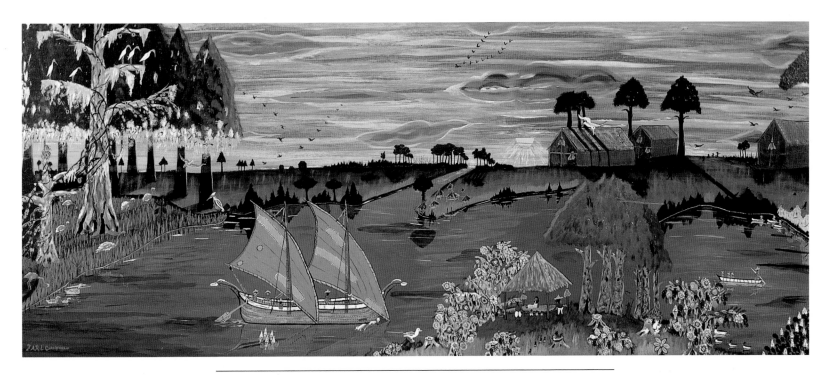

The Everglades. *32½ × 60¾". John F. Kennedy Library and Museum, Boston*

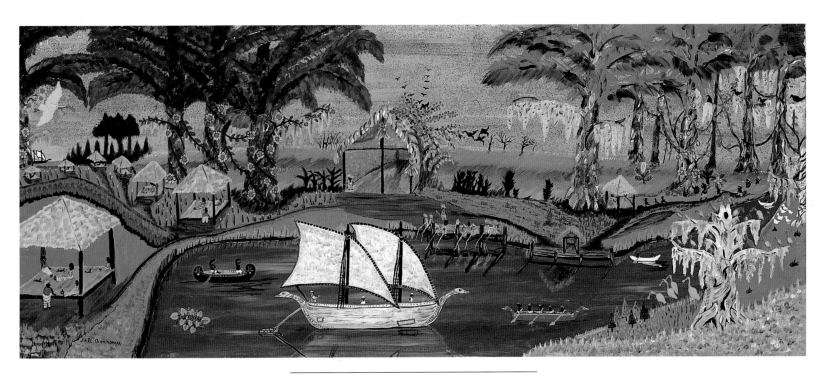

Seminole Indian Summer Camp. *16⅞ × 40¾".*
National Museum of American Art, Smithsonian Institution, Washington, D.C., Gift of Mr. and Mrs. Michael Mennello

knowledge of art from department stores than from museums.[91] While vernacular spin-offs of these department store galleries appeared throughout the country, few entrepreneurs would have called themselves curators as Cunningham did. If they used any label, it would most likely be "colonel" or "captain," because these widely understood military titles legitimized their enterprises to a wide range of people.

When Cunningham decided to create his art for a museum setting, he internalized a range of current attitudes about museums, which included making art a special and restricted world separate from daily life. Even though he contextualized his paintings through the anteroom of nautical equipment, his works existed in a private space that emphasized both their formal qualities and the relationships between them. Just as a museum might transform crucifixes into sculpture, so Cunningham's gallery reinforced the universal character of his art and implied the idea of lasting value. While this attitude might be devastating to a religious object, it reinforced the Platonism of Cunningham's work by making its symbolic aspect readily apparent.

Not only did the museum concept function as a script for reading the paintings as timeless and universal symbols, but it also encouraged Cunningham to think in terms of series and to create with the goal of making his collection function sequentially and spatially. Encouraging himself to believe that his work would someday be viewed in its entirety, Cunningham was able to consider how a group of paintings might look on a single wall or in separate galleries, an approach that is evident in the different series he painted. Some are grouped by subject—hurricanes, covered bridges, lighthouses, and scenes of the Everglades—while others are cohered by a single color scheme, with such strong hues as purple, pink, and yellow dominating. Although Cunningham may have joked about working simultaneously on a series of paintings because he could repeat colors and thus save trips to the paint store, his concern for sustaining and developing ideas in groups of paintings cannot be written off as mere convenience or thrift.[92]

It is possible that the commission (circa 1950) of a now-lost series of pictures of Native Americans for the Michigan Historical Society encouraged Cunningham to think of his works in terms of groups of related ideas. Noted on the back of a photograph of one of the Mackinac Island paintings is the following statement signed by the artist: "20 of these was done for Mackinac Island, I have none of them now Thay sold for $250.00 each. Each was different."[93] This series may have provided Cunningham with a necessary incentive to think about his work on a grand scale and to develop as themes not only the Great Lakes but also Maine, Florida, Georgia, and South Carolina. Such series would not only give a range and a necessarily dramatic sequence to the museum, they would also allow Cunningham time to sustain and savor his imaginary journeys away from St. Augustine and the Over Fork Gallery.

On May 9, 1961, the artist received a letter of encouragement from Mrs. John F. Kennedy's social secretary, Letitia Baldrige, who wrote, "On behalf of

Mrs. Kennedy, I would like to thank you for your thoughtfulness in sending her your original painting 'The Everglades.' Since she is eager to encourage an interest in, and a development of, the Arts in this country, you can imagine her appreciation of your work."[94] Although Cunningham later told people that Mrs. Kennedy visited St. Augustine and acquired the painting *The Everglades* for $1,200, it appears from Ms. Baldrige's letter that the work was a gift from the artist. It is possible that Mrs. Kennedy or one of her associates who were then restoring the White House may have expressed interest in the painting, and thus Cunningham donated it to the White House.[95] Whatever the circumstances regarding its selection for the president's collection, the acceptance of the gift is indicative of the general high esteem for the vernacular arts in the early 1960s, when they began to reflect official American taste.[96] Mrs. Kennedy herself painted in a whimsical style reminiscent of self-taught artists.[97] And the president, who was proud of his naval experience, had assembled a notable yet modest collection of scrimshaw, which decorated his office. According to an article in *American Heritage*, Kennedy's "White House office was filled with reminders of the world of sailors and sailing ships . . . [and] in moments of great stress during the days of his Presidency, the doodlings his secretary found on his scratch-pad often tended to be sailboats."[98] Given the Kennedys' fascination with the vernacular arts in general and with sailing images in particular, it is conceivable that Cunningham's painting hung for a period of time in the president's office and that

the artist was correct when he attested that he had seen his painting on television behind the president and located in his office. After President Kennedy's death, this painting, together with other memorabilia and papers, became part of the John Fitzgerald Kennedy Library in Boston, Massachusetts.

The Kennedy acknowledgment was a source of great pride for Cunningham because it represented official approval and helped to alleviate some of the pain of being a marginalized eccentric in St. Augustine. Excited by this association with the White House, Cunningham collected news clippings of Jacqueline Kennedy for his scrapbook and relished telling the story of how *The Everglades* made its way to Washington. Having a painting in the White House encouraged Cunningham to continue contemplating the eventual acquisition of his entire body of work for a museum. And the thought of such an acquisition spurred him to continue to create ambitious series of new pieces.

For Cunningham to think of art in terms of a series instead of individual pieces is a sophisticated idea that connects him with such Romantic American history painters as Thomas Cole and such modern artists as Robert Motherwell and Frank Stella. While Cunningham may not have known the work of these painters, he could have become acquainted with the idea of series painting through the local artists with whom he began exhibiting in 1953 at the St. Augustine Art Association.

Also, during his youthful travels throughout the state of Maine and the Northeast, Cunningham would have had ample opportunity to come in con-

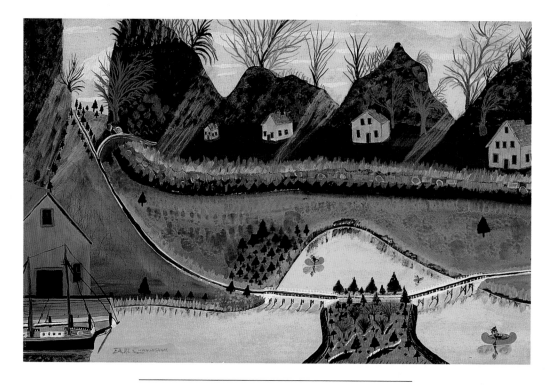

Morning Rays Through the Carolina Hills. *16 × 24″*

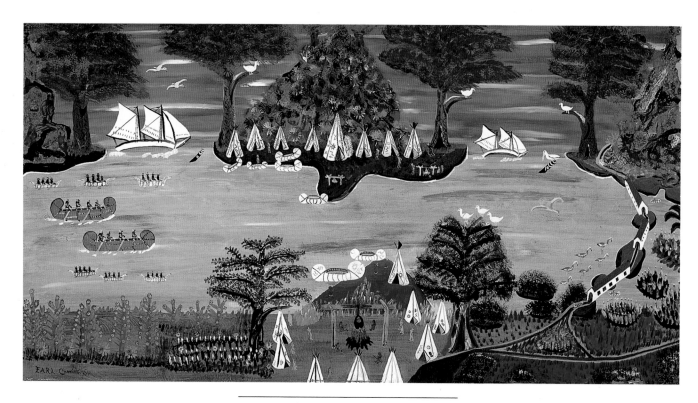

Visiting White Teepee Village. *22½ × 43″*

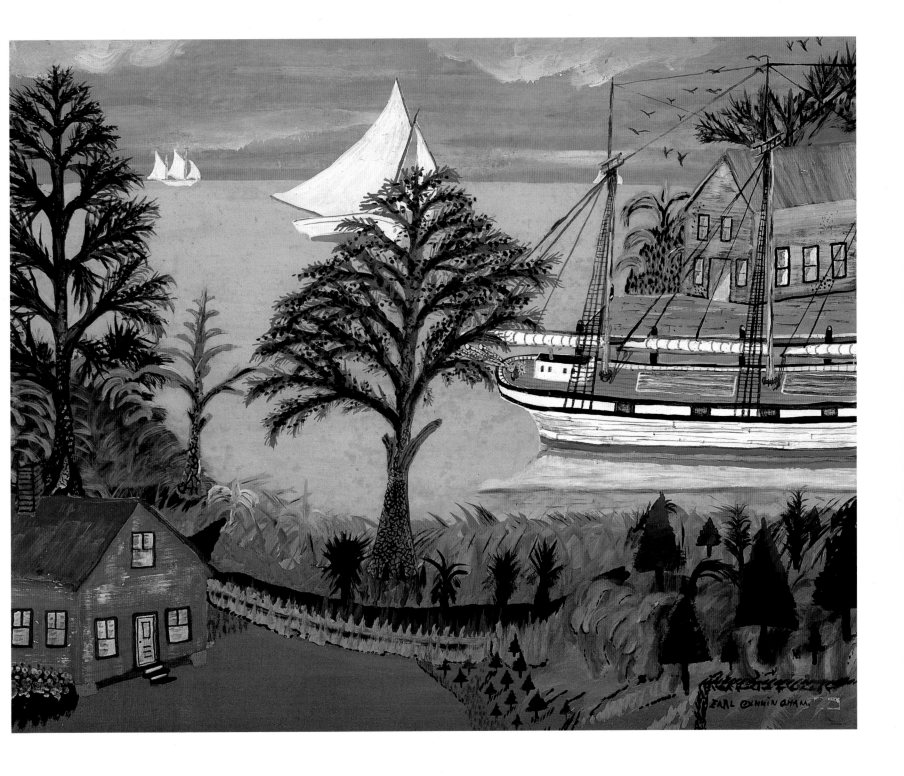

Etowah River Dock. *15×19"*

tact with a number of ideas about art, including working in a series, from the great number of contemporary artists who summered in Maine, in such artistic centers as Boothbay Harbor, Deer Isle, Monhegan Island, and Ogunquit. Since a number of these artists, particularly George Bellows, Edward Hopper, John Marin, and John Sloan, painted seascapes, the likelihood that Cunningham was aware of at least a few of them is increased. Cunningham's family home near Boothbay Harbor and Monhegan Island, which was reached by steamer from Boothbay, put him in close proximity to a number of important twentieth-century artists. It is conceivable that the presence in Boothbay of the Pennsylvania Impressionist Edward W. Redfield, who was known for his light, colorful landscapes and vigorous brushwork, had an impact on Cunningham. The activity of such painters as Rockwell Kent, Hopper, Sloan, and the Wyeths, who spent time in the area, might have influenced Cunningham's growing ambition as a painter.

Maine was the site for a major reevaluation of folk art. This art was first popularized in the teens and twenties by a group of painters and sculptors associated with the Ogunquit School of Painting and Sculpture, including its founder Hamilton Easter Field, its later director Robert Laurent, and such participating artists as Bernard Karfiol, Yasuo Kuniyoshi, and William Zorach, who traveled throughout the state collecting vernacular paintings, hooked rugs, ship figures, and weather vanes, among other objects. Because of their travels and because of his own wide collecting interests, Cunningham

might have had an opportunity to become aware of this new appreciation of the vernacular arts and to learn that he, too, was an "American Primitive," an appellation he used for himself.

Given Cunningham's penchant for traveling in the early decades of the twentieth century, he might have come in contact with art dealers similar to Isabel Carleton Wilde of Cambridge, Massachusetts, and Edith Halpert of New York City, who were the first to focus on the vernacular arts. Edith Halpert's initial visit to Ogunquit occurred in 1925 when her husband, Sam, a painter, joined the summer colony. She returned with both her husband and Holger Cahill, who had become interested in European folk art and who later curated important exhibitions of untutored artists' work for the Newark Museum (1931) and the Museum of Modern Art, New York (1932). Both Halpert and Cahill were intrigued with the American vernacular objects they saw in Laurent's home. In 1929 Halpert, who already operated the Downtown Gallery, which specialized in modern American art, opened her American Folk Art Gallery. To obtain works of art that would appeal to her illustrious clients, including Abby Aldrich Rockefeller and a number of Hollywood celebrities such as Irene Dunne, Halpert combed antique shops and barns in New England for the work of self-taught artists "not because of . . . antiquity, historical association, utilitarian value, or the fame of their makers, but because of their definite relationship to vital elements in contemporary American art."[99]

Because of his proud acceptance of the "Ameri-

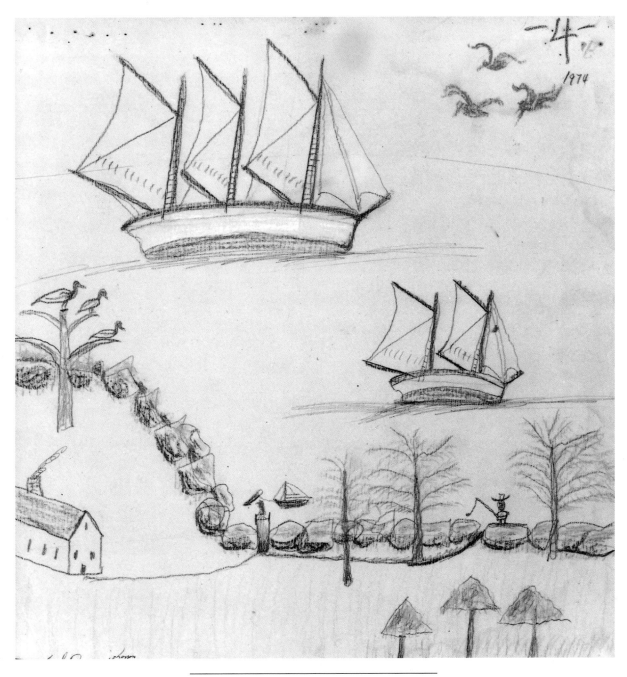

Two Vessels. *1974. Graphite on paper, 15×12"*

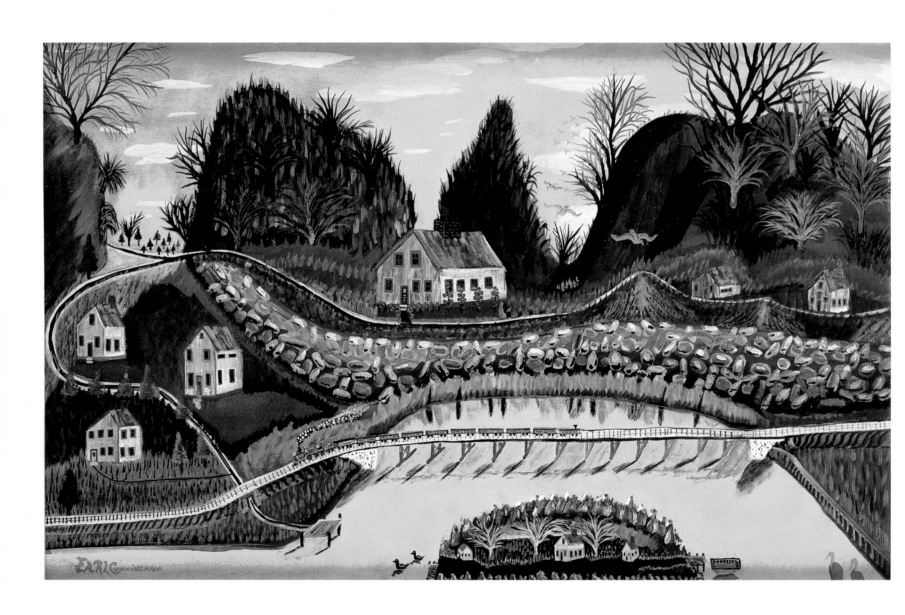

Valley Freight Train. *16×25½". Abby Aldrich Rockefeller Folk Art Center, Williamsburg, Virginia*

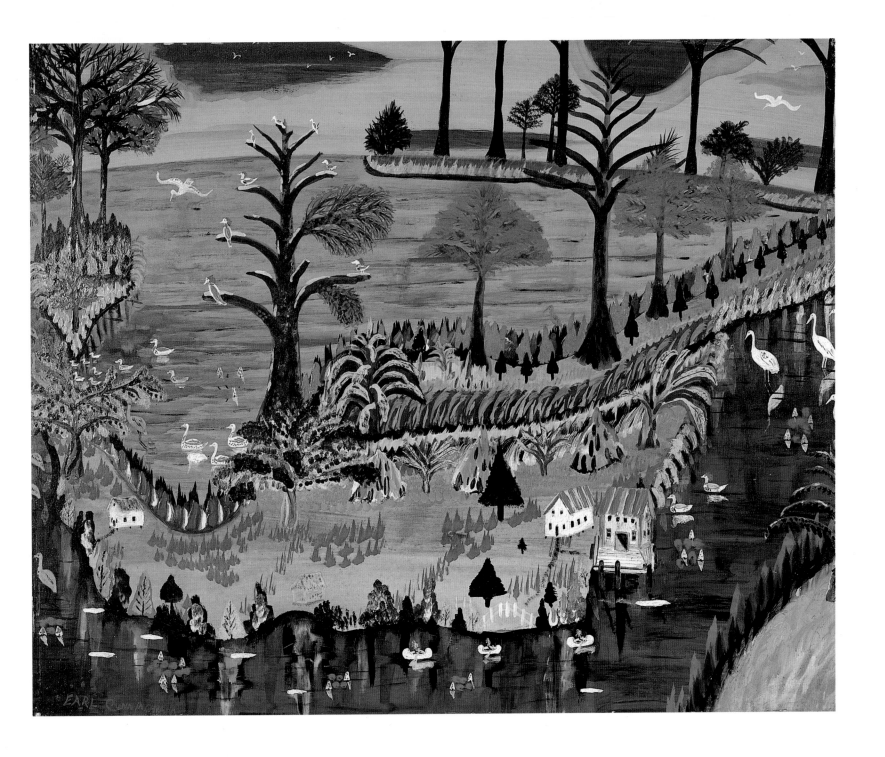

Everglades Settlement, Dawn. *20×24". Private collection*

can Primitive" designation, Cunningham may have had some contact with the sophisticates who were beginning to appreciate the vernacular arts. Although they were primarily interested in nineteenth-century art, their respect for the genre in general would have validated his efforts and encouraged him to continue his artistic pursuits. This appreciation might also be a contributing factor to Cunningham's initial plans for his museum, which began about this time.

Although the vernacular arts are usually considered apart from mainstream art history, they partake of its realities. Even if these arts aspire to a universal and timeless realm as the above discussion of their Platonic aspects has suggested, they are created at specific times and are subject to some of the same aspirations and concerns of mainstream culture. Cunningham, for example, began painting around 1906 and established a recognizable style in the post–World War I epoch, when the United States underwent a number of profound transformations, including changing from a rural to an urban nation. By 1920, when he began to travel regularly from Maine to Florida, over half the American population lived in large cities. In addition to the growth of American cities, the country was caught up in a mood of isolationism and a desire to reintrench itself in its own past. Both these profound changes had the effect of encouraging writers and artists, including Cunningham, to become nostalgic about the past and to explore their American roots. On the front page of its July 1926 issue, the *Saturday Review* acknowledged the boom in Americana

as a "national industry."[100] The anonymous author of the cover essay elaborated on this industry in the following way: "There are almost as many 'antique' signs in Connecticut as gas stations, and it is impossible to guess at the millions which have been spent in refurnishing ornate Louis XIV houses and apartments with plain but far more costly American pine and maple."[101] According to the folk-life scholar Eugene W. Metcalf, Jr., Americans in the 1920s relished new products which industry could produce, but they were deeply afraid of becoming standardized themselves. Metcalf believes that folk art became popular at this time because it played an important compensatory role in preserving simple, bygone values.[102]

Cunningham may have internalized some of the values of the antique dealers, collectors, artists, and old-timers with whom he came in contact and then incorporated their nostalgic and retrospective view of America in his art. Thus, Cunningham was not simply a passive reflector of his childhood world: in fact, he may have been participating in the same type of reevaluation of the nation's past that intrigued his contemporaries. Such a hypothesis gains credence when one compares the iconography of his paintings with that of nineteenth-century artists.

A compelling comparison is a painting by Leila T. Bauman entitled *Geese in Flight* of around 1860. This work contains many of the same basic iconographic features that occur in Cunningham's art: a house, a train, a canoe, sailing vessels, and a steamboat. In addition there is a carriage, small figures in

the foreground, and a flock of geese flying in a prominent V formation, symbolizing harvesttime and the approach of winter. The entire painting symbolizes reaping the fruits of the American wilderness, a common theme in American art beginning in the 1840s, when the image of the United States as the biblical promised land was invoked. Important to the Bauman, as to most Cunningham paintings, is the peaceful coexistence of the rural and the industrial worlds that occurs on both land and sea.

Given the great number of similarities between the Bauman and Cunningham paintings, one might hazard an influence of the earlier work on the later one. But there is no need to establish a definite connection between the two artists because one can point to the general trend in nineteenth-century art that extolled new inventions and placed them in the landscape as part of the vast harvest of human industry. When Cunningham makes some of these elements, particularly sailing vessels, trains, steamboats, and canoes, the mainstay of his art, he reaffirms nineteenth-century optimism and frames it in the universal and transcendent format of vernacular painting. In doing so he supports the revivalist and isolationalist view of his contemporary world. Although this theory might seem to ascribe a great deal of self-consciousness to Cunningham, he did not need to be conscious of it in order to enact it in his art. Since the visual arts are nonverbal, they allow artists to free-associate with a relatively wide range of culturally encoded images.

Although Cunningham probably did not know Bauman's *Geese in Flight*, he may have seen works with similar subjects such as Currier & Ives prints. Among the material left in Cunningham's studio at the time of his death were the captions for one of The Travelers calendars featuring Currier & Ives images that he had removed from the pictures. Since The Travelers company published several Currier & Ives calendars during the 1940s, Cunningham may have enjoyed a daily acquaintance with these images for a number of years. Although his ostensible purpose in cutting up these calendars might have been to use the pictures in Victorian frames as many antique dealers did, the subjects of these illustrations were of great importance to Cunningham's art. Since Currier & Ives prints were readily available and inexpensive early in the century, Cunningham may have been acquainted with originals. The many subjects depicted by the Currier & Ives firm included some fifty images of railroad trains, more than thirty prints of Robert Fulton's early steam-propelled vessel called *North River Steamboat*, about seventy-five images of clippers, and at least seventy lithographs dealing with the sport of yachting, and twenty or more devoted to vessels participating in the America's Cup races. Originally sold by push-cart vendors and backpack peddlers working in New York City and such neighboring cities as Brooklyn and Hoboken, Currier & Ives prints reproduced works by A. F. Tait, George H. Durrie, Louis Maurer, and Fanny Flora Palmer, among others. Both the range of artists working for the firm and their breadth of subject matter would have given Earl Cunningham the opportunity to carry on an exten-

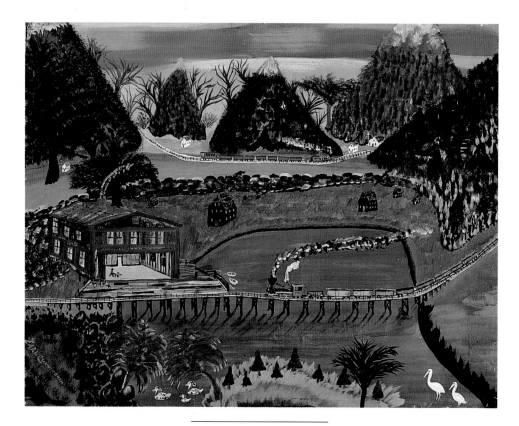

Mountain Trains. *16×20"*

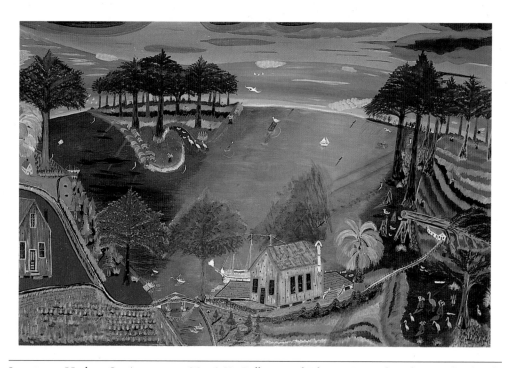

Imaginary Harbor, St. Augustine. *30×36". Collection of John H. Surovek, Palm Beach, Florida*

sive dialogue with nineteenth-century ideas and with a series of images that came to be regarded in the twentieth century as quintessentially American.

Currier & Ives's gentle and optimistic reveries enjoyed a tremendous resurgence of popularity in America beginning in the 1930s, when they came to epitomize the isolationist aspirations of the country and helped to alleviate the painful realities of the Great Depression. While Grandma Moses used these prints to create ingratiating rather than stark images of the past, Earl Cunningham may have employed them as aids in forging his symbolic view of a halcyon America. His patriotism, evident in the many flags decorating his seaworthy vessels, is concerned with America's self-renewing potential attainable through periodic returns to its roots. The manifest destiny so important to nineteenth-century Americans, who understood it as God's sanction for their march across first the continent and later the world is reinterpreted by Cunningham as a retreat to a vital past. He considered progress a return to the past rather than a move to the future, and manifest destiny in his hands becomes not only destiny manifested but also destiny reinvigorated with a large dose of its early optimism. When using for his own art such popular nineteenth-century subjects as those found in Currier & Ives prints, Cunningham gave new meaning to a set of well-worn ideas and enlarged upon his own personal dream, making it a cultural dream. In the process he affirmed tradition and provided it with a distinctly new and authentic voice by aligning it with his own vernacular style. And as he idealized his childhood through these

culturally encoded symbols of the nation's youth, so his fantasies become potentially meaningful images to the nation at large.

Even though his art participates in the Regionalist trend that first became important in the visual arts in the 1930s, he is similar to Thomas Hart Benton in mixing codes so that a simple and straightforward translation of the meaning of his art is impossible. Both artists infused a Regionalist and populist subject matter with aspects of a modernist and implicitly elitist style. In Benton's case, Synchromism provided a structure for his popular and traditional subject matter. But whereas Benton was self-conscious about his early experience with modernism, which continued to inform his art despite his efforts to eradicate it, Cunningham most likely had never heard of Fauvism and was unaware of his modernist connections. When he took degenerated Fauvist ideas used in Disney cartoons and commercial advertising and reinforced them with lessons learned from intensely colored Currier & Ives prints, garish nineteenth-century chromos, and twentieth-century retouched postcards, his completed works of art reframe all his sources within an artistic context and thus emphasize painting and Fauvism over the more popular and prosaic sources. And thus his works seem to recast Matisse's and André Derain's dreams of a golden age into an American vernacular. Similar to them, he used such modernist means as saturated colors to heighten his recapitulations of the past.

Even when Cunningham's views of the past appear at best whimsical and at worse quirky, they

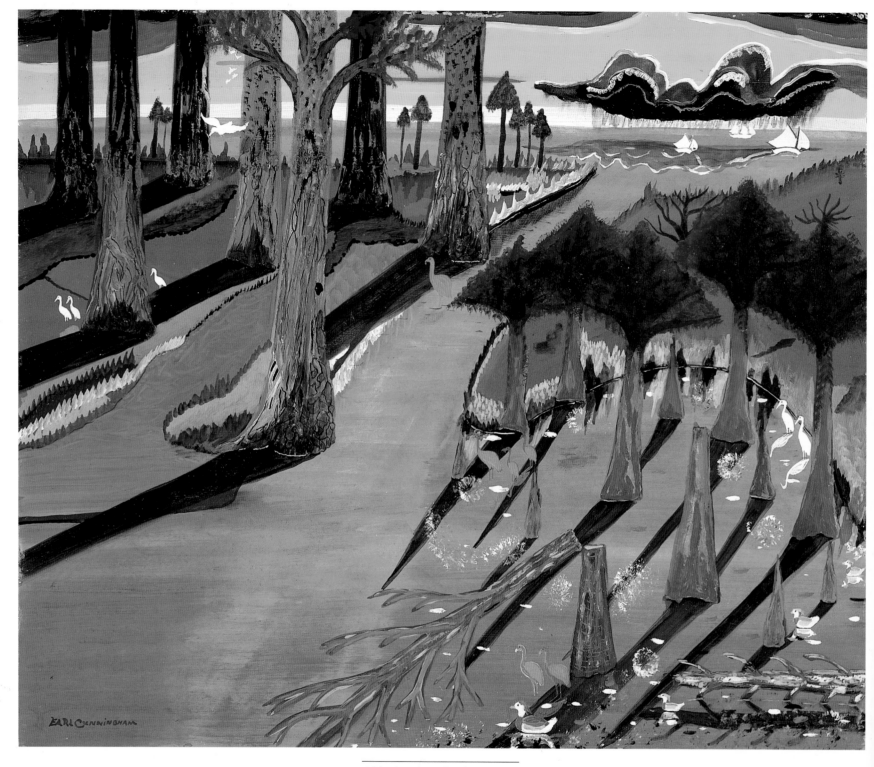

Old Thunder Cloud. *20×24″*

Old Thunder Cloud *(detail)*

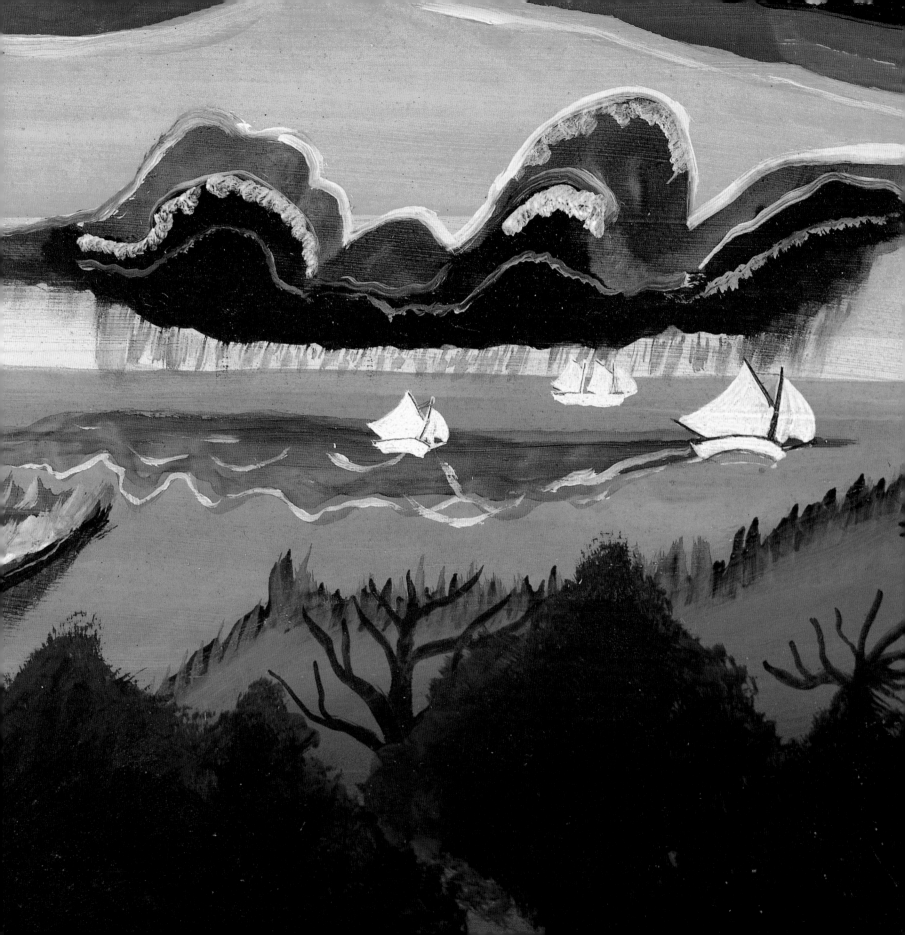

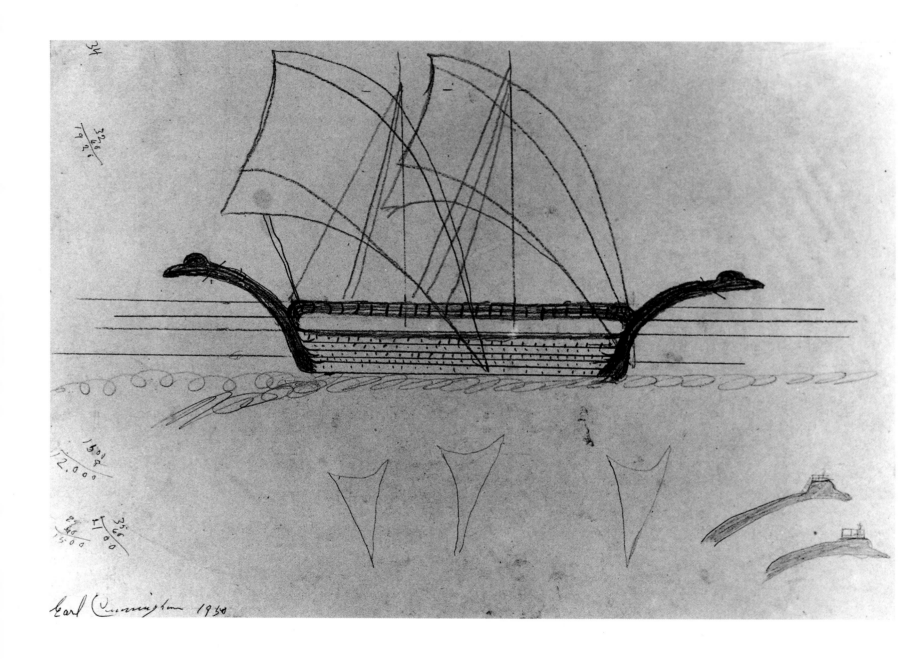

Norse Ship. 1950. Charcoal on paper, 10×16″

need to be taken seriously and considered in conjunction with the rest of his work. Probably no single element of his art has elicited as much bemusement as has the inclusion of Norse ships in his compositions. Ketchum has recommended that the role of these ships in Cunningham's art be relegated to a whimsical gesture. Although Ketchum admits that they might have a source in popular movies or magazines, he concludes that vernacular artists "are not troubled by . . . inconsistencies, nor do they employ them the way an academic artist might . . . for shock value or to teach a lesson or whatever calculated reason. From his point of view he simply wanted to paint this particular work with a Viking longboat in it."[103] Ketchum's estimation of film or magazine illustrations as possible sources for the Norse ships would be plausible if Cunningham had begun painting them in the late 1950s. In May 1958 five sixty-nine-foot Norwegian-built replicas of Viking ships sailed into the New York harbor to rendezvous with Norway's liner *Stavangerfjord* near the Statue of Liberty. The vessels, which are amazingly similar to those appearing in Cunningham's paintings, had been used in the 1958 film epic entitled *The Vikings*, in which Kirk Douglas and Tony Curtis played leading roles. Although this film and the publicity surrounding both it and the arrival of these vessels in New York City might have interested Cunningham, he had already begun to include Norse boats in his paintings by the 1930s. Also, it should be pointed out that only on a few occasions did Cunningham depict Viking ships: one small work, for example, pictures them surrounded by

fjords. Mostly Cunningham was interested in the Western Scandinavians known as Norsemen, who explored the American coast, and he was not intrigued with the marauding Vikings who wrecked havoc on the European coasts from the eighth to the tenth century.

Cunningham's use of Norsemen might seem less arbitrary if one considers the popular New England folklore about Leif Eriksson and his crew of thirty-five, who headed south from Greenland, explored the coast from Newfoundland to southern New England, and spent the winter on an island named Vinland, which may be Martha's Vineyard. Further expeditions made attempts to colonize the new land. On the ledges of Manana Island, which is approached by steamer service from Cunningham's childhood home in Edgecombe, are unusual marks—scratches four feet long and six inches wide—that many people during Cunningham's lifetime considered to be absolute proof that Norsemen visited the island about A.D. 1000. The presence of these marks and the ensuing belief that they were left by Norsemen no doubt profoundly affected Cunningham and are a factor in his inclusion of Norse ships in his paintings. Since the ocean was the first means through which Europeans came in contact with the Americas and since the Norse were the first known European explorers of this area, Cunningham's reference to them in his paintings is consistent with his overall focus on the sea as America's initial melting pot of different cultures.

Crucial to this American genesis is not only the European experience but also that of Native Ameri-

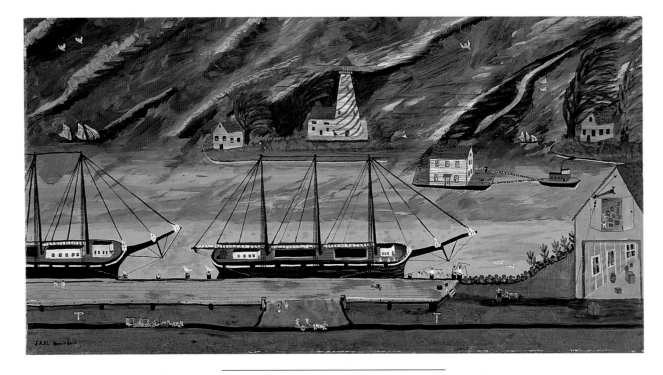

Approaching Squall at Boothbay. 23 × 43″

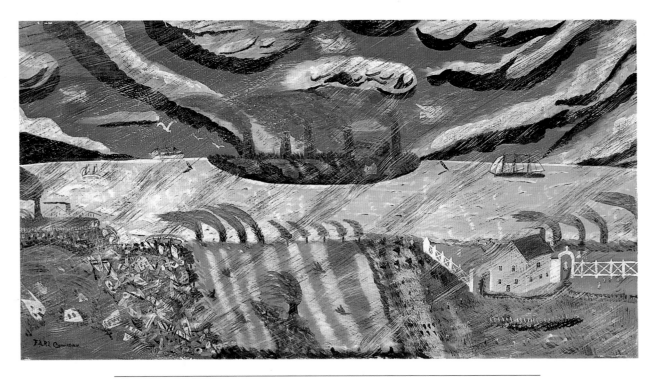

Hurricane. 22¾ × 42″. *The Museum of Arts and Sciences, Daytona Beach, Florida,
Gift of Kenneth Worcester Dow and Mary Mohan Dow*

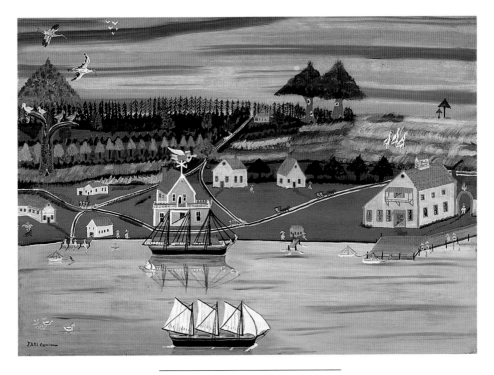

Big Pines Harbor Village. 27×37″

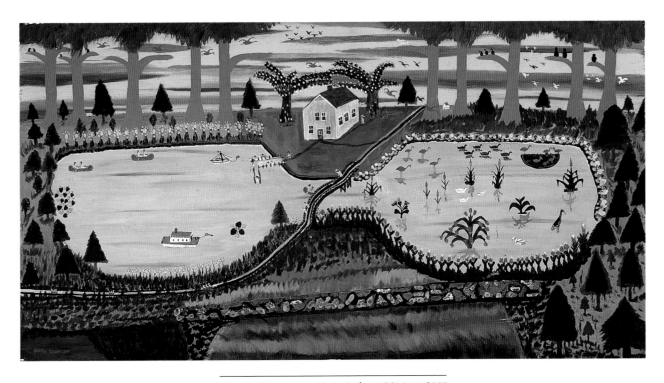

Dream House on Twin Lakes. 22¾×42¾″

cans who appear in many of Cunningham's paintings. He felt an affinity with Native Americans and was fond of saying that he had spent time in the Everglades with the Seminoles. Whether or not he really lived with them, he was fascinated by them and depicted them in a number of important paintings, such as *Seminole Village Deep in the Everglades* and *Seminole Indian Summer Camp*. He no doubt knew that they had been incarcerated during the Seminole War (1835–42) in Fort Marion (known earlier as Fort San Marcos), located in St. Augustine, and thus could appreciate how they had suffered. A postcard of a Seminole wedding in Miami, Florida (circa 1950s?), that was in the artist's collection contains the following information:

> *The Seminole Indians, natives of the Everglades, now number only about 700. They are a most peaceable lot of folks and watch the pale faces amuse themselves. They dwell in villages in the winter near Miami, which are among the attractions for visitors. In the summer they load their canoes and paddle back to their virgin hammocks, miles from civilization.*[104]

It is the Seminoles in the Everglades, far from the inroads of civilization, that Cunningham chose to paint.

Cunningham was also intrigued with prehistoric Native-American cultures. From 1922–25 he spent several weeks and possibly even months of each year in the region of the Etowah mounds, which are located near Cartersville, Georgia. On the back of a

snapshot of an early stone relic, Cunningham noted that he found many similar items at these mounds. From his description of employing a group of Negroes going side-by-side through the woods and putting their finds in their aprons, it appears that his time in Georgia overlapped with that of Warren K. Moorehead, director of archaeology at Phillips Academy, who explored the mound area from 1925–27. Even if he worked only a short time with Moorehead, Cunningham would have gained an appreciation for early Native-American cultures and for their highly sophisticated ceremonial art, and thus his rejection of this information in his art is significant.

Although he had firsthand knowledge of Native-American art, Cunningham was largely unconcerned with portraying Native Americans with historical accuracy in his paintings. One exception is his detailed depiction of the high, curved-back birchbark canoe that offers protection against the tremendous waves of the larger lakes and also the oceans. But when he shows, as he often does, these canoes in streams and on small ponds where they would have been inappropriate, he disregards historical truth. And even though he often includes representations of true traditional Seminole dwellings called "chickees" and at times depicts the Seminoles in the appliquéd garments that they adopted after 1900, he also shows them living in teepees with elaborate pictographic decorations, which were only used by Native Americans in the West. In a Cunningham painting, Seminoles are as likely to row the birchbark canoes of Woodland peoples and sport

Earl Cunningham in Georgia, August 17, 1922

Plains-style feathered bonnets as they are to appear in their own native costumes, guiding their scows through the brown-colored waterways stained with tannin from cypress and other trees that thrive in parts of the Everglades.

While Cunningham's lack of concern with historical precedent can be chalked up to disregard, it cannot be ascribed to naiveté. Because tribal distinctions among the Native-American groups found in Maine disappeared long ago and because these groups catered to tourists by adopting manners and costumes entirely foreign to them, Cunningham may have felt a similar freedom to create generic Indians in his paintings. His work was made shortly after a period of Pan-Indianism—roughly the end of the nineteenth century and beginning of the twentieth century, when Wild West shows modeled on Buffalo Bill Cody's outdoor extravaganzas became

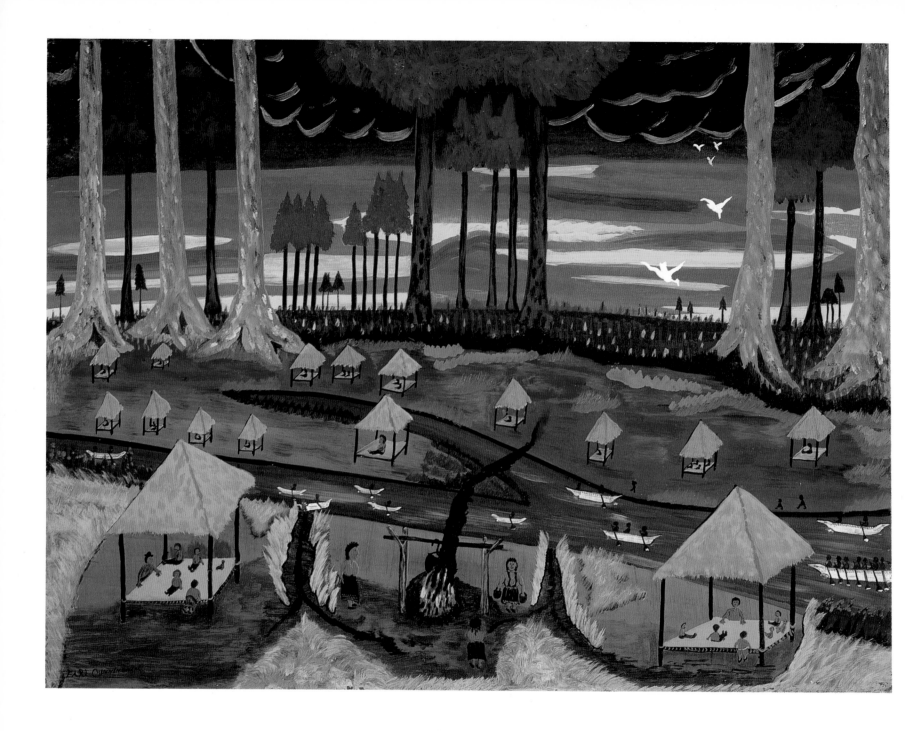

Seminole Village Deep in the Everglades. *20¾ × 26⅞"*

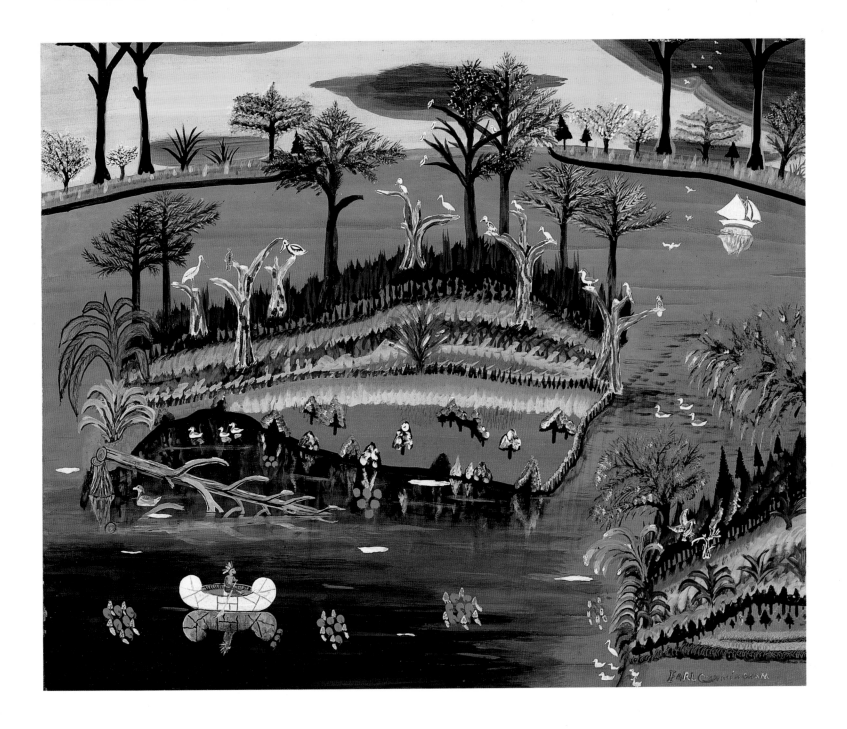

Island Farm. *21½×26"*

120

popular. At this difficult time in their history, many Native Americans were adjusting to life on reservations. They began associating with other tribal groups at these Wild West shows and at powwows where a shared identity, indicated through a generalized Plains-style dress, represented their disenfranchised state and desire to reclaim some of the earlier heroism and romance associated with being Native American. Since Cunningham represents aspects of this Pan-Indian culture in his paintings, he may have intuited this dress as a clear sign of their chosen generic status and romantic yearnings and used it accordingly to emphasize the symbolic, categorical role that Native Americans play in his paintings.

Although Cunningham's compositions might seem arbitrary because of their novel juxtapositions or proliferation of objects, they are actually highly selective. He took pride in the great amount of detail he painted in his works, even bragging to Uelsmann that a particular painting had over 140 figures in it.[105] He owned a book full of statistics and delighted in its myriad detailed facts by asking friends if there were more living creatures bigger or smaller than a dog and bigger or smaller than an ant.[106] But his art is not all-inclusive, as the discussion of Norse ships and Native Americans has shown. He had a clearly established, if unarticulated, criterion of what to include in his art. In his works he painted numerous birds but only occasionally included other creatures, such as rabbits, turtles, and alligators. Considering that a short distance from his shop on St. George Street there was a natural history museum with monkeys, reptiles, and

fish, as well as live and mounted specimens of birds, his emphasis on birds is significant. He was knowledgeable about birds and painted many different varieties of them, including the following, which are frequently seen in Florida: anhingas, cormorants, wood ducks, bald eagles, flamingos, geese, sea gulls, great blue and great white herons, glossy ibises, limpkins, screech owls, brown and white pelicans, rosette spoonbills, wood storks, and both black and turkey vultures.[107] Not only birds but also specific regions of Florida are differentiated in his work, including fresh- and saltwater marshes, cypress swamps, and coastal prairies. While he carefully depicted specific regions in Florida in his art, his paintings of Maine are more generalized renditions of the coast.

Even with the great amount of specific detail in his paintings, Cunningham maintained a pervading interest in ways that objects function as symbols, and for this reason he subsumed details under the general interaction of land and sea. Traditionally, the sea symbolizes mobility, change, and freedom. It is an open-ended sign full of possibilities, limited in the visual arts only by the horizon line or by land. The harbor often takes on the biblical overtones of a safe refuge. Although essentially safe, this harbor in Cunningham's art is still subject to the strong winds that cause the sailing craft to heel, revealing their red hulls. And land in this equation is usually an adjunct to the harbor. In Cunningham's painting the openness of the sea is held strictly in check by the surrounding land. In his imaginary world, islands safeguard harbors by keeping the ocean within man-

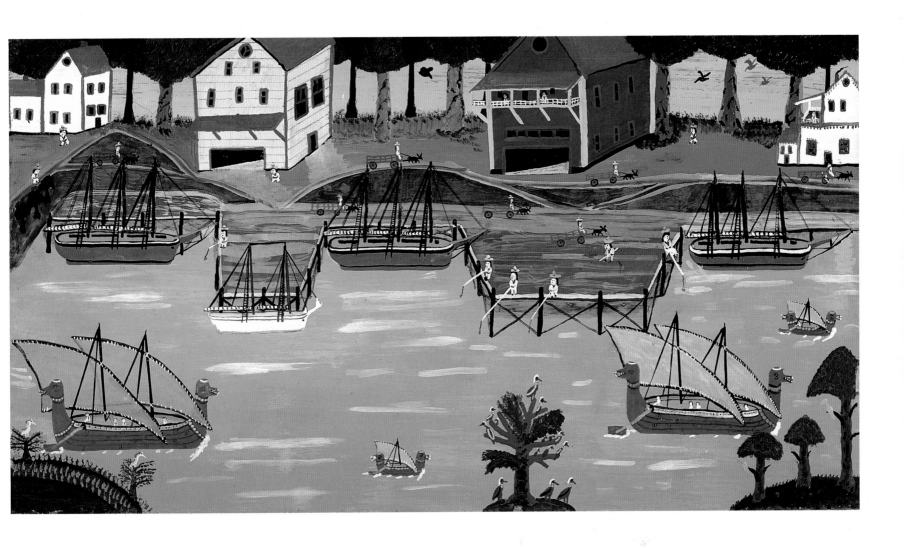

Crowded Marina. *20¼×30″*

ageable limits. One could thus argue that Cunningham is a painter of harbors rather than the sea, since the comforts and security of this area are important to him. As art historian Roger Stein has pointed out in his important study of American marine painting, to culminate a seascape with land on the horizon is to signal an inhabitable space.[108] In a similar manner a foreground area of land in a marine painting contains, controls, and limits the view of the sea: it makes the sea subservient to it. Such views occur often in Cunningham's oeuvre. Rarely does he present the sea without some protective land barrier.

Throughout his life Cunningham was in close proximity to lighthouses, and it is not surprising that they occur frequently in his art. He knew such important Maine lighthouses as the Pemaquid Light and the Two Lights at Cape Elizabeth, which Edward Hopper painted in the 1920s. In Florida, Cunningham lived near the St. Augustine Lighthouse (erected in 1874), which rises to a height of 165 feet and is visible from twenty miles at sea. From the same site as this later lighthouse, Sir Francis Drake saw a Spanish signal tower in 1586. Because of their long tradition, their role as guides in storms, and their Christian associations as beacons of faith, lighthouses are significant elements in Cunningham's art. Although his barber pole–striped lighthouses appear to be figments of a wonderfully active imagination, such structures actually exist in Hope Town, which is located in the Abaco Islands in the Bahamas. Considering their prominence in his paintings, it is possible that Cunningham made a foray there early in his life.

In addition to culminating his marines with lighthouses, Cunningham at times depicted Gabriel weather vanes in his compositions. Painted after wooden cutouts he made in his studio, these images have a source in a metal weather vane that Cunningham inherited from his father. Situated prominently in his paintings, the Gabriel weather vanes are polyvalent symbols that reinscribe the values of the past and the importance of the vernacular art tradition at the same time that they symbolize the Annunciation—the Christian metaphor for the inception of spiritual values in everyday life.

The Gabriel weather vanes also reinforce the overall orientation of these paintings as peaceable kingdoms—images of a national renewal symbolized through harmonious relationships between disparate groups of people from different times. In addition to the figures of Gabriel, the great proliferation of birds in his art strongly suggests that these meetings are divinely provident.

Cunningham's peaceable kingdoms share affinities with the more than one hundred paintings on the subject undertaken by Edward Hicks beginning in the 1820s. This connection with Hicks was first alluded to by the critic Robert L. Pincus in his review for *The San Diego Union*.[109] Hicks's paintings were inspired in part by the prophecy in Isaiah 11:6–9, regarding a child who would lead fierce and defenseless animals into harmonious coexistence. This prophecy, which has long been thought to foreshadow the coming of Christ, can be considered the Quaker counterpart to Cunningham's Gabriel weather vane because both of them are symbols

Archangel Gabriel. *Watercolor, 15×21″*

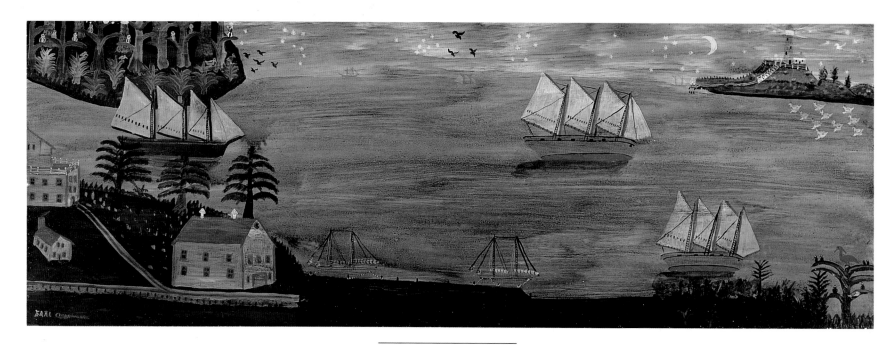

Midnight Cruise. *17×48″*

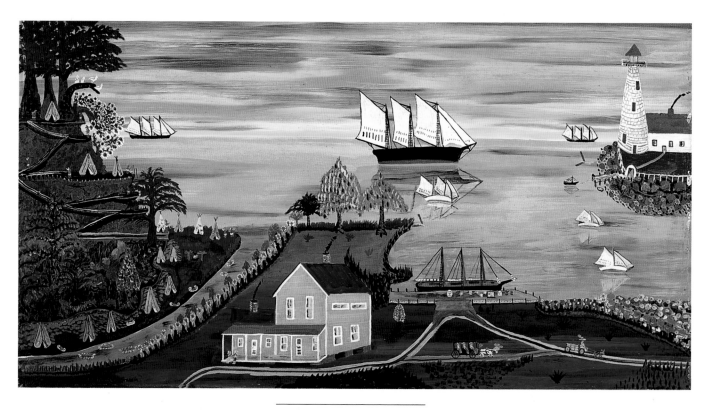

Lighthouse Cove. *22³⁄₄×43″*

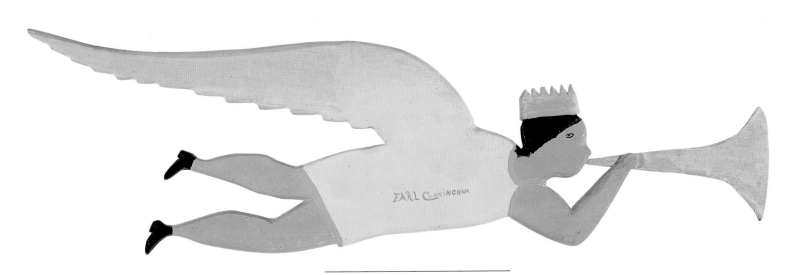

Archangel Gabriel. *Wood, 13×36″*

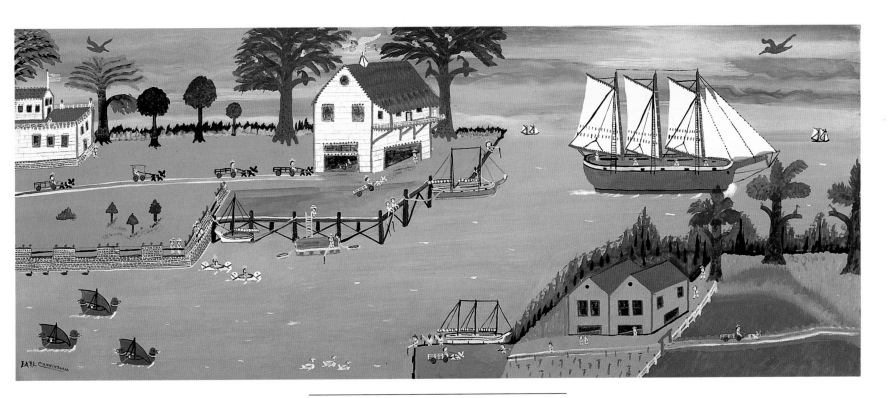

Gabriel Overlooking Boothbay Harbor. *30×56″*

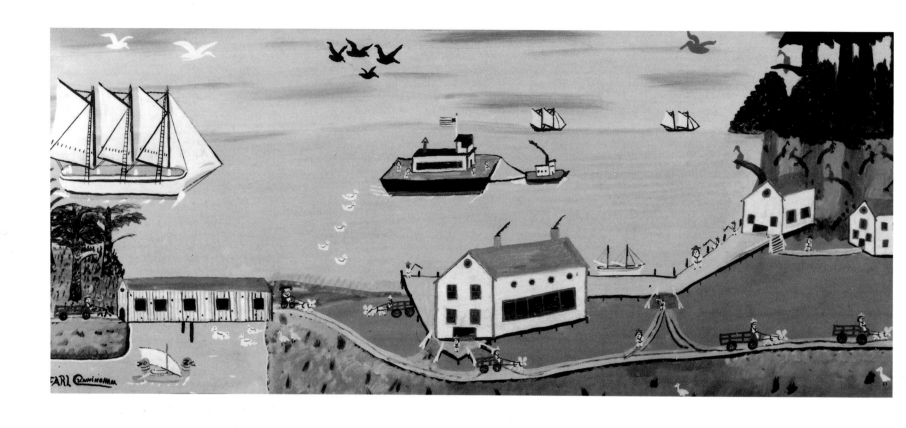

Bustling Village. *15½ × 36". New Orleans Museum of Art, Gift of Marilyn and Michael Mennello*

foreshadowing Christian redemption. In a number of his works Hicks commemorated William Penn's famous treaty with the Indians. Instead of a treaty, Cunningham shows Native Americans in close proximity to Norsemen and mainstream nineteenth-century Americans. A member of the Society of Friends from his youth and a preacher from 1812, Hicks became involved in the controversial Separation of 1827 that occurred when the Hicksite faction, which was named for his second cousin Elias, broke away from the society.[110] In many paintings, Hicks may be characterizing this faction as the only living limb on the dead tree of Quakerism. Or the tree could be a conflation of the tree of life/tree of death theme important in Christianity. This same motif occurs in several paintings by Cunningham, such as *Everglades Settlement, Dawn*, in which the artist took its form but not necessarily its meaning. In his work the living limb sprouting from a dead tree might be a symbol of regeneration—perhaps even an unconscious yearning for self-regeneration. While any such reading is of necessity conjectural, the coincidences between the two place Cunningham in the following group of twentieth-century vernacular artists who revived Hicks's schema: Horace Pippin (who made four peaceable kingdom paintings), Victor Joseph Gatto, Frank Bortlik, and Jack Savitsky.[111]

Occasionally in Cunningham's halcyon realm a note of tragedy appears in the form of fallen trees. Since these trees, which assume an almost identical form in several paintings, have been sawed rather than destroyed by lightning or slow decomposition

as have some of the stumps in paintings such as *Marsh Birds*, they point to human destruction as the major element of discord in otherwise paradisiacal scenes. This image of a sawed stump together with a fallen tree places Cunningham at the end of a well-established nineteenth-century tradition made up mostly of second-generation Hudson River painters who presented cut trees and prominent stumps as ambiguous symbols of progress. As with other nineteenth-century references, Cunningham could have learned of this concept from looking at Currier & Ives prints rather than the work of such artists as George Inness. In Cunningham's works the pristine appearance of the cut trees and the polished surfaces of the paintings in general endow them with a mythic quality of inevitability—a quality heightened by the bird that is prominently positioned on its trunk. In this manner Cunningham reconfigures the accidental so that it resembles a recurring ritual.

Even with the discordant note of the fallen tree, Cunningham regarded his paintings as safe harbors for his long-anticipated and yet never acquired houseboat.[112] In several works he provided careful depictions of this vessel, which is essentially a barge with a superstructure built as a houseboat. The cabin is covered with canvas, which would have been adequate for Florida's warm climate, and it is equipped with lateen, or triangular, sails fore and aft. On each side of this flat-bottomed boat, he projected leeboards going straight down into the water to stabilize the structure. Since no propeller is evident, he may or may not have had an engine for his dream barge. But he could have had a small engine

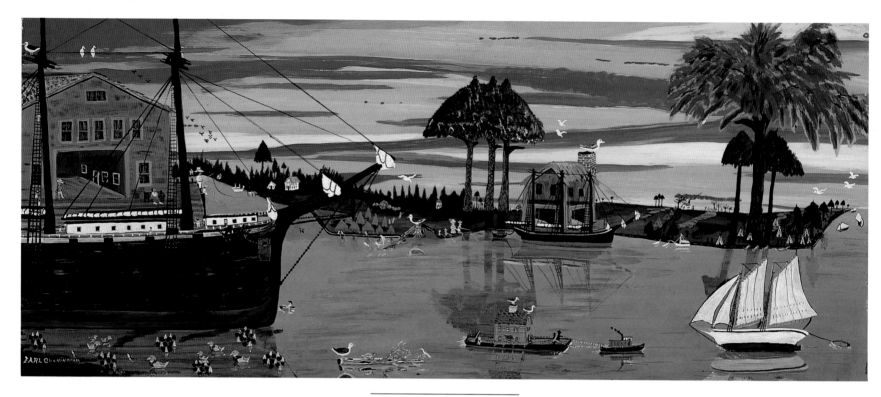

The Twenty-one. *17 × 40¾"*

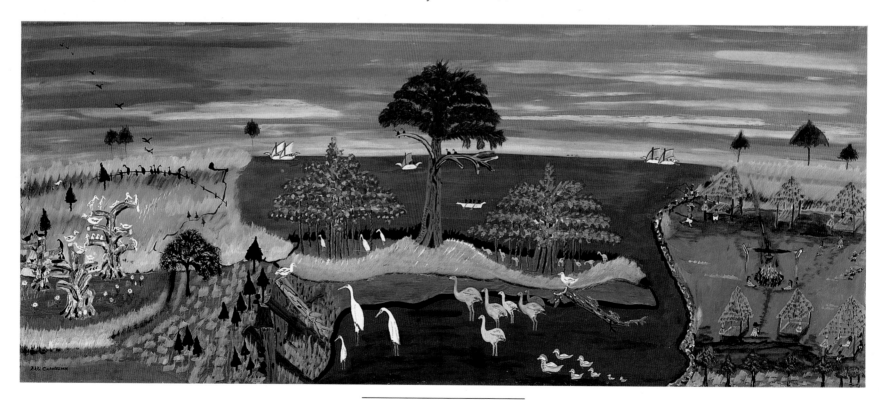

Banyon Tree Camp. *17 × 40½"*

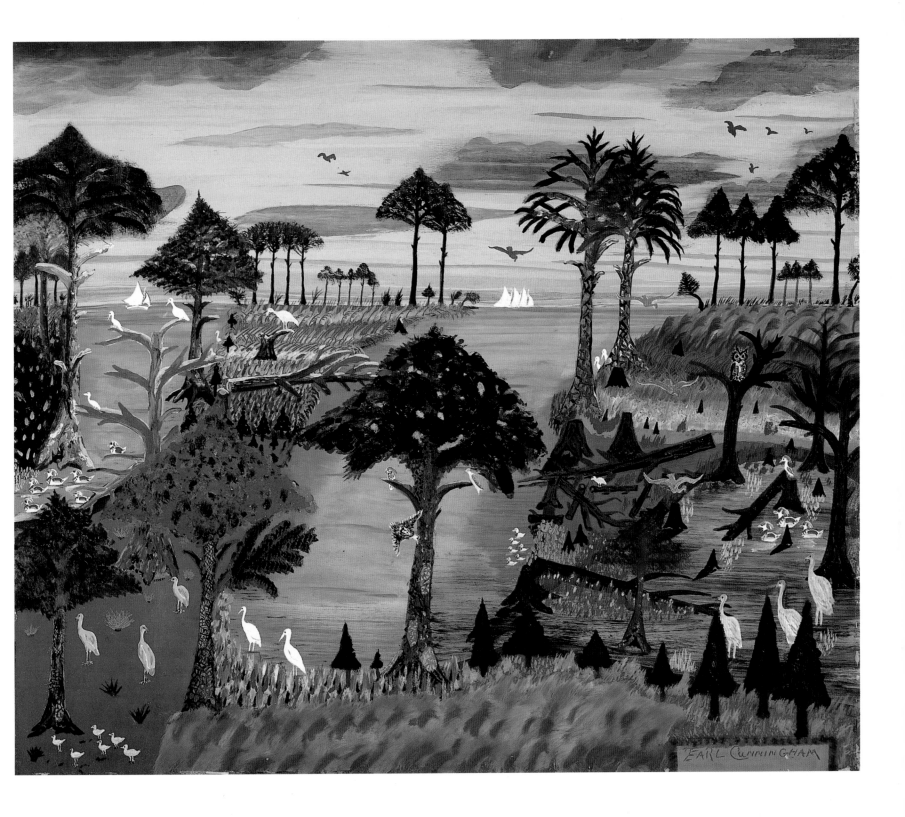

Sanctuary. *21½×26″*

connected with the prominent chimney, which would serve as an exhaust. Inside the boat he probably had a steering wheel connected with a rudder. In one painting, *Houseboat at Oyster Key*, he shows an attractive redheaded woman walking beside the barge. Nearby, clothes, including his own long johns, are drying on the line. In other paintings the barge is docked along inland waterways. One of his scenes of hurricanes may be intended as a depiction of his houseboat, but if it is, the boat differs significantly from his other portrayals of it.

In the history of vernacular art Cunningham's paintings of hurricanes are remarkable but not unique. They can be compared with Henri Rousseau's painting *Surprise (Storm in the Forest)* (1891) and with Grandma Moses' *The Thunderstorm* (1948) and *Taking in Laundry* (1951). As with the Rousseau and Moses paintings, Cunningham's works challenge the limits of vernacular Platonism, for they break apart the conventions of realistic painting while maintaining the quality of a specific event. This series, including such works as *The Big Storm* and *Hurricane Warning*, may relate to the hurricanes that hit Florida beginning with Hurricane Donna in 1960, Cleo in 1964, followed closely by Dora, which struck St. Augustine with 125-mile-an-hour winds between August 28 and September 16 of that same year. While the element of time is an important component in these works as in many of Cunningham's paintings that depict dawn, sunset, evening scenes, approaching storms, and clearing skies, the overall effect is more cyclical and thus thematic. This cyclical quality connects his art with

vernacular Platonism. Although it is less apparent in the storm series than in other works, the schematic houses and figures in the hurricane paintings help to disembrace these works from particular events and translate them into a transcendent and timeless realm.

In conclusion, this study has made the following assumptions:

1. Simplicity of form does not equal simplicity of subject and thought, and childlike form does not necessarily connote naiveté.
2. Even though vernacular artists are untaught and marginalized, they are not necessarily ignorant of mainstream culture and its traditions.
3. Marginalized art relates to more than a marginalized culture: frequently this art stresses values that the dominant culture lacks, thus providing an implicit critique of it.
4. While nostalgia needs to be carefully considered, it is not an accurate re-creation of the past. Because nostalgia is so clearly conditioned by contemporaneous circumstances, it is a culturally constructed code.

When considered together, these four attitudes toward vernacular art comprise a new means for evaluating Earl Cunningham's work. Although his painting is highly individualized, it is a mediated vision that relates to a long and rich series of traditions, such as nineteenth-century American art and international modernist painting trends. In addition

it responds to such contemporary issues as the isolationism of American culture between the World Wars, and the rising appreciation of the vernacular arts in the twentieth century. Whereas some artists create viable images of the future, Cunningham has reconceived the past as a halcyon realm wherein the American genesis is ritualistically reenacted. Even though his vision is mediated by its culture, it is highly charged, as is the work of many self-taught artists who work with intense beliefs and often great needs to reify their dreams. In his art Cunningham reinvigorates clichés, imbuing them with conviction, and thus causes people to see already familiar and at times hackneyed cultural norms from a fresh point of view.

More than a mere treasure trove of his own past experiences, Cunningham's museum of memories is a qualitative reconception of them. His art is an alembic for distilling not only his own life but also his understanding of America's past. The result is a collection of compelling metaphors of regeneration attained through a harmonious meeting of differences. For Cunningham, this museum was the anticipated ultimate destination for his art as well as a working premise that enabled him to conceive paintings in terms of related series and mutually reinforcing themes. Over the years he no doubt took many treks through this long-imagined museum, in which the whole would be greater than the sum of its individual parts because it would provide the full-blown narrative of lasting value, cultural significance, and social renewal through an immersion in an idyllic past. Cunningham's imposing museum collection of paintings that portray an American Eden assures him an important and lasting place in twentieth-century American vernacular art.

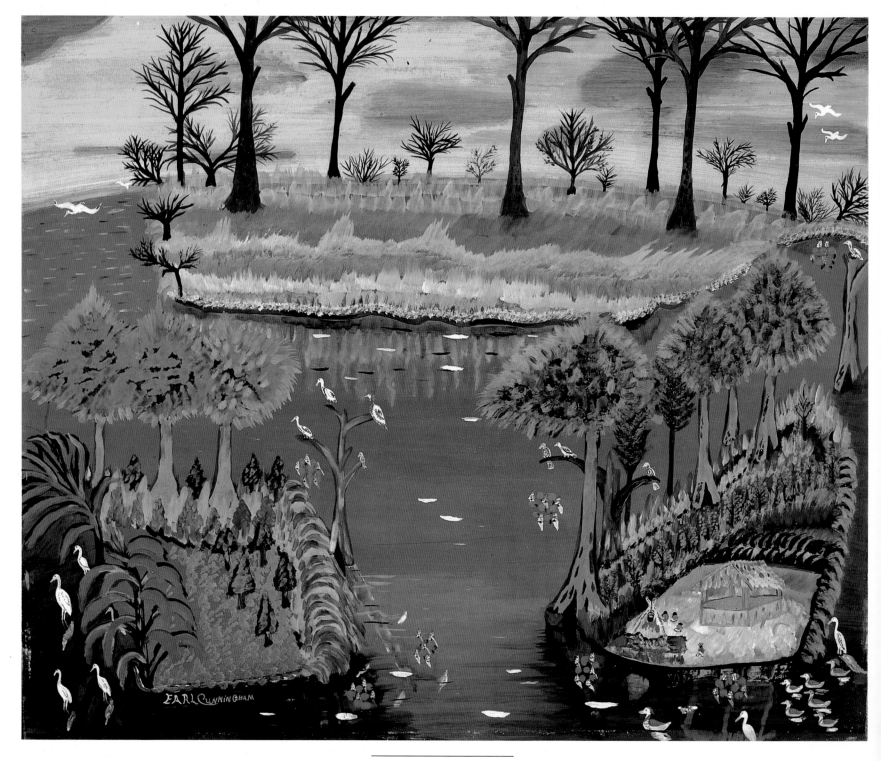

Mosquito Lagoon. *21 × 25"*

Mosquito Lagoon *(detail)*

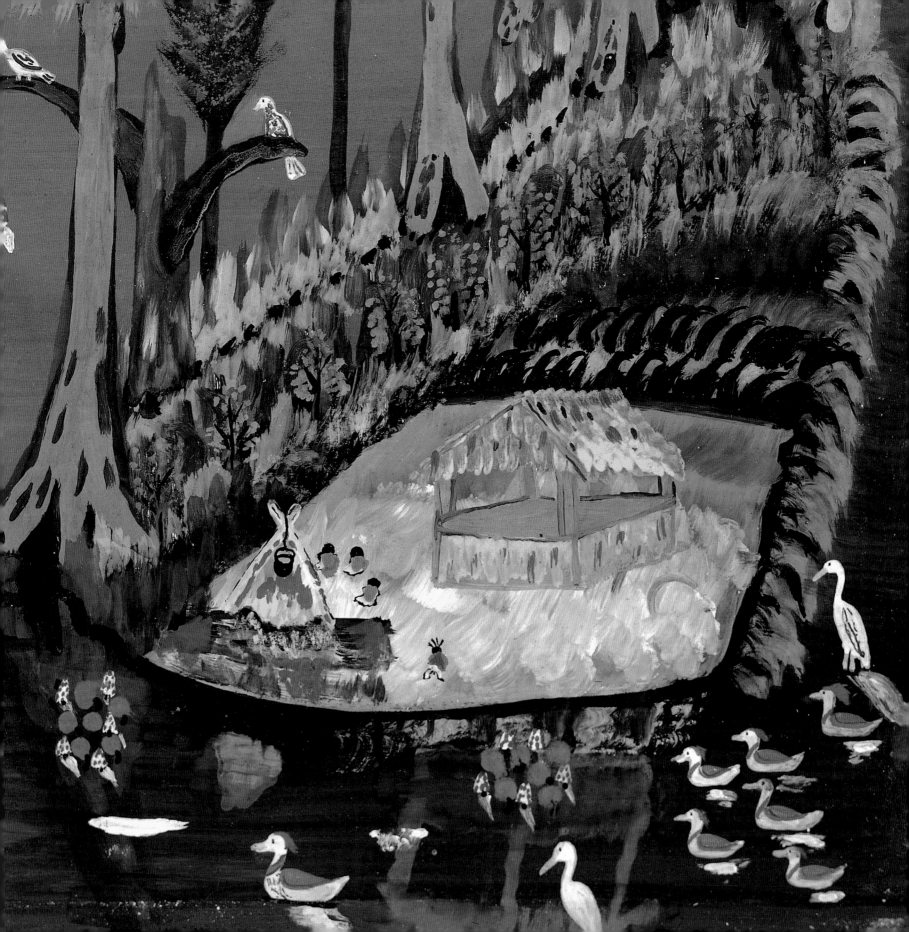

Notes

Foreword

1. Brian O'Doherty, *American Masters: The Voice and the Myth* (New York: Ridge Press/Random House, 1974), 6.
2. Columbus Museum of Art, *Elijah Pierce: Woodcarver* (Seattle and London: University of Washington Press, 1992), and Judith E. Stein et al., *I Tell My Heart: The Art of Horace Pippin* (Philadelphia and New York: The Pennsylvania Academy of the Fine Arts in association with Universe Publishing, 1993).

Earl Cunningham: Painting an American Eden

1. Charles Messer Stow, "Primitive Art in America," *Antiquarian* 8 (May 1927): 20–24.
2. Fred E. H. Schroeder, *Outlaw Aesthetics: Arts and the Public Mind* (Bowling Green, Ohio: Bowling Green University Popular Press, 1977), 10.
3. Robert Bishop, in *Earl Cunningham Exhibition at the Orlando Museum of Art* (1988), a videotape, in the archives of Michael and Marilyn Mennello, containing passages from Bishop's lecture at the Orlando Museum of Art on October 17, 1986.
4. Robert Bishop, "Comment," in *Earl Cunningham: The Marilyn L. and Michael A. Mennello Collection*, exhibition catalogue (Huntington, West Virginia: Huntington Museum of Art, 1990), 10.
5. Robert Bishop, "The Rediscovery of a Major Twentieth Century American Folk Artist," brochure for exhibition "Earl Cunningham: His Carefree American World," Museum of American Folk Art, New York, 1986. The curator for the Cunningham retrospective at the Museum of American Folk Art was Hank Niemann.
6. Charles Brigham, telephone interview with Robert Hobbs, January 17, 1993.
7. Jerry Uelsmann, telephone interview with Robert Hobbs, August 17, 1991. In an interview with Maude Wahlman, December 1, 1989, Uelsmann stated that Cunningham's dream was a museum of just his own work.
8. Robert Cunningham, telephone interview with Robert Hobbs, December 21, 1992.
9. Ibid.
10. Cunningham was fond of pointing out that the term "overfork" was a more polite way of encouraging people to "fork over" their money for the antiques in his shop.
11. Brigham, telephone interview with Hobbs.
12. John Surovek, telephone interview with Robert Hobbs, January 27, 1993.
13. During his lifetime Cunningham sold relatively few works. He made an exception to Kenneth and Mary Dow, who began purchasing works in 1949 and continued until the artist's death; Cunningham also sold thirteen paintings to Margaret Hahn and two to John Surovek. In addition to these collectors he allowed Charles Brigham, Jane Dart, Marilyn Wilson (later Mennello), and Jerry Uelsmann each to acquire one painting. When Surovek wanted to acquire one large and small painting, Cunningham priced both works $500 apiece. To Surovek's suggestion that price be commensurate with the size, Cunningham responded by asking how one could differentiate between two masterpieces by Michelangelo.
14. Surovek, telephone interview with Hobbs.
15. Ibid.
16. According to Cynthia Parks, "'The crusty dragon' got his name from a headline by the late Charles Brock, who was entertainment editor of *The Florida Times Union*." Cynthia Parks, "The Crusty Dragon: His Work Is Private No Longer," *The Florida Times-Union Jacksonville Journal* (Sunday, December 16, 1979).
17. Cynthia Parks, "The Crusty Dragon of St. George Street," *Times Journal Magazine* [*Times-Union and Journal*, Jacksonville, Florida], August 20, 1972, p. 9.
18. When asked about the name, he would respond with the question, "I couldn't very well call it Fork Over, could I?" Parks, 1979.
19. This information is taken from a statement by Mrs. Moses' daughter-in-law Dorothy, who discusses life on the farm. Otto Kallir, ed., *Grandma Moses: American Primitive* (New York: The Dryden Press, 1946), 30.
20. Bishop, *Earl Cunningham Exhibition at the Orlando Museum of Art*.
21. John Hubenthal, unpublished paper on defining folk art, 1991, for a seminar taught by Robert Hobbs.
22. Simon J. Bronner, *Grasping Things: Folk Material Culture and Mass Society in America* (Lexington: The University Press of Kentucky, 1986), 201, 206.
23. Ibid., 192.
24. Ibid., 207.
25. Charles Brigham, "Biographical Survey . . . ," in *Earl Cunningham: American Primitive*, exhibition catalogue (Daytona Beach: Museum of Arts and Sciences, 1974).
26. Surovek, telephone interview with Hobbs.
27. In addition, Cunningham's second museum exhibition was subtitled "American Primitive." According to Surovek, this designation was Cunningham's idea.
28. Surovek, telephone interview with Hobbs.
29. Uelsmann, telephone interview with Hobbs, August 17, 1991.
30. Surovek, telephone interview with Hobbs.
31. Ibid.
32. Although early snapshots of these paintings are extant, the

works themselves have not been located.

33. Uelsmann, telephone interview with Hobbs.

34. Thomas J. Steele, S.J., *Santos and Saints: The Religious Folk Art of Hispanic New Mexico* (Santa Fe, New Mexico: Ancient City Press, 1982).

35. Ibid., 46.

36. Ibid.

37. Ibid.

38. Ibid., 47.

39. Ibid.

40. Donald Kuspit, "'Suffer the Little Children to Come unto Me': Twentieth Century Folk Art," in *American Folk Art: The Herbert Waide Hemphill, Jr. Collection*, exhibition catalogue (Milwaukee: Milwaukee Art Museum, 1981), 37–47.

41. Ibid., 43.

42. Robert Motherwell, "What Abstract Art Means to Me," *The Museum of Modern Art Bulletin* 18 (Spring 1951): 12–13.

43. Kuspit, in *American Folk Art*, 46.

44. Ibid., 43.

45. Surovek, telephone interview with Hobbs.

46. Beverly Winslow, telephone interview with Robert Hobbs, January 27, 1993.

47. C. G. Jung, *Mandala Symbolism*, trans. R. F. C. Hull (Princeton: Princeton University Press, 1959), 10.

48. William C. Ketchum, Jr., lecture on Earl Cunningham for the Jacksonville Museum of Art, October 1, 1987. Archives of Michael and Marilyn Mennello.

49. Brigham, in *Earl Cunningham*, n.p.

50. Parks, 1979.

51. Brigham, in *Earl Cunningham*, n.p.

52. Ibid.

53. "Cunningham Collection on View," *The St. Augustine Record*, October 24, 1978, p. 3.

54. David Jaffee, "'A Correct Likeness': Culture and Commerce in Nineteenth-Century Rural America," in John Michael Vlach and Simon J. Bronner, eds., *Folk Art and Art Worlds* (Ann Arbor: UMI Research Press, 1983), 70.

55. Ibid.

56. Brigham, in *Earl Cunningham*, n.p.

57. The postcard is in the archives of Marilyn and Michael Mennello.

58. Robert Cunningham, telephone interview with Hobbs.

59. Brigham, in *Earl Cunningham*, n.p.

60. Ibid.

61. Warren James Balasco, *Americans on the Road: From Autocamp to Motel, 1910–1945* (Cambridge, Massachusetts: The MIT Press), 8.

62. Ibid., 74.

63. Ibid., 71ff.

64. Ibid., 11, 15.

65. Parks, 1979.

66. Recognizing their historic value, Joe Brunson collected and preserved these materials.

67. Cunningham's annotation on back of photograph labeled "Old Fort Marion." Archives of Michael and Marilyn Mennello.

68. Ketchum, lecture, 9.

69. Earl Cunningham diary, c. 1960s. This diary is in the archives of Michael and Marilyn Mennello.

70. Ibid.

71. Ibid.

72. Ibid.

73. The original of this letter is in the archives of Michael and Marilyn Mennello.

74. Ibid.

75. Surovek, telephone interview with Hobbs.

76. Jackie Clifton, telephone interview with Marilyn Mennello, October 1988.

77. Earl Cunningham's scrapbook, n.p.

78. Ibid., n.p.

79. Ibid., n.p.

80. *The Vacationer* (September 26, 1973), 10–11.

81. In a letter of May 1, 1977, to his uncle Earl Cunningham, Carroll Winslow refers to a book that Cunningham was evidently writing, "Well how is the book coming along. I know that it is slow work but you must be coming along on it by now. . . . I know that you are busy with the book and hope that it comes along the way that you want it to, but don't get too busy and forget to write."

82. Uelsmann, interview with Hobbs. This anxiety may have extended to Cunningham's identity as an artist, for he stopped wearing a beret in the mid-1970s.

83. Although Miss Paffe's close friend Jean Troemel repeatedly told Cunningham to draw up a will, he died without one.
 Jean Troemel helped Miss Paffe manage her Cunningham paintings. She arranged for one of the works to be sent to Jay Johnson's gallery in New York City, and she wrote to Robert Bishop at the Museum of American Folk Art about this artist. She also worked with Robert Harper, exhibition coordinator of the St. Augustine Art Association, who organized a showing of Cunningham's paintings.

84. Jung, *Mandala Symbolism*, 3.

85. Ibid.

86. C. G. Jung, *Memories, Dreams, Reflections*, recorded and edited by Aniela Jaffe, trans. Richard and Clara Winston (New York: Pantheon Books, 1963), 195ff.

87. Jung, "Flying Saucers: A Modern Myth," as quoted in *Mandala Symbolism*, vi.

88. Ibid., 4.

89. Surovek, telephone interview with Hobbs.

90. Parks, 1972.

91. Neil Harris, "Museums, Merchandising, and Popular Taste: The Struggle for Influence," in *Material Culture and the Study of American Life*, ed. by Ian M. G. Quimby (New York: W. W. Norton & Company, 1978), 152, 162.

92. Maude Southwell Wahlman, "Earl Cunningham: Visionary American Artist," unpublished manuscript, 1989, 7. Archives of Michael and Marilyn Mennello. Wahlman writes that Cunningham "worked on several paintings at a time, allowing one to dry completely before adding new de-

tails. . . . And because there were several works in progress, he was able to move from one to another using the paints on his palette until they were gone rather than adding new pigments."

93. The photograph is in the archives of Michael and Marilyn Mennello.

94. A copy of Baldrige's letter to Cunningham is in the archives of Michael and Marilyn Mennello. In addition they have a copy of an investigation claim filed with the Railway Express Agency and dated April 27, 1961. This claim indicates that the painting, valued at $1,200, was sent to Mrs. Kennedy at the White House by Earl Cunningham on January 27, 1961.

95. The painting is now in the collection of the John Fitzgerald Kennedy Library, Columbia Point, Boston, Massachusetts.

96. The widespread popularity of the vernacular arts in the late 1950s can be gauged by the fact that Easy Apply Corporation commissioned Grandma Moses to create a mural design to be produced as wallpaper, which was sold in four-by-eleven-foot reproductions on washable canvas and printed in fourteen colors. These wallpaper murals were sold in stores across the country for $39.50. "Grandma Moses by the yard," *Look* (November 13, 1956), 124–25.

97. One of Mrs. Kennedy's vernacular paintings was reproduced along with a Utrillo-like work by President John F. Kennedy the following year. Mrs. Kennedy was said to paint "with a comic inventiveness, without concern for 'what people will think.' Her pictures are often lighthearted documentaries of family occasions." *McCall's* 89 (April 1962): 95.

98. Clare Barnes, Jr., and Croswell Bowen, "The Scrimshaw Collector," *American Heritage* 15 (October 1964): 9.

99. Edith Gregor Halpert, "Folk Art in America Now Has a Gallery of Its Own," *Art Digest* 6, no. 1 (October 1, 1931): 3. This quotation is cited in Beatrix T. Rumford's important essay "Uncommon Art of the Common People: A Review of Trends in the Collecting and Exhibiting of American Folk Art," in *Perspectives on American Folk Art*, ed. by Ian M. G.

Quimby and Scott T. Swank (New York: W. W. Norton & Company, 1980), 25. Another important article dealing with the historiography of the vernacular arts in America is Eugene W. Metcalf, Jr., and Claudine Weatherford, "Modern, Edith Halpert, Holger Cahill, and the Fine Art Meaning of American Folk Art," in *Folk Roots, New Roots: Folklore in American Life*, ed. by Jane S. Becker and Barbara Franco (Lexington, Massachusetts: Museum of Our National Heritage, 1989), 141–66.

100. This essay is discussed in Bronner, *Grasping Things*, 190.

101. Ibid.

102. Eugene W. Metcalf, Jr., "From the Mundane to the Miraculous: The Meaning of Folk Art Collecting in America," *Clarion* 12 (Winter 1987): 57ff.

103. Ketchum lecture.

104. This postcard is in the archives of Michael and Marilyn Mennello.

105. Wahlman, interview with Uelsmann.

106. Uelsmann, interview with Hobbs.

107. The author wishes to acknowledge the help of Lynda Wilson in identifying these species.

108. Roger B. Stein, *Seascape and the American Imagination* (New York: Clarkson N. Potter, 1975), 62.

109. Robert L. Pincus, "Artist's world is free of grim social realities," *The San Diego Union*, Sunday, August 20, 1989, sec. E, pp. 1, 8.

110. For an excellent discussion of Edward Hicks's relationship to the Society of Friends and to the Hicksites, see David Tatham, "Edward Hicks, Elias Hicks and John Comly: Perspectives on the Peaceable Kingdom Theme," *American Art Journal* 13 (Spring 1981): 37–50.

111. N. F. Karlins, "The Peaceable Kingdom Theme in American Folk Painting," *Antiques* 109 (April 1976): 738–41.

112. The author gratefully acknowledges Joan Meuller's expertise in figuring out the various components of Cunningham's houseboat.

Chronology

By Mary L. Lynch

1893 June 30. Born Erland Ronald Cunningham in Edgecomb, Maine, near Boothbay Harbor, fifty-nine miles from Portland. Parents are Charles and Elwilda Drake Cunningham; there are two older sisters and, later, three younger brothers. Their father lives and works on the farm that has been in the family since the early nineteenth century. According to family tradition, they were of Scottish descent and had emigrated to Nova Scotia and then moved south to Maine.

1906 Leaves home at age thirteen. His mother makes him promise that he will finish the eighth grade; his father then pronounces him a man, and he strikes out on his own. Makes his living as a tinker and is befriended by the son of the inventor and founder of the Diamond Match Company. Returns to Boothbay Harbor for part of each year until 1937.

1909 Lives in a fisherman's shack on Stratton Island off Old Orchard Beach, Maine. Supports himself by peddling and by painting salvaged wood with pictures of boats and New England farms for fifty cents each. Eventually acquires a rowboat, tent, and a twenty-two-foot sailboat, which he sails to within fifteen miles of New York City, to Jamaica Bay, Sandy Hook, and Long Island Sound, and even up beyond the narrows of the Hudson River.

1912 May 1. Receives a certificate from Hamlin Foster School of Automobile Engineering, Portland, Maine. Also finds time to study coastal navigation and receives a government license as a pilot of harbors and rivers.

Prior to World War I Sails on giant coastal ships, 159 to 250 feet long, schooner-rigged, with four and five masts. Travels down the East coast to Florida and ports on the way, carrying coal, naval stores, and other cargo. Relates the story that he was once taken by "coaster" to Labrador, Canada, where he was put ashore for two weeks to light a huge bonfire for the ship on its return. During that time he befriended raccoons, birds, and other animals, many of which appear later in his paintings.

c. 1913 Meets Captain Foster, skipper of the J. P. Morgan family yacht, the *Grace*, and eventually learns to sail the vessel. Saves the *Grace* from possible disaster by repairing a shackle that had been undone by the weather. In return for Earl's diligence, Captain Foster goes to Boston and returns with an eleven-foot mahogany-topped white cedar canoe, a gift from the Morgan family. Later, a loan from Captain Foster enables him to buy a twenty-two-foot sailboat.

1913 June. Postcard from Boothbay Harbor mentions traveling "from Portland, Maine to Boothbay Harbor on the *Grace*. . . . Captain Foster's daughter and I went to the fire around nine o'clock at night June 1913." Fire destroys a large hotel called the Menawarmet.

1914 August. Stays in cabin at Pendleton homestead, Crescent Beach Road, Anastasia Island, Florida. That same year sells a painting for eight dollars.

1915 June 29. Marries Iva Moses, a piano teacher, whom he calls Maggie throughout their marriage. Buys a thirty-five-foot cabin cruiser named the *Hokona*, on which he and his bride live. Drives a truck for the navy during World War I and is sent to Jacksonville, Florida, to test an instrument used to detect alloys in junk metals. While on this job visits St. Augustine for the first time.

1916 *Hokona* is docked near Cape Elizabeth, Maine. Photograph of chickens bears inscription "product of our farm 1916."

1917 Photograph of the vessel *Bay State* grounded on the rocks, Cape Elizabeth, near Portland, Maine. Later uses this scene in a painting.

1918–c.1928 For a decade after World War I spends the winters in Florida at Tampa Bay, Cedar Keys, and St. Augustine, digging for Indian relics and collecting opalized coral to take back to Maine to sell. Also catches fiddler crabs on the beaches of Anastasia Island, Florida, which he preserves and takes back to Maine.

1919 In Freeport, Maine, and Schenectady, New York.

1920 Lives in Freeport, Maine. Has several buildings and a sawmill.

1921 July. Photograph taken in Freeport, Maine, with the truck named *Dirigo: The Good Barge*.
July 10. Travels between Florida and Maine.
August 6. Visits Niagara Falls.
August 8. Travels the coast of Lake Erie beyond Lackawanna, New York.
October 14. Spends time in Ohio; the Cunninghams husk eight hundred bushels of corn for a Mr. Riddles.

1922 April. Visits Cartersville, Georgia.
August. Photograph taken near Cartersville shows Etowah

burial mounds in the background. On the reverse Cunningham notes, "Found lots of things here: 1922 – 23 – 24 – 25."

1923–24 Continues to visit Anastasia Island and St. Augustine, Florida. Stays long enough to invest in a small motorized tractor.

1925 Rents a house in the district of West Augustine, St. Augustine, Florida, for five years; catches fiddler crabs and sends them to Maine as well as all over the U.S. Continues to call Maine home; moves from Freeport to Boothbay Harbor.
October 19. Earl's brother Donald dies in a sawmill accident. Family situation becomes difficult.

c. 1920s–40 Maintains a twenty-five-acre farm in Maine, which he names "Fort Valley," and plans a museum.

1936 Sells his house in Maine. Some time after this date his marriage ends in divorce.

1938 January. Again visits Cartersville, Georgia.

1940 Sells Fort Valley farm and purchases a fifty-acre farm in Waterboro, South Carolina. Has museum project under way when World War II begins. Farm is converted to raise chickens for the army; nevertheless continues to paint.

1949 Moves to 51–55 St. George Street, St. Augustine, Florida, and establishes Over Fork Gallery. Landlady, close friend, and patron is fifty-one-year-old Theresia (Tese) Paffe, who lives upstairs.

c. 1950 Paints series of twenty pictures (now lost) of Native Americans for the Michigan Historical Society. Notes on back of a photograph of Mackinac Island, Michigan: "I have none of them now. They sold for $250.00 each. Each was different." Finds Native-American stone figure of bison in Georgia mountains.

1953 February 1. Oil painting entitled *American Primitive* offered for sale in catalogue of St. Augustine Art Association.

1955 Exhibits *Hilton Head*. Notes on back of painting, "Was in the National Show in St. Augustine, Florida, April 1955. Private showing."

1959 February 12. Takes pride in becoming a member of the International Oceanographic Foundation and has certificate framed, even though membership in the foundation is similar to belonging to the National Geographic Society.

1960 Has business card printed identifying himself as "Earl R. Cunningham, Zoologist" with the word "Specimens" below. Card also bears family crest with the name Cunningham; address is listed as 51–53–55 St. George Street.

1961 January 27. Ships painting entitled *The Everglades* to Jacqueline Kennedy in the White House. Declares its value to be $1,200.
May 9. Painting sent to Mrs. Kennedy is acknowledged by her secretary, Letitia Baldrige, in a letter to Cunningham.

1962 Visits his nephew Carroll Winslow and his wife, Beverly, in Maine.

1968 Identifies himself on a business card as a "Primitive Artist."

1969 November. Meets Marilyn Logsdon Wilson (now Mennello) and her friend Jane Dart; is persuaded to sell paintings to both of them.

1970 May 31–July 5. Loch Haven Art Center, Orlando, Florida (now the Orlando Museum of Art), holds Cunningham's first museum exhibition, "The Paintings of Earl Cunningham." Jerry Uelsmann takes a series of photographs of the artist and his studio.

1972 September 19. Is requested to move by the first of the year by Theresia Paffe.

1973 Both he and Theresia Paffe move to a shop-home-studio on Florida State Road AIA (U.S. 1), which is also 1004 N. Ponce De Leon Boulevard, St. Augustine.

1974 August 8–September 5. Museum of Arts and Sciences, Daytona Beach, Florida, holds exhibition "Earl Cunningham: American Primitive," featuring over two hundred paintings. According to museum director John Surovek, the artist wishes the paintings to be hung from floor to ceiling.

1975 Notes in diary: "Counted my paintings today August 15. I have 330 all in frames."

1976 June 3. Notes in diary: "Finished all paintings today making me 405 on hand now."

1977 December 29. During a visit from his nephew Carroll Winslow and his wife, Earl Cunningham shoots himself. His funeral takes place January 3, 1978.

Bibliography

By Marilyn L. Mennello

Books

Bishop, Robert. *Folk Painters of America*. New York: E. P. Dutton, 1979.

Johnson, Jay, and William C. Ketchum, Jr. *American Folk Art of the Twentieth Century*. New York: Rizzoli, 1983.

Meyer, George H., ed., with George H. Meyer, Jr., and Katherine P. White, assoc. eds. *Folk Artists Biographical Index*. Detroit: Gale Research Company, 1987.

Rosenak, Chuck, and Jan Rosenak. *Museum of American Folk Art Encyclopedia of Twentieth-Century American Folk Art and Artists*. New York: Abbeville Press, 1990.

Museum Publications

Brigham, Charles F. "Biographical Survey." In *Earl Cunningham, American Primitive*. Exhibition catalogue, Museum of Arts and Sciences, Daytona Beach, Florida, August 8–September 5, 1974.

Duncan, Katherine. "Earl Cunningham; His Carefree American World." *Polk Museum of Art Newsletter*, Lakeland, Florida (January–April, 1990): 5.

"Earl Cunningham, Folk Artist: The Marilyn L. and Michael A. Mennello Collection." *Huntsville Museum of Art Calendar* (September–November, 1989): 3.

"Earl Cunningham, His Carefree American World: The Mennello Collection." *Orlando Museum of Art Magazine* 8, no. 3 (September–November, 1986): 5.

Goley, Mary Anne. "Folk Art Traditions: Three Contemporary Masters." In *Earl Cunningham, His Carefree American World*. Washington, D.C.: Federal Reserve Board Building, January 23, 1990.

Henry, John B., III. *Two Centers of American Folk Art: Nineteenth and Twentieth Century Masterworks from the Collection of Mr. and Mrs. Robert P. Marcus*. Vero Beach, Florida: Center for the Arts, August 1987.

Libby, Gary R. "Earl Cunningham: American Folk Artist." *Museum of Arts and Sciences Magazine*, Daytona Beach, Florida (Spring 1988): 9.

Mennello, Marilyn. *Earl Cunningham, Folk Artist, 1893–1977: His Carefree American World*. Introduction by Henry Moran and Edeen Martin. Exhibition catalogue, Exhibits USA: A National Division of Mid-American Arts Alliance, Kansas City, Missouri, January 1988–July 1990.

——— *Earl Cunningham, Folk Artist, 1893–1977: His Carefree American World*. Exhibition catalogues, with different introductions for each venue: Introduction by Gary R. Libby, Museum of Arts and Sciences, Daytona Beach, Florida, April 1988. Introduction by Bill Atkins, Triton Museum of Art, Santa Clara, California, December 10, 1988–February 5, 1989. Introduction by Jo Farb Hernandez, Monterey Peninsula Museum of Art, Monterey, California, February 18–May 14, 1989. Introduction by Martha Longnecker, Mingei International Museum of World Folk Art, La Jolla, California, August 5–September 1989. Introduction by David M. Robb, Jr., Huntsville Museum of Art, Huntsville, Alabama, October 8–November 12, 1989. Introduction by Ken Rollins, Polk Museum of Art, Lakeland, Florida, December 8, 1989–February 25, 1990. Introduction by Charles Thomas Butler, Huntington Museum of Art, Huntington, West Virginia, May 20–July 15, 1990. Introduction by R. Andrew Maas, Tampa Museum of Art, Tampa, Florida, February 2–March 29, 1992.

Surovek, John H. "Introduction." In *Earl Cunningham, American Primitive*. Exhibition catalogue, Museum of Arts and Sciences, Daytona Beach, Florida, August 8–September 5, 1974.

Valdes, Karen. "A Separate Reality, Florida Eccentrics." Exhibition catalogue, Museum of Art, Fort Lauderdale, April 23–October 1987.

Magazine and Newspaper Articles

"American Primitive." *Eastern Review* (April 1988): 15.

Barrett, Didi. "Miniatures: Earl Cunningham Exhibitions." *The Clarion* 13, no. 1 (Winter 1988): 14.

"Breckenridge Fine Arts Center Presents Earl Cunningham Exhibit." *Breckenridge American News* (Texas), May 26, 1990, 4B.

Brigham, Charles. "Mr. Earl Cunningham, More Than a Man." *The Vacationer* (Daytona Beach, Florida), September 26, 1973, 6.

Busby, Mary Ann. "Arts Center Shows Folk Artist's Work." *Springdale News* (Arkansas), April 1989.

Craven, Waldo. "Earl Cunningham Works Open at Art Museum." *Jacksonville Register*, September 24, 1987, 17.

"Cunningham Collection on View." *The St. Augustine Record*. October 24, 1978, 3.

"Cunningham Exhibit Opening." *The St. Augustine Record*. December 12, 1979, B2.

"Cunningham Folk Paintings at Museum of Arts and Sciences." *Volusia Arts*. April 8–14, 1988, 9.

"Cunningham Works on Display." *The Traveler* (St. Augustine, Florida), November 8, 1978, 11.

Darrel, Joseph. "Earl Cunningham's Carefree American World." *Vue: The Arts Magazine* (Jacksonville, Florida) 3, no. 2 (September 1987): 21.

Dishman, Laura Stewart. "Cunningham's Folk Art Reflects Cheerful World." *The Orlando Sentinel*, October 17, 1986, E3.

———. Folk Artist Puts Flights of Fancy in Common Terms." *The Orlando Sentinel*, March 10, 1986, C1, C2.

"Earl Cunningham: His Carefree American World." *Jacksonville Register* 2, copy 23 (September 10, 1987): 4.

"Earl Cunningham 'One Man Exhibition.'" *The Vacationer* (St. Augustine, Florida), August 28, 1974, 4–9.

"Earl Cunningham's Paintings on Display at Museum of Art." *Huntsville News* (Alabama), October 12, 1989, B1.

Edwards, Diana. "A Peaceful, Idyllic World on Canvas." *The Compass* (St. Augustine, Florida), September 10, 1987, 3–4.

Freudenheim, Susan. "Cunningham's Folksy Nautical Works Hard to Resist." *The Tribune* (San Diego, California), August 11, 1989, C6.

Hoffman, Alice J. "The History of the Museum of American Folk Art: An Illustrated Timeline." *The Clarion* 14, no. 1 (Winter 1989): 59.

Hyman, Ann. "Two Jacksonville Art Museum Exhibits Produce Varied Reactions." *The Florida Times-Union/Jacksonville Journal*, September 27, 1987, E1, E5.

Joel, Sharon. "The Collectors and Their Collections." *Antiques and Art Around Florida* (Spring/Winter 1990), 42, 54, 55, 98.

Lagorio, Irene. "St. Augustine's 'Crusty Dragon' and How His Work Came to Monterey." *The Sunday Herald* (Monterey, California), April 2, 1989, D6.

Leighton, Anne. "Cunningham's Genius: Unique Vision in a Genre of Forced Innocence." *Folio Weekly* (Jacksonville, Florida), September 29, 1987, 15.

Lewis, Carol L. "Museums Begin Fall Showings." *The Florida Times-Union/Jacksonville Journal*, September 13, 1987, E1, E9.

Milani, Joanne. "Exhibit Resounds with Rhythms of the Simple Life." *The Tampa Tribune*, February 27, 1992, 1–2.

Murphy, Drew. "On Display: Folk Artist's Carefree American World." *The News-Journal* (Daytona Beach, Florida), April 16, 1988, D1, D10.

Ollman, Leah. "A Free-Spirited but Repetitious Exhibition." *Los Angeles Times*, August 18, 1989, IV, 18.

Parks, Cynthia. "The Crusty Dragon of St. George Street." *Times Journal Magazine* (Jacksonville, Florida), August 20, 1972, 6–11.

———. "The Crusty Dragon: His Work Is Private No Longer." *The Florida Times-Union/Jacksonville Journal*, December 16, 1979, J1.

———. "Earl Cunningham: Artist Was Particular About Sharing His Work." *The Florida Times-Union/Jacksonville Journal*, October 26, 1986, D1, D8.

Pincus, Robert L. "Artist's World Is Free of Grim Social Realities." *The San Diego Union*, August 20, 1989, E1, E8.

Rybinski, Paul. "Three New Shows: Exhibits of Colorful Painting Open at Polk Museum of Art." *The Ledger* (Lakeland, Florida), December 7, 1989, C1, C5.

"Two Art Exhibits Open." *The News Journal* (Daytona Beach, Florida), April 9, 1988, 12D.

"Winter Park Couple Funds Art Research." *Winter Park Outlook* (Florida), February 2, 1989, 2.

"Works of Earl Cunningham to Be Shown in New York." *Antiques and the Arts Weekly*, February 28, 1986, 28.

Yost, Lee. "Mennellos Capture Art Treasure." *La Femme* (Winter Park, Florida) 14, no. 1 (October 23, 1986): 3, 11.

Index

Italic page numbers refer to illustrations.